2 8 1978

391.093
Hope, Thomas
 Costumes of the Greeks and
 Romans

 00600

OCEANSIDE PUBLIC LIBRARY
330 N. Coast Highway
Oceanside, CA 92054

DEMCO

D0211187

two volumes bound as one

(formerly titled: Costume of the Ancients)

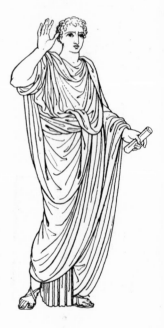

391.093
HOP

Costumes of the Greeks and Romans

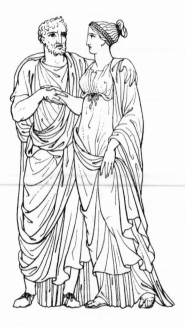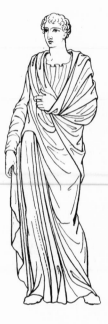

By Thomas Hope

Dover Publications, Inc., New York

OCEANSIDE PUBLIC LIBRARY
330 N. Coast Highway
Oceanside, CA 92054

#176

1. Costume — Greece
2. Costume — Rome
I. T

Published in Canada by General Publishing Company, Ltd., 30 Lesmill Road, Don Mills, Toronto, Ontario.

Published in the United Kingdom by Constable and Company, Ltd., 10 Orange Street, London WC 2.

This Dover edition, first published in 1962, is an unabridged republication of the work originally published by William Miller in 1812 under the title *Costume of the Ancients.* The work previously appeared in two volumes, but this Dover edition is complete in one volume.

Costumes of the Greeks and Romans belongs to the Dover Pictorial Archive Series. Up to ten illustrations from this book may be reproduced on any one project or in any single publication free, and without special permission. Wherever possible include a credit line indicating the title of this book, author, and publisher. Please address the publisher for permission to make more extensive use of illustrations in this book than that authorized above.

The republication of this book in whole is prohibited.

Standard Book Number: 486-20021-3
Library of Congress Catalog Card Number: 62-2519

Manufactured in the United States of America
Dover Publications, Inc.
180 Varick Street
New York, N.Y. 10014

OCEANSIDE PUBLIC LIBRARY
615 FOURTH STREET
MAR 1 9 1998

List of Plates

VOLUME ONE

List of the Plates

List of the Plates

List of the Plates

VOLUME TWO

List of the Plates

List of the Plates

List of the Plates

List of the Plates

List of the Plates

Introduction

ON THE COSTUME OF THE ANCIENTS

A THOROUGH proficiency in drawing the external anatomy of the human frame must be confessed the first requisite of all historical painting. It is indispensable to the correct representation not only of the parts that are left bare, but even of the clothing in which others are enveloped. If the painter cannot draw correctly the naked figure, he cannot array it according to truth; since the very folds of the raiment must depend on the forms and motions of the body and limbs underneath: above all, he cannot attire it with elegance; since, in order to render his figure pleasing to the eye, the general attitude and proportions of the frame itself should ever remain distinctly perceptible even through the fullest drapery. Where the human figure, instead of only being covered, is concealed by the garment, it no longer offers beauties superior to what the various articles of apparel might have displayed, collected in a mere bundle.

Even the most thorough knowledge, however, of those peculiarities of the human skeleton and muscle which remain unvaried from age to age, is not yet alone sufficient to constitute a correct historical painter.

To attempt representing a real event, and to violate in the execution all truth of costume,—to clothe (as Paul Veronese has done) Alexander in French brocade, and Statira in Genoa cut velvet, is before-hand wantonly to mar the best fruits of one's labour, the applause of the judicious. It is offering a masquerade instead of a historic subject, a riddle in place of a tale clearly told. The ignorant and the vulgar, who only notice the brilliancy of the hues, who hardly enquire into the particulars of the subject, may applaud; but the man of discernment, who expects that the performance should accord with the name, will remain dissatisfied. However masterly the touch, however fascinating the colours, he still will consider the work as being at best but a splendid absurdity, cal-

culated to excite at least as much laughter as admiration. Those who to a fine natural feeling join a cultivated taste, can only receive unqualified pleasure from that scrupulous imitation of historical truth, carried even into the minutest accessory parts, which alone gives every personage the peculiar physiognomy and every scene the individual locality that serve to distinguish them from all others; and that bring the place and the action at once home to the mind of a well informed observer.

It must be owned, indeed, that the knowledge of costume requisite for this purpose is not always as easily attainable as the proficiency in anatomy above urged. For while the natural forms of the human body remain nearly the same in all ages and climes; while the English youth, if well shaped, may still serve for the model of an Adam in the garden of Eden, it fares otherwise with the artificial clothing of that person. Every clime and every period have seen this latter vary, and have offered some modification of dress and furniture different from others. Authentic descriptions and faithful monuments alone can convey the accurate knowledge of these variations; and to these records of past ages the artist of our times must have access, who wishes to retrace them in his works.

This communication, at least with the memorials of the more classic eras of Greece and Rome, whose subjects offer the happiest mixture of beautiful naked forms with grand features of attire and armour, has always been rendered easier in France than in most other countries. A magnificent library, ever open to all in the most liberal way, supplied at Paris every species of representation which the graver could offer, of originals not in the country; and so far back as Louis XIV, a branch of the French Academy of Arts was established in the heart of Rome, in order that young painters of promise might there have an opportunity of studying at the public expense the originals themselves, of which elsewhere they could only behold the transcripts. Even now that the finest of the moveable works of art, formerly in Italy, are transplanted to Paris, this Academy at Rome has recently been placed on a better footing than before, in order that its inmates might be enabled to study with greater fruit those vaster monuments of ancient magnificence, whose roots are too deeply implanted in the native soil to bear being wrested from it.

I shall not dwell on the total want of all similar provision with

us. I shall not expatiate on the penurious spirit with which our government has hitherto suffered its native artists to struggle unassisted with all their difficulties; on the scanty means of information the young painter and sculptor find at home; on the absence of all public assistance they labour under to pursue their studies abroad. The theme is ungrateful; and the circumstance causes many a young artist of an aspiring mind to curb his native genius, to throw aside his canvass ready to teem with gods and heroes, or to people it at best with clowns and beggars.

With a view to supply at least in a small degree the deficiencies here stated, and to afford artists a convenient and a cheap collection of those leading features of ancient costume of which the knowledge can least be dispensed with, was this work undertaken. I had in former days had the good fortune frequently to visit most of the celebrated Musea abroad; had taken some pains to distinguish, among their contents, from the genuine antique stock remaining, the spurious and often wretched modern restorations engrafted upon it; and had lamented that these indifferent additions should so seldom be pointed out as such in the engravings executed from the originals in question, and should consequently render these latter so much more frequently calculated to mislead than to instruct the youthful student. I had moreover preserved memorials of several curious specimens of ancient art not hitherto published: and the materials thus collected abroad, together with what my own little assemblage particularly of Grecian fictile vases afforded at home, proved of great utility in the execution. They enabled me to trace my sketches, however rude, in such a way as to offer separated from each other in distinct groups the forms that belonged to different eras, climes, or stations, and combined together in the same compositions the features that appertained to the same region, period, or profession. Thus was the substance of many expensive and cumbersome works condensed in the small compass of a portable volume or two, containing all that might be necessary to give to artists, nay even to dramatic performers and to others engaged in classic representations, an idea of ancient costume sufficiently ample to prevent their offending in their performances by gross and obvious blunders.

Small and restricted however must remain even to the artist the use of my little book, while we continue to give to landscape and

low-life subjects so decided a preference over the sublimer scenes of history and of mythology; while individuals in general testify so little feeling for the beauties of historical composition, that the most excellent and laborious performances in that class remain precisely the longest unsold on the walls of our yearly exhibitions; while corporate bodies never dream of encouraging the production of historical works, by adorning with them their halls and meeting-places; while the nation at large seems unmindful of the importance of a sedulous cultivation of the higher branches of art, not merely to the promoting the national industry, but to the higher purpose of humanising the national manners, exalting the national character, and increasing the national spirit and happiness; while ministers, however lavish and profuse in other respects, continue so penurious with regard to what is most conducive to the pride and splendour of the country, as to withhold the comparatively trifling sums necessary to encourage by adequate premiums those performances that inspire future heroes, by nobly displaying the achievements of past worthies; while, consequently, the painter dares not encounter the expense and the labour attendant on high-wrought historical compositions, unless the fire of his genius be so vivid as not to be damped by the chilling prospect of want of bread; nay, not even by the still more discouraging dread of a total lack of well deserved and hardly earned fame.

To the professed but purely theoretic antiquarian I presume not in these pages to offer anything likely to prove interesting or useful, either immediately, or at any future period whatever. A work, intended solely for the easy reference and the ready application of actual practitioners in art, not only required not but admitted not specimens so uncommon or speculations so recondite as to absorb all the leisure of the student, without proportionably increasing the store of essential forms transferable to his canvass. That very mode, besides, which I thought best suited to the painter's purpose, of frequently combining in a single figure the representations of articles collected from many different originals, has been precisely the greatest bar to my proving in every instance the faithfulness of my imitations, by quoting my authorities. A list of these would have added to the trouble of the artist, in the same proportion in which it might have afforded satisfaction to the antiquary; since I must often, for the truth of a single collective transcript, have had to refer

to so many distinct originals, as would greatly have swelled the volume, and increased the labour of the verification.

Most difficult is it, even in the slightest copies from the antique, entirely to obliterate all trace of the exalted and manifold perfections of the admirable originals. Perhaps, therefore, with regard to the single figures of portrait painters, even the sketches here presented may still, slight as they are, offer some hints not wholly without value, towards attaining in a greater degree than we usually find them displayed the more general beauties of mere ease, and grace, and unaffected simplicity of attitude. But as to the more detailed and minute excellencies of the ancient workmanship, such as that thorough knowledge of anatomy, that exquisite selection of forms, that sublimity of expression, that prodigious diversity in the texture of the stuffs and in the forms of the folds, which ancient relics everywhere exemplify, of these a compendium like the one here offered cannot be expected to retain the least vestige. This species of ancient superiority, in order to be faithfully represented, would have required a work almost as elaborate as the originals themselves; and thence the student should ever remember that this small hand book, only intended to instill a few of the most essential rudiments, can afford no dispensation from studying either the antique itself, or the more important modern works which represent its beauties more explicitly, whenever he finds either of these accessible.

I shall begin the order of my figures with representations of the inhabitants of that corner of Africa called Egypt, because these stand most aloof from the nations of the other parts of the ancient world, and would elsewhere break that uninterrupted connection which I have endeavoured to preserve throughout. I shall thence pass over to the Asiatics, inasmuch as the dresses, the manufactures, and the civilization of the natives of Asia were, in their commencement, of a much remoter date than those of any Europeans, and experienced much fewer subsequent changes,—many of the Asiatic modes of apparel recorded in the most ancient monuments still resembling such as are worn to this day in the same regions. Next I shall proceed to the Greeks, because these not only were prior in civilization to the Romans, but the very people who in process of time became the principal *arbitri elegantiarum* and fashion-mongers of the Romans themselves, and of all the later and more barbarous nations successively blended with, or sprung from the Romans; whence, on the

one hand, the modification of attire and of building of the Greeks, offer an uninterrupted transition to those of the Romans; and, on the other, those of the Romans of the more civilized eras can only be considered as those belonging to the Greeks of the same periods. In truth the Roman works of art only present those peculiar deviations from the purer Greek models of prior ages, which the subsequent corruption and degeneracy of taste insensibly introduced in the very cradle of art itself.

A hundred new plates have been added to those of the first edition; and I regret that I could not arrange these so as to enable their being purchased separately, and bound up with those before published. This however was impossible, since, to perfect and complete the work, it was found necessary to alter and to improve many of the old plates themselves, to substitute to many of these entire new ones, to intermix the old and new in an entire new order, and consequently, to new number the whole series. The only thing, consistent with the improvement of the work, that depended on me, I have endeavoured to do—namely, to make it as cheap as possible.

COSTUME OF THE EGYPTIANS*

THE ancient Egyptians were descended from the Ethiopians, and while their blood remained free from any mixture with that of European or Asiatic nations, their race seems to have retained obvious traces of the aboriginal Negro form and features. Not only all the human figures in their coloured hieroglyphics display a deep swarthy complexion, but every Egyptian monument whether statue or bas-relief presents the splay feet, the spreading toes, the bow-bent shins, the high meagre calves, the long swinging arms, the sharp shoulders, the square flat hands, the head, when seen in profile, placed not vertically but obliquely on the spine, the jaws and chin consequently very prominent, together with the skinny lips, depressed nose, high cheek bones, large unhemmed ears raised far above the level of the nostrils, and all the other peculiarities characteristic of the Negro conformation. It is true that the practice prevalent among the Egyptians of shaving their heads and beards close to the skin (which they only deviated from when in mourning) seldom allows their statues to show that most undeniable symptom of Negro extraction, the woolly hair; the heads of their figures generally appearing covered with some sort of cap, or, when bare, closely shaven. In the few Egyptian sculptured personages, however, in which the hair is introduced, it uniformly offers the woolly texture, and the short crisp curls of that of the Negroes; nor do I know a single specimen of genuine Egyptian workmanship, in which are seen any indications of the long sleek hair or loose wavy ringlets of Europeans or Asiatics. The black streak, which, in the masks or faces carved and painted on the cases of the mummies, is carried from the outside corner of the eye-lids to the temple, seems to denote

* [Hope wrote at a time when very little was known about Ancient Egyptian art. Later researches have shown that much of what he says is incorrect. For the sake of completeness, however, his text has been allowed to stand, without deletion or emendation. Publisher's Note, 1961]

that anciently, as to this day, the natives of Egypt were in the habit of artificially deepening the hue and increasing the length of their eye lashes, by means of some species of pigment.

The inferior classes seem in Egypt to have gone nearly naked; and all the different orders of the community alike to have worn little and thin clothing. The lower extremities of the body appear to have been covered the most. Many male figures display no other garment than a short apron or piece of stuff, fastened round the waist by a belt, and descending half way down the thighs; and in many representations of personages of both sexes, the whole upper part of the body appears entirely bare, or only adorned with a profusion of necklaces, belts, armlets, and bracelets; while the aforesaid apron, wrapped round the loins, descends like a petticoat down to the ankles. The complete tunic, reaching all the way from the neck to the feet, seems to have been reserved for the higher orders; and even this in the genuine Egyptian statues is so scanty, and drawn so tight round every part of the body and limbs, that not a crease appears throughout, and that all the natural forms shew themselves through it most distinctly; so as to leave it difficult to conceive how the wearers could move a step, without rending it from top to bottom.

In later times, however, the Egyptian vestments seem, in imitation of those of the Greeks and the Romans, to have acquired more fulness. The statues of Isis and of her priestesses found in Italy, indicate that under the Roman dominion the ladies of Egypt not only wore more ample tunics, falling in easy folds like those of their neighbours, but cast over these a fringed veil or mantle, of which the ends drawn from behind the back over the shoulders across the chest, were made in front, by means of a large knot, to tie with and to uphold the middle part.

The byblus or papyrus plant seems to have furnished the material for some of the shorter and tighter coverings as well of the body itself as of the head and feet, if we may judge from the narrow ribs which even the little aprons wound round the thighs frequently display. The ampler dresses were in general made of flax; more rarely of cotton; and never of silk, I believe, until after the Roman conquest. Rich dies of green, yellow, red, and blue seem to have been very common.

The Egyptians adorned their heads with a variety of caps, some-

Costume of the Egyptians

times rising to a great height above the head, sometimes descending very low on the chest, in the shape of lappets. Those of the priests and of their attendants are often loaded with a profusion of symbolical decorations, composed of feathers, lotus leaves, and other natural productions; and in some of the head-dresses of Isis and of her followers we easily recognize the disk and the horns, representative of the orb and the phases of the moon.

In religious processions it was common to wear masks that encompassed the whole head and neck down to the shoulders. These represented the head and bust of various sacred animals, such as the ibis, the hawk, the bull, the dog, and the ram.

Numerous rows of rich beads were worn by both sexes round the neck; a belt encircled the body immediately under the paps of the breast, and another confined the small of the waist. Gorgeously worked straps or braces crossed the shoulders, and met or supported these zones.

Armlets, manacles, and rings round the ankles also were common. The kings bore long staffs or sceptres, and the priests carried wands, decorated with the heads of birds and various other insignia.

The Egyptians were wont to consider the habitations of the living only as inns where no one tarried; and to the tombs of the dead alone they gave the name of permanent dwellings, which, when once occupied, their tenants no more quitted. Thence all edifices of a private nature seem to have been of slight texture, and made of perishable materials; probably often only of the mud of the Nile, and of the reeds that grew along its banks. Even the kings were indifferent as to the permanence and sumptuosity of their palaces, and employed all their wealth in the construction of their sepulchral monuments. It was for the dead and for the immortals that they reserved every species of magnificence and durability which architecture could display; and those pyramids and those temples which were raised long prior to the ages of historic certainty, seem likely to reach the latest eras of mortal existence.

The roofs of the sacred edifices were supported by columns of enormous thickness, adorned with capitals representing the foliage and fruit of the palm tree, the leaf and the flower of the nymphea, and other aquatic vegetables; the massy walls, often made, for the purpose of great stability, to slope or spread downwards, were covered with hieroglyphics, whose faint relief, sunk beneath the level

of the surface, was often rendered more conspicuous through means of various pigments as durable as they were vivid. Yet is there such breadth, such repose of surface, combined with so much contrast and boldness of outline, displayed in these huge masses—the solid parts and the apertures are so happily intermixed and divided—that the effect of the whole is, in spite of the gawdy embroidery of the detail, indescribably grand and majestic.

Buildings of a more airy and light description seem to have been frequently coated with alternated horizontal stripes or layers of black and of white marble, somewhat like the cathedrals of the middle age in the cities of Tuscany. Couches, seats, and other articles of furniture generally offer their extremities terminating in the heads and claws of lions, and of other beasts of prey.

As Palestine, from its geographical situation, formed as it were the connecting link between Egypt and Syria, a few specimens of the Hebrew costume would have offered a desirable transition from that of Africa to that of Asia. Unfortunately the Jews have left no monuments of art behind them to assist us in this research. The circumstance of their inhabiting the intermediate tract of country between the Egyptians and the Syrians, however, makes it fair to presume that their dress and their buildings partook of the character of both. Nor could the artist, I should imagine, greatly err, who, having to represent Hebrew personages during their abode in, or soon after their flight from Egypt, should make them partly preserve the garb of those Egyptians, of whom they retained so many rites and customs; and who again, having to picture the Jews of later periods, and during or subsequent to their intercourse with the nations of Syria and their captivity in Babylon, should represent them as humble imitators of Assyrian pomp and manners. At any rate, the same deficiency of Jewish monuments, which prevents us from ascertaining the exact truth with regard to the cut of the Jewish cloak, will also prevent us from being offended at any involuntary error in this respect, which offers not a palpable deviation from Eastern fashions in general.

COSTUME OF THE ASIATICS

I DO NOT, under this head, mean to notice the Chinese, the Hindoos, or other more remote eastern nations, who were hardly known by name to the Greeks, who were never represented on their monuments, and whose costume can be of little use to the historical painter. I only wish to offer a few observations with regard to those less distant inhabitants of Asia, who under the name of Medes, Assyrians, Persians, and Parthians, Amazons, Phrygians, Lycians, and Syrians, though a race totally distinct from the Greeks, had with these European neighbours some intercourse; and whose representations not unfrequently recur in their paintings and sculpture.

Of the male attire of the different nations inhabiting the region now called Asia Minor, the prevailing features seem to have been a vest with long tight sleeves reaching down to the wrists, and long pantaloons descending to the ankles, nay often hanging over the instep, and losing themselves within side the shoes or sandals. These pantaloons even clothe those masculine ladies the Amazons, whenever they are represented on some warlike expedition; though at other times, when at home and engaged in peaceful pursuits, they appear (as on one of my fictile vases) in petticoats like other females. Sometimes these pantaloons were made of the skins of animals, at others of rich and fine tissues, embroidered or painted in sprigs, spots, stripes, cheques, zig-zags, lozenges, or other ornaments. Sometimes they fit tight, at others they hang loose, and fall in large wrinkles over the shoes. The vest, always of the same stuff and design with the pantaloons, seems like our modern waistcoats, to have opened in front; and to have been closed by means of clasps or buttons placed at considerable distances from each other.

Over this vest was most frequently worn a wide sleeveless tunic of a different texture and pattern, clasped on the shoulders, confined by a girdle round the waist, and when long, gathered up a second

time, by means of another ligature lower down; and of this tunic the skirts reached to about the middle of the thigh. To this thus far light and airy dress, aged and dignified persons still added a mantle or peplum, different from that of the Greeks in being edged round with a regular and distinct fringe, not interwoven with the body of the stuff, but purposely tacked on; and this studied enrichment, never observable in Grecian dresses, is in fact represented by Eschylus as a peculiarity characteristic of the peplum of the barbarians, or Asiatic nations.

The Parthian, and other more inland sovereigns of Asia, are sometimes, though seldom, represented on their coins bareheaded with their long hair and bushy beards most finically dressed and curled. Often they wear a cylindrical cap, rather wider at the top than at the bottom, called mitra by the Greeks. Sometimes this cap was encircled by a diadem, and at others loaded with different emblematic ornaments. Its shape is to this day preserved in that worn by the Armenian priests.

The Medes and Persians seem more generally to have worn the cidaris, or conical cap, sometimes terminating in a sharp point, at others truncated, and mostly loaded with ornaments. The prevailing male head-dress of the Asiatics, bordering on the Euxine and the Archipelago, appears to have been that which is generally known by the name of the Phrygian bonnet, and of which the characteristic features are its point or top bent down forward, and its long flaps descending on the shoulders. Sometimes this covering seems to have been a mere loose cap of the most soft and pliant stuff, unable to support itself upright, and hanging down in large wrinkles; at others it appears to have formed a helmet of the most hard and inflexible substance—of leather, or even of metal—standing quite stiff and smooth, and enriched with embossed ornaments.

In many of these helmets the flaps descending on the shoulders are four in number, and probably were cut out of the legs of the animals, whose hide or skin formed the body of the casque. In most of the lighter caps we only discern one single pair of flaps, which are often tucked up, and confined by a string round the crown.

In the figures of Amazons we often see the beak of the helmet terminate in the bill of a griffin, and the spine or back of the casque rise in the jagged crest of that fabulous animal. When thus shaped this covering may be considered as a sort of trophy, worn in conse-

Costume of the Asiatics

quence of the defeat, and formed out of the very spoil of some of those griffins, with whom the Amazons are represented as constantly at war. Minerva herself sometimes appears in a Phrygian helmet of this species, probably when represented as worshipped at Troy; and Roma likewise wears it on many Latin coins; in order, no doubt, to indicate the kindred which the Romans claimed with the Trojans. This Phrygian bonnet seems to have been retained by many of the officers of the Byzantine emperors: and to have been, in its turn, again borrowed from these by several of the dignitaries of the Turkish empire; nay, to have travelled, during the intercourse of the Venetians with the Greeks, as far westward as Venice itself, where the Doge continued to wear it to the last day of his existence.

The Asiatics often wore half-boots laced before, with four long depending flaps, shaped like those of their bonnets, and, like those, probably formed out of the legs of the animals, whose skins were converted into these buskins. Frequently eastern personages appear in shoes or slippers; seldom, if ever, in mere sandals, that leave the toes bare, like those worn by the Greeks.

In war the Asiatics never seem, like the Greeks, to have worn either breast plates or greaves, but frequently a coat or jacket with sleeves, entirely of mail. A flap of mail frequently descended from under the helmet, to protect the neck and shoulders.

The chief defensive weapon of the Asiatics was the pelta, or small shield in the form of a crescent, sometimes with, and sometimes without its curved side divided by a point into twin concavities. The peculiar offensive weapons of the inhabitants of Asia were the bipennis, or double battle-axe, the club, and the bow and arrow, generally carried in two different partitions of the same case or quiver.

The Dacians, though inhabitants of the European shores of the Euxine, but near neighbours to, and probably of the same origin with the Asiatic nations here mentioned, seem to have deviated little from them in their costume. They wore their shoes or soles fastened with long strings, wound several times round the ankle, and their pantaloons very wide. On the Trajan column not only many of the Dacian soldiers themselves, but even many of their horses, appear entirely enveloped in a coat of mail, or covering of small scales, in close contact with the body and limbs. Their helmets were conical, and ended in a sharp spike.

Many of the Asiatic nations were celebrated for their constant use and skilful management of horses; and are often represented as fighting on horseback against Greeks on foot.

GRECIAN COSTUME

IT IS precisely in its earliest periods that the Grecian attire, whether of the head or of the body, exhibits in its arrangement the greatest degree of study, and if I may so call it, of foppishness. In those Grecian basso-relievos and statues which either really are of very early workmanship, or which at least profess to imitate the style of work of the early ages (formerly mistaken for Etruscan), every lock of hair is divided into symmetrical curls or ringlets, and every fold of the garment into parallel plaits; and not only the internal evidence of those monuments themselves, but the concurring testimony of authors, shews that in those remote ages heated irons were employed both to curl the hair and beard, and to plait the drapery. It was only in later times that the covering, as well of the head as of the body, was left to assume a more easy and uncontrolled flow.

At first, as appears both from ancient sculpture and paintings, men and women alike wore their hair descending partly before and partly behind in a number of long separate locks, either of a flat and zig-zagged, or of a round and corkscrew shape. A little later it grew the fashion to collect the whole of the hair hanging down the back, by means of a riband, into a single broad bundle, and only to leave in front one, two, or three long narrow locks or tresses hanging down separately; and this queue was an ornament which Minerva, a maiden affecting old fashions and formality, never seems to have quitted; and which Bacchus, though not originally quite so formal, yet when on his return from amongst the philosophers of India he also chose to assume the beard and mien of a sage, thought proper to readopt. Later still, this queue depending down the back was taken up, and doubled into a club; and the side locks only continued in front, as low down as the nipple. But these also gradually shrunk away into a greater number of smaller tufts or ringlets, hanging about the ears, and leaving the neck quite uncon-

fined and bare. So neatly was the hair arranged in both sexes round the forehead, and in the males round the chin, as sometimes to resemble the cells of a bee-hive, or the meshes of wirework.

With regard to the attire of the body, the innermost article, that garment which does not indeed appear always to have been worn, but which, whenever worn, was always next the skin, seems to have been of a light creasy stuff, similar to the gauzes of which to this day the eastern nations make their shirts. The peculiar texture of this stuff not admitting of broad folds or drapery, this under garment was in early times cut into shapes fitting the body and arms very closely and confined or joined round the neck, and down the sleeves, by substantial hems or stays of some stouter tissue. But even this part of the attire seems in later times to have been worn very wide and loose round the body, and often at the shoulders; where, as in the figures of Minerva and of the bearded Bacchus, the sleeves are gathered up in such a way as totally to lose their shape.

The outer garment assumes in the figures of the old style an infinite variety of shapes, but seems always to have been studiously plaited; so as to form a number of flat and parallel folds across its surface, a zig-zag line along its edge, and a sharp point at each of its angles.

Though the costume of the Greeks appears to have been more particularly of the sort just described, at the periods when the sieges of Troy and Thebes were supposed to have taken place, and is in fact represented as such in the more ancient monuments relative to those events, the later works of art, nevertheless, even where they profess to represent personages belonging to those early ages, usually array them in the more unconfined habiliments of more recent times. In the male figures even of such primeval heroes as a Hercules, an Achilles, and a Theseus, we generally find the long formal ringlets of the heroic ages, omitted for the short crops of the historic periods.

I shall now enter into a somewhat greater detail with regard to the different pieces of which was composed the Grecian attire.

The principal vestment both of men and of women, that which was worn next the skin, and which, consequently, whenever more than one different garment were worn one over the other, was undermost, bore in Greek the name of χιτών; in Latin that of tunica. It was of a light tissue; in earliest times made of wool, in later periods

of flax, and last of all, of flax mixed with silk, or even of pure silk. Its body was in general composed of two square pieces sewed together on the sides. Sometimes it remained sleeveless, only offered openings for the bare arms to pass through, and was confined over the shoulders by means of clasps or buttons; at other times it had very long and wide sleeves; and these were not unfrequently, as in the figures of Minerva and of the bearded Bacchus, gathered up under the arm-pits, so as still to leave the arms in a great measure bare. Most usually however the body of the tunic branched out into a pair of tight sleeves reaching to near the elbow, which in the most ancient dresses were close, with a broad stiff band running down the seams, and in more modern habiliments open in their whole length, and only confined by means of small buttons carried down the arms, and placed so near the edge of the stuff as in their intervals to shew the skin. In very richly embroidered tunics the sleeves sometimes descended to the wrists; in others they hardly reached half way down the upper arm.

The tunic was worn by females either quite loose, or confined by a girdle; and this girdle was either drawn tight round the waist, or loosely slung round the loins. Often, when the tunic was very long and would otherwise have entangled the feet, it was drawn over the girdle in such a way as to conceal the latter entirely underneath its folds. It is not uncommon to see two girdles of different widths worn together, the one very high up, and the other very low down, so as to form between the two in the tunic a puckered interval; but this fashion was only applied to short tunics by Diana, by the wood nymphs, and by other females, fond of the chase, the foot race, and such other martial exercises as were incompatible with long petticoats.

Among the male part of the Greek nation those who, like philosophers, affected great austerity, abstained entirely from wearing the tunic, and contented themselves with throwing over their naked body a simple cloak or mantle; and even those less austere personages who indulged in the luxury of the tunic, wore it shorter than the Asiatic males, or than their own women, and almost always confined by a girdle.

From Greek vases and paintings we learn that the tunic often was adorned with sprigs, spots, stars, &c. worked in the ground of the stuff; and rich scrolls, meanders, &c. carried round its edges; and this

tunic was frequently, as well out of doors as within, worn without any other more external garment. In mourning, when the Grecian ladies cut their hair close to the head, they wore the tunic black, as appears from two of my Greek vases, both representing Electra performing funeral rites at the tomb of Agamemnon.

Over this tunic or under-garment, which was made to reach the whole length of the body, down to the feet, Grecian females generally, though not always, wore a second and more external garment, only intended to afford an additional covering or protection to the upper half of the person. This species of bib seems to have been composed of a square piece of stuff, in form like our shawls or scarfs, folded double, so as to be apparently reduced to half its original width; and was worn with the doubled part upwards, and the edge or border downwards next the zone or girdle. It was suspended round the chest and back, in such a way that its centre came under the left arm, and its two ends hung down loose under the right arm; and according as the piece was square or oblong, these ends either only reached to the hips, or descended to the ankles. The whole was secured by means of two clasps or buttons, which fastened together the fore and hind part over each shoulder.

In later times this bib, from a square piece of stuff doubled, seems to have become a mere single narrow slip, only hanging down a very short way over the breasts; and allowing the girdle, even when fixed as high as possible, to appear underneath.

The peplum constituted the outermost covering of the body. Among the Greeks it was worn in common by both sexes; but was chiefly reserved for occasions of ceremony or of public appearance, and as well in its texture as in its shape, seemed to answer to our shawl. When very long and ample, so as to admit of being wound twice round the body—first under the arms, and the second time, over the shoulders—it assumed the name of diplax. In rainy or cold weather it was drawn over the head. At other times this peculiar mode of wearing it was expressive of humility or of grief, and was adopted by men and women when in mourning, or when performing sacred rites; on both which accounts it was thus worn by Agamemnon, when going to sacrifice his daughter.

This peplum was never fastened on by means of clasps or buttons, but only prevented from slipping off through the intricacy of its own involutions. Endless were the combinations which these exhi-

Grecian Costume

bited; and in nothing do we see more ingenuity exerted or more fancy displayed, than in the various modes of making the peplum form grand and contrasted draperies. Indeed the different degrees of simplicity or of grace observable in the throw of the peplum, were regarded as indicating the different degrees of rusticity or of refinement, inherent in the disposition of the wearer.

For the sake of dignity, all the goddesses of the highest class, Venus excepted, wore the peplum; but for the sake of convenience, Diana generally had her's furled up and drawn tight over the shoulders and round the waist, so as to form a girdle, with the ends hanging down before or behind. Among the Greeks the peplum never had, as among the barbarians, its whole circumference adorned by a separate fringe, but only its corners loaded with little metal weights or drops, in order to make them hang down more straight and even.

A veil of lighter tissue than the peplum was often worn by females. It served both as an appendage of rank, and as a sign of modesty. On the first account it is seen covering the diadem of Juno, the mitra of Ceres, and the turreted crown of Cybele, and of the emblematical figures of cities and of provinces; and on the latter account it is made, in ancient representations of nuptials, to conceal the face of the bride. Penelope, when urged to state whether she preferred staying with her father, or following her husband, is represented expressing her preference of the latter, merely by drawing her veil over her blushing features.

Gods and heroes, when travelling, or on some warlike expedition, and men in inferior stations or of simple manners at all times, used instead of the ample peplum to wear a shorter and simpler cloak called chlamys, which was fastened over the shoulder or upon the chest with a clasp. Such is the mantle we observe in the Belvedere Apollo; and in many statues of Mercury, a traveller by profession; as well as in those of heroes and of other simple mortals.

Besides these dresses common among all ranks and stations, the Greeks had certain other vestments appropriate to certain peculiar characters and offices. Apollo, when in the company of the Muses, wore in compliment to the modesty of those learned virgins, a long flowing robe similar to that of females. Bacchus, and his followers of both sexes, often appear wrapped up in a fawn or tiger skin; and heralds distinguish themselves by a short stiff jacket, divided in

formal partitions, not unlike the coats of arms of the same species of personages in the times of chivalry. Actors, comic and tragic, as well as other persons engaged in processions sacred or profane, wore fantastical dresses, often represented on vases and other antique monuments.

The numerous colourless Greek statues, still in existence, are apt at first sight to impress us with an idea that the Grecian attire was most simple and uniform in its hue, but the Greek vases found buried in tombs, the paintings dug out of Herculaneum and of Pompeya, and even a few statues in marble and in bronze, enriched with stained or with inlaid borders, incontestably prove that the stuffs were equally gaudy in their colours and varied in their patterns. The richest designs were traced upon them, both in painting and needle-work.

Greatly diversified were, among the Grecian females, the coverings of both extremities. Ladies reckoned among the ornaments of the head the mitra or bushel-shaped crown, peculiarly affected by Ceres; the tiara, or crescent-formed diadem, worn by Juno and by Venus; and ribands, rows of beads, wreaths of flowers, nettings, fillets, skewers, and gew-gaws innumerable. The feet were sometimes left entirely bare. Sometimes they were only protected underneath by a simple sole, tied by means of thongs or strings, disposed in a variety of elegant ways across the instep and around the ankle; and sometimes they were also shielded above by means of shoes or half-boots, laced before, and lined with the fur of animals of the feline tribe, whose muzzle and claws were disposed in front. Ear-rings in various shapes, necklaces in numerous rows, bracelets in the forms of hoops or snakes for the upper and lower arms, and various other trinkets were in great request, and were kept in a species of casket or box, called pyxis, from the name of the wood of which it was originally made; and these caskets, as well as the small oval hand mirrors of metal (the indispensable insignia of courtesans), the umbrella, the fan formed of leaves or of feathers, the calathus or basket of reeds to hold the work, and all the other utensils and appendages intended to receive, to protect, or to set off whatever appertained to female dress and embellishment, are often represented on the Grecian fictile vases.

The men, when travelling, protected their heads from the heat or the rain by a flat broad brimmed hat tied under the chin with

Grecian Costume

strings, by which, when thrown off, it hung suspended on the back. Mercury, and heroes, on their journies, are represented wearing this hat. There was also a conical cap, without a rim, worn chiefly by sea-faring people, and which therefore characterises Ulysses.

The same variety in the covering of the feet was observable among men as among women. Soldiers fastened a coarse sole, by means of a few strings, round the ankle; philosophers wore a plain shoe. Elegant sandals, with straps and thongs cut into various shapes, graced the feet of men of rank and fashion.

Crowns and wreaths of various forms and materials were much in use among the Greeks. Some of these were peculiarly consecrated to particular deities, as the turreted crown to Cybele, and to the figures emblematic of cities; that of oak leaves to Jupiter, of laurel leaves to Apollo, of ivy or vine branches to Bacchus, of poplar to Hercules, of wheat-ears to Ceres, of gold or myrtle to Venus, of fir twigs to the fauns and silvans, and of reeds to the river gods. Other wreaths were peculiarly given as rewards to the winners in particular games. Wild olive was the recompense in the Olympic, laurel in the Pythiac, parsley in the Nemean, and pine twigs in the Isthmic games. Other similar ornaments, again, served to indicate peculiar stations or ceremonies. The diadem or fillet called credemnon, was among gods reserved for Jupiter, Neptune, Apollo, and Bacchus, and among men, regarded as the peculiar mark of royalty. The radiated crown, formed of long sharp spikes emblematic of the sun, and always made to adorn the head of that deity, was first worn only on the tiaras of the Armenian and Parthian kings; and afterwards became adopted by the Greek sovereigns of Egypt and of Syria. A wreath of olive branches was worn by ordinary men at the birth of a son, and a garland of flowers at weddings and festivals. At these latter, in order that the fragrance of the roses and violets with which the guests were crowned might be more fully enjoyed, the wreath was often worn, not round the head, but round the neck.

As a symbol of their peaceful authority, gods, sovereigns, and heralds, carried the sceptre, or hasta, terminated not by the metal point, but by the representation of some animal or flower. As the emblem of their massive and conciliatory capacity, Mercury and all other messengers bore the caduceus, twined round with serpents.

The defensive armour of the Greeks consisted of a helmet, breast-plate, greaves, and shield.

Grecian Costume

Of the helmet there were two principal sorts; that with an immoveable visor, projecting from it like a species of mask; and that with a moveable visor, sliding over it in the shape of a mere slip of metal. The helmet with the immoveable visor, when thrown back so as to uncover the face, necessarily left a great vacuum between its own crown and the skull of the wearer, and generally had, in order to protect the cheeks, two leather flaps, which, when not used, were tucked up inwards. The helmet with the moveable visor, usually displayed for the same purpose a pair of concave metal plates, which were suspended from hinges, and when not wanted were turned up outwards. Frequently one or more horses manes cut square at the edges, rose from the back of the helmet, and sometimes two horns or two straight feathers issued from the sides. Quadrigae, sphinxes, griffins, sea-horses, and other insignia, richly embossed, often covered the surface of these helmets.

The body was guarded by a breast-plate or cuirass; which seems sometimes to have been composed of two large pieces only, one for the back and the other for the breast, joined together at the sides; and sometimes to have been formed of a number of smaller pieces, either in the form of long slips or of square plates, apparently fastened by means of studs on a leather doublet. The shoulders were protected by a separate piece, in the shape of a broad cape, of which the ends or points descended on the chest, and were fastened by means of strings or clasps to the breast-plate. Generally, in Greek armour, this cuirass is cut round at the loins; sometimes however it follows the outline of the abdomen; and from it hang down one or more rows of straps of leather or of slips of metal, intended to protect the thighs.

The legs were guarded by means of greaves, rising very high above the knees, and probably of a very elastic texture, since, notwithstanding they appear very stiff, their opposite edges approach very near at the back of the calf, where they are retained by means of loops or clasps. Those greaves are frequently omitted, particularly in figures of a later date.

The most usual shield was very large and perfectly circular, with a broad flat rim, and the centre very much raised, like a deep dish turned upside down. The Theban shield, instead of being round, was oval, and had two notches cut in the sides, probably to pass the spear, or javelin through. All shields were furnished inside with

Grecian Costume

loops, some intended to encircle the arm, and others, to be laid hold of by the hand. Emblems and devices were as common on ancient shields as on the bucklers of the crusaders. Sometimes, on fictile vases, we observe a species of apron or curtain suspended from the shield, by way of a screen or protection to the legs.

The chief offensive weapon of the Greeks was the sword. It was short and broad, and suspended from a belt, on the left side, or in front. Next in rank came the spear; long, thin, with a point at the nether end, with which to fix it in the ground; and of this species of weapon warriors generally carried a pair.

Hercules, Apollo, Diana, and Cupid, were represented with the bow and arrows. The use of these however remained not, in after-times, common among the Greeks, as it did among the Barbarians. Of the quivers some were calculated to contain both bow and arrows, others arrows only. Some were square, some round. Many had a cover to them to protect the arrows from dust and rain, and many appear lined with skins. They were slung across the back or sides by means of a belt passing over the right shoulder.

Independent of the arms for use, there was other armour of lighter and richer texture, wrought solely for processions and trophies; among the helmets belonging to this latter class some had highly finished metal masks attached to them.

The car of almost each Grecian deity was drawn by some peculiar kind of animal: that of Juno by peacocks, of Apollo by griffins, of Diana by stags, of Venus by swans or turtle doves, of Mercury by rams, of Minerva by owls, of Cybele by lions, of Bacchus by panthers, of Neptune by sea-horses.

In early times warriors among the Greeks made great use in battle of cars or chariots drawn by two horses, in which the hero fought standing, while his squire or attendant guided the horses. In after times these bigae, as well as quadrigae drawn by four horses abreast, were chiefly reserved for journies or chariot races.

The Gorgon's head with its round chaps, wide mouth, and tongue drawn out, emblematic of the full moon, and regarded as an amulet or safeguard against incantations and spells, is for that reason found not only on the formidable aegis of Jupiter and of Minerva, as well as on cinerary urns, and in tombs, but on the Greek shields and breast-plates, at the pole ends of their chariots, and in the most con-

spicuous parts of every other instrument of defense or protection to the living or the dead.

Of the Greek gallies, or ships of war, the prow was decorated with the cheniscus, frequently formed like the head and neck of an aquatic bird; and the poop with the aplustrum, shaped like a sort of honey-suckle. Two large eyes were generally represented near the prow, as if to enable the vessel, like a fish, to see its way through the waves.

I shall not make this short sketch an antiquarian treatise, by launching into an elaborate description of Grecian festivals. In the religious processions of the Greeks masks were used as well as on their theatre, in order to represent the attendants of the god who was worshipped. Thus, in Bacchanalian processions (the endless subject of ancient bas-reliefs and paintings), the fauns, satyrs, and other monstrous beings are only human individuals masked; and in initiations and mysteries, the winged genii are in the same predicament: and the deception must have been the greater, as the ancient masks were made to cover the whole head. Of these masks (which together with all else that belonged to the theatre were consecrated to Bacchus) there was an infinite variety. Some representing abstract feelings or characters, such as joy, grief, laughter, dignity, vulgarity, expressed in the various modifications of the comic, tragic, and satyric masks; others offering portraits of real individuals, living or dead. The thyrsus, so frequently introduced, was only a spear, of which the point was stuck in a pine cone or wound round with ivy leaves; afterwards, in order to render less dangerous the blows given with it during the sports of the Bacchanalian festival, it was made of the reed called ferula.

Infinitely varied were the Greek dances; some slow, some quick, some grave, some gay, some voluptuous, some warlike. It was common at feasts to have women that professed dancing and music, called in to entertain the guests.

As of musical modes, so of musical instruments there was a great diversity. The phorminx, or large lyre, dedicated to Apollo, and played upon with an ivory instrument called plectrum, seems, from certain very intricate and minute parts always recurring in its representations, to have been a very complicated structure. It was usually fastened to a belt slung across the shoulders, and sometimes suspended from the wrist of the left hand, while played upon with

the right. The cithara, or smaller lyre, dedicated to Mercury, and, when its body was formed of a tortoise shell, and its handles composed of a pair of goat's horns, more strictly called chelys, was played upon by the fingers.

The barbitos was a much longer instrument, and emitting a graver sound.

To these may be added the trigonum, or triangle; an instrument borrowed by the Greeks from eastern nations, and much resembling the harp.

Independent of these instruments with chords, the Greeks had several wind instruments, principally the double flute, and the syrinx, or Pan's flute. To these may be added certain instruments for producing mere noise, such as the tympanum or tambourine, a metal hoop covered with skin and adorned with ribands or bells, chiefly used in the festivals of Bacchus and of Cybele; the crembala, or cymbals, formed of metal cups; and the crotals, or castagnets, formed of wooden shells.

With respect to Grecian architecture I shall only observe, that the roofs and pediments of buildings were generally very richly fringed with tiles of different shapes, to turn off the rain, and with spouts of various forms, to carry off the water. The sarcophagi, made to imitate the forms of houses, generally had covers wrought in imitation of those roofs.

Terms, or square pillars, first only surmounted with heads of Mercury, from whom they derived their name; afterwards with those of other gods, of heroes, of statesmen, and of philosophers, were much used for the division and support of book-presses, of galleries, of balustrades, of gates, and of palings. Tripods, some of marble, and with stationary legs, others of metal and with detached legs, made to unhook from the basin, and to fold up by means of hinges and sliders, were in great request both for religious and for domestic purposes; as well as candelabra and lamps, either supported on a base, or suspended from a chain.

To afford repose to the frame, the Greeks had couches covered with skins or drapery, on which several persons might lie with their bodies half raised; large arm chairs with foot-stools, called thrones; other more portable small chairs, divested of arms, and with legs frequently made of elephants' tusks; and finally stools without either

arms or back, but with legs imitated from those of animals and made to fold up.

Endless was the variety of Greek vases for religous rites and for domestic purposes. Among the most singular was the rhyton, or drinking horn, terminating in the head of some animal. These vessels depended for their beauty on that elegance of outline which may make the plainest utensil look graceful, and not on that mere richness of decoration which cannot prevent the most costly piece of furniture, where the shape is neglected, from remaining contemptible to the eye of taste.

COSTUME OF THE ROMANS

THE pre-eminent dress of the Romans, and which distinguished them in the most marked way as well from the Greeks as from the Barbarians, was the toga. This they seem to have derived from their neighbours the Etrurians; and it may be called their true national garb. In the earliest ages of Rome it appears to have been worn by the women as well as by the men, by the lowest orders as well as by the highest, at home as well as abroad, in the country as well as in town. Love of novelty probably caused it first to be relinquished by the women; next, motives of convenience, by the men in lower stations; and afterwards, fondness of ease and unconstraint, even by the men of higher rank, when enjoying the obscurity of private life, or the retirement of the country. From the unsuccessful attempts however, first of Augustus, and afterwards of Dómitian, entirely to abolish a dress which still continued to remind the people more forcibly than was wished of their ancient liberty, it appears that the toga remained the costume of state and representation with the patricians, nay, with the emperors themselves, unto the last days of Rome's undivided splendor; and we may, I think, assert, that not until the empire was transferred to Constantinople, did the toga become entirely superseded by that more decidedly Grecian dress, the pallium.

Infinite have been the queries of the learned, whether the toga of the Romans was, like the peplum of the Greeks, a square piece of stuff; whether it was a round one, or whether, preserving a medium between these two extremes, it offered one side straight, and the other rounded off in a semi-circle. To judge from the numberless statues dressed in togas, in none of which there appear any corners perfectly square, though in all of them may be traced some hems or edges describing a straight, and others, a curved line, I am most inclined to think the semicircular to have been the true form of the toga.

Great pains have also been taken to discover whether the toga derived its form on the body, like the pallium, from the mere spontaneous throw of the whole garment, or, like modern dresses, from some studious and permanent contrivance to model and to fasten together the different component parts. No tacks or fastenings of any sort indeed are visible in the toga, but their existence may be inferred from the great formality and little variation displayed in its divisions and folds. In general the toga seems only to have formed as it were a short sleeve to the right arm, which was left unconfined, but to have covered the left arm down to the wrist. A sort of loop or bag of folds was made to hang over the sloped drapery in front, and the folds were ample enough in the back to admit of the garment being occasionally drawn over the head, as it was customary to do during religious ceremonies, and also, probably, in rainy weather.

The material of the toga was wool. The colour, in early ages, its own natural yellowish hue. In later periods this seems however only to have been retained in the togas of the higher orders; inferior persons wearing theirs dyed, and candidates for public offices bleached by an artificial process. In times of mourning the toga was worn black, or was left off altogether.

Priests and magistrates wore the *toga pretexta,* or toga edged with a purple border, called pretexta. This toga pretexta was, as well as the bulla or small round gold box suspended on the breast by way of an amulet, worn by all youths of noble birth to the age of fifteen; when both these insignia of juvenility were disposed together for the toga without rim or border, called the *toga pura.*

The knights wore the trabea, or toga striped with purple throughout; and the generals, during their triumphal entries, were clad in a toga entirely of purple, to which gradually became added a rich embroidery of gold.

The tunic, of later introduction among the Romans than the toga, was regarded as a species of luxury; and was discarded by those who displayed an affected humility, such as candidates and others. The tunic of the men only reached half way down the thigh; longer tunics being regarded in the male sex as a mark of effeminacy, and left to women and to eastern nations. The inferior functionaries at sacrifices wore the tunic without the toga; so did the soldiers, when in the camp. The tunic of senators was edged round with a broad

Costume of the Romans

purple border, called lati-clavus; and that of the knights with a narrow purple border, called angusti-clavus.

I shall here observe that the hue, denominated purple by the ancients, seems to have run through all the various shades of colour intervening between scarlet, crimson, and the deep reddish blue, called purple at the present day.

The pallium, or mantle of the Greeks, from its being less cumbersome and trailing than the toga of the Romans, by degrees superseded the latter in the country and in the camp. When worn over armour, and fastened on the right shoulder with a clasp or button, this cloak assumed the name of paludamentum.

The common people used to wear a sort of cloak made of very coarse brown wool, and provided with a hood, which was called cucullus. This hooded cloak, always given to Telesphorus the youthful companion of Aesculapius, remains to this day the usual protection against cold and wet with all the seafaring inhabitants both of the islands of the Archipelago and the shores of the Mediterranean.

The Roman ladies wore by way of under-garment a long tunic descending to the feet, and more peculiarly denominated stola. This vestment assumed all the variety of modification displayed in the corresponding attire of the Grecian females. Over the stola they also adopted the Greek peplum, under the name of palla; which palla however was never worn among the Romans, as the peplum was among the Greeks, by men. This external covering, as may be observed in the statues of Roman empresses, displayed the same varieties of drapery or throw at Rome as at Athens.

The *togati* seem to have worn a sort of short boot or shoe with straps crossed over the instep, called calceus. The foot covering of the ladies at first had the same shape; but by degrees this latter assumed all the varieties of form of the Grecian sandal. Like all nations in whom were combined great means and opulence wherewith to foment the exuberances of fashion, and little taste through which to check its pruriencies, the Romans carried to a great pitch the shapeless extravagance of some parts of their attire; as may be seen in the absurd headdresses of the busts of Roman matrons, preserved in the capitol.

The Romans, like the Greeks, had peculiar dresses appropriated to peculiar offices and dignities. The Flamens, or priests of Jupiter, wore a pointed cap or helmet, called apex, with a ball of cotton

wound round the spike. The priests that ministered to other deities wore the infula, or twisted fillet, from which descended on each side along the neck flowing ribands.

Wreaths of various sorts were in use among the Romans as well as among the Greeks, and were chiefly given as rewards of military achievements. The *corona castrensis,* wrought in imitation of a palisadoe, was presented to whoever had been the first to penetrate into an enemy's camp. The *corona muralis,* shaped in the semblance of battlements, to whoever had been the first to scale the walls of a besieged city. The civic crown, formed of oak leaves, to whoever had saved the life of a citizen; and the naval crown, composed of the *rostra,* or beaks of gallies, to whoever had been the first to board the vessel of an enemy.

When the arts fell into a total decline, glitter of materials became the sole substitute for beauty of forms; and hence the Grecian and Roman portraits of the middle ages are loaded from head to foot with pearls and precious stones, intermixed with large cameos.

The armour of the Romans seems chiefly to have been that of the Greeks of the same periods. The helmet with the fixed visor, and which required being thrown back in its whole, in order to uncover the face, fell very early into disuse in the very heart of Greece itself; and never appears on Roman figures. On these the cuirass or *lorica,* when belonging to distinguished personages, generally follows the outline of the abdomen; and appears hammered out into all the natural convexities and concavities of the human body. It was often enriched, on the belly, with embossed figures; on the breast, with a gorgon's head by way of amulet; and on the shoulder-plates, with scrolls, thunderbolts, &c. This cuirass was made to open at the sides, where the breast and back-plates joined by means of clasps and hinges. One or more rows of straps, richly adorned and fringed, descended by way of protection, not only over the thighs, but also down the upper arms. The cuirass of the common soldiers often was cut simply round, and destitute of such straps. Sometimes this latter was formed of metal hoops or plates, sliding over each other; sometimes of small scales equally pliant; and sometimes of a plain surface of metal or leather. The Roman soldiers wore no greaves, but either used sandals tied with strings, or short boots laced before, and lined with the skin of some animal of which the muzzle and claws were displayed as an ornamental finish.

Costume of the Romans

The Roman shield seems never to have resembled the large round buckler used by the Greeks, nor the crescent-shaped one peculiar to the Asiatics; but to have offered an oblong square, or an oval, or a hexagon, or an octagon. The cavalry alone wore a circular shield, but of small dimensions, called parma. Each different legion had its peculiar device marked on its shields.

As offensive weapons the Romans had a sword, of somewhat greater length than that of the Greeks; a long spear, of which they never quitted their hold; and a short javelin which they used to throw to a distance. Their armies were moreover provided with archers and with slingers.

Infinite were the variety and the magnificence of their military insignia. These offered, fixed one over the other along the poles of spears, eagles, figures of victory, laurel wreaths, banners, tablets inscribed with the initials of the republic and the number of the legion, pateras for libations, consecrated fillets, and other civil military and religious emblems.

The poops of the Roman gallies had for ornament the *aplustrum;* their prows, spurs shaped like swords, with which they hit and destroyed those of the enemy.

The architecture of the Romans was only that of the Greeks when on its decline,—that of the Greeks, divested of its primitive consistency and breadth and chastity. From the circumstance however of all the wealth and population of every other country flowing by degrees to Rome, certain descriptions of buildings, such as circuses, amphitheatres, triumphal arches, aqueducts, and baths, seem to have become not only more numerous but more splendid in that capital of the world, than any that could be erected in the small republics of Greece. The temples also, at Rome, from the greater variety of worships, assumed a greater diversity of shapes.

The altars of the Romans, as well as those of the Greeks, displayed a vast variety both of purposes and forms. Some were intended for burning incense only; others for receiving libations of milk or of wine; others for consuming the first fruits of the earth; others for the sacrificing of victims. Many were only meant for shew, and erected in commemoration of some signal event, or in gratitude for some important benefit. Of these altars some were round, some triangular, some square. They displayed, by way of ornament, sculptured skulls of such animals, and wreaths of such fruits and flowers

as were consecrated to the deity which they served to worship, mixed with sacred fillets, instruments of sacrifice, inscriptions, bas-reliefs, &c.

Among the sacred instruments, observable in the processions and sacrifices of the Romans, may be numbered the pastoral staff which Romulus made use of to mark out the different districts of his new city; and which afterwards, under the name of lituus, became the distinctive badge of honour of the augurs, who used it in the same way to mark out the different regions of the heavens, when drawing their prognostics. This lituus, together with the basin containing the lustral water, the aspergillum to sprinkle it, the simpulum or ewer for holding the consecrated wine, the cotton fillets for adorning the horns of the victim, the axe for slaying, and the single and double knives for cutting it up, are frequently represented in bas-reliefs.

In the decoration and furniture of their houses the Romans were very sumptuous. Rich marbles and gay arabescoes decorated the walls, elegant mosaics the floors of their apartments. On the ornaments of the triclinia or couches, on which they reclined at their feasts, they bestowed immense sums. The curule chairs or seats of state of the patricians were wrought in ivory; and prodigious is the number of beautiful utensils in marble and in bronze, richly chased and inlaid with silver, that have been found among the ruins of that comparatively insignificant provincial city Pompeya. Natives of Greece seem at all times to have been employed to give and to execute the designs, intended to display the taste and opulence of the Romans.

The writings of these latter were contained in two different sorts of receptacles; namely in rolls of papyrus or parchment, called *volumina;* and on tablets of box, ivory, or metal, called *codices.* When travelling they used to carry their manuscripts in a little round case, called *scrinium.*

B EFORE I dismiss my reader entirely, I beg I may be allowed the pleasure of expressing my obligations to Mr. Moses, the young artist who has made the engravings from most of my drawings. Those especially that have been transferred on copper in the most superior manner.

In shadowed engravings, offering figures surrounded by acces-

sories and background, a small portion only of the collective merit of the whole performance depends on the peculiar excellence of the principal outline. Other objects by which that outline is obscured or confused, such as the darkness of the shadows, and the flicker of the lights, prevent both its beauties and its defects from becoming very prominent in this species of engraving. Hence it may be executed more mechanically, by artificers themselves less skilled in drawing.

Not so engravings in mere outline, destitute of shadow, of accessories, and of background. In these every part of that outline stands as it were by itself, unassisted and undisguised, in the fullest light, and in the most prominent situation. In these, whatever does not positively add to the merit of the performance, positively detracts from it. In these no part remains indifferent, none can be slighted. In these not a single unmeaning, or tame, or even superfluous stroke of the graver can remain concealed, or can become perceptible without immediately offending the eye, and producing deformity.

Of this species of engraving, consequently, no part can be executed mechanically, or by inferior hands. Every stroke here requires an artist skilled in drawing, and uniting with a correct eye a free and masterly touch. Hence many artists, deservedly applauded in shadowed engraving, would appear very contemptible in engraving, in mere outline; and this probably is one of the reasons why, among the great number of copper-plate engravers employed on different works, I have found so few willing or able to engage in mine—a circumstance which has not a little increased my difficulties in its completion, and has even made me in some instances, unskilled as I was, take up the graver myself, and etch a few plates.

A Note on the Artists and Engravers

The names of the artists and engravers were indicated on some plates in the 1812 edition of this book. Plates so marked are listed below:

Drawn by Thomas Hope and engraved by H. Moses: 1, 3, 23-25, 29-31, 33, 46, 48, 50, 52, 54, 56-58, 60, 61, 68, 70, 72-75, 77, 78, 80-86, 88, 91-96, 99-107, 110, 114, 118, 119, 121, 123, 137, 175, 178, 180, 193, 210, 212, 227, 240, 241, 258, 283, 284

Drawn and engraved by Thomas Hope: 16, 18, 98, 108, 109, 166-169, 172, 174, 187, 191, 194, 196, 199, 207, 208, 211, 223, 225, 245, 246, 260

Drawn by Thomas Hope and engraved by R. Roffe: 17, 20, 27, 28, 32, 34, 87, 89, 276

Drawn and engraved by H. Moses: 22, 90, 111, 115, 136, 139

Drawn by Thomas Hope and engraved by Burnett: 215

Drawn by Thomas Hope: 122, 124, 132, 140, 150, 296

The following plates were unsigned in the 1812 edition:

2, 4-15, 19, 21, 26, 35-45, 47, 49, 51, 53, 55, 59, 62-67, 69, 71, 76, 79, 97, 112, 113, 116, 117, 120, 125-128, 130, 131, 133-135, 138, 141-149, 151-165, 170, 171, 173, 176, 177, 179, 181-186, 188-190, 192, 195, 197, 198, 200-206, 209, 213, 214, 216-222, 224, 226, 228-239, 242-244, 247-257, 259, 261-275, 277-282, 285-295, 297-300.

For further general information on the process of engraving these illustrations, see the author's introduction, page xlvi.

Costumes of the Greeks and Romans

VOLUME ONE

Plate 1

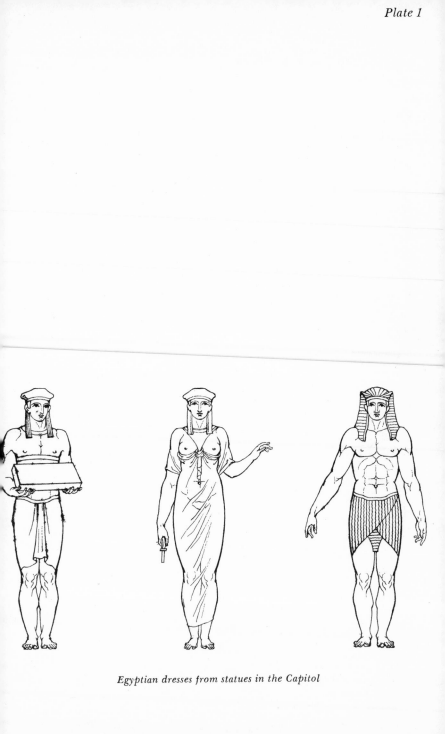

Egyptian dresses from statues in the Capitol

Plate 2

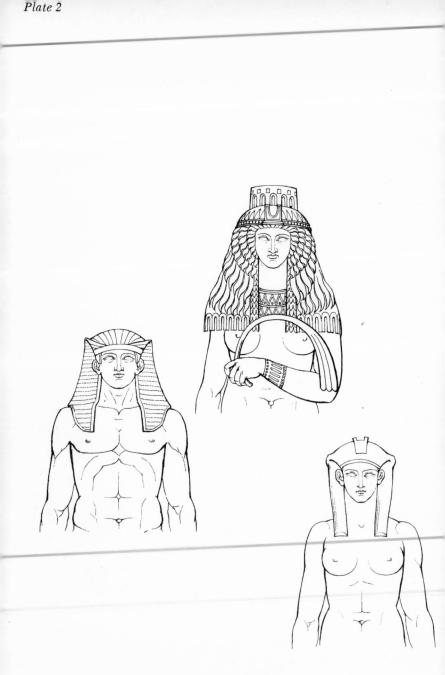

Egyptian priest and priestesses from statues in the Capitol

Plate 3

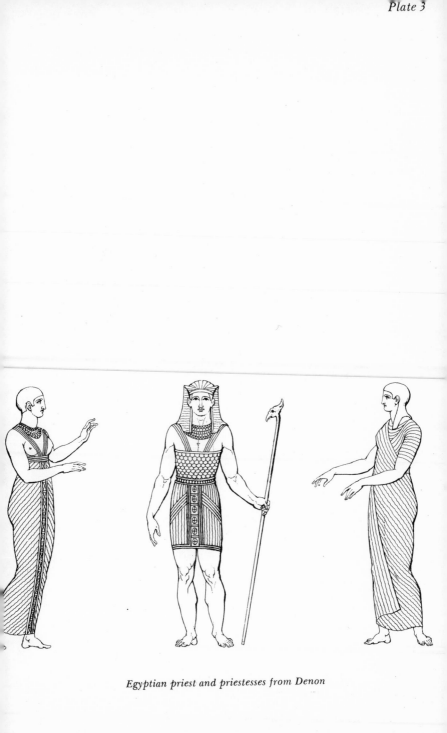

Egyptian priest and priestesses from Denon

Plate 4

Egyptian headdresses worn in religious processions

Plate 5

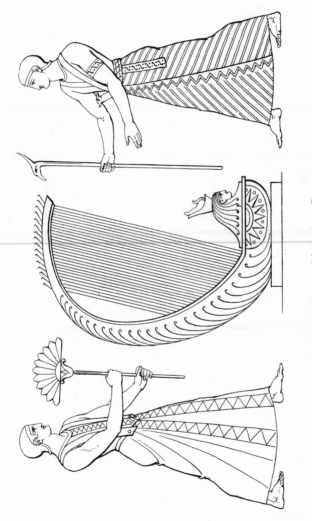

Egyptian priests and harp from Denon

Plate 6

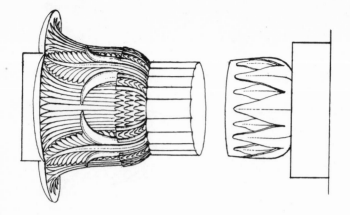

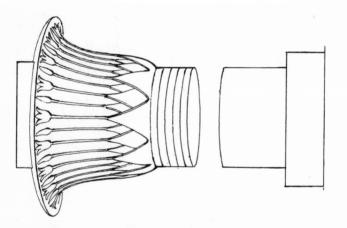

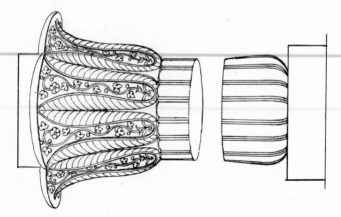

Egyptian capitals and bases of columns from Denon

Plate 7

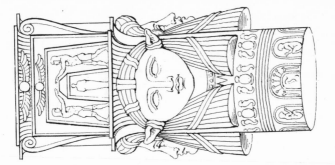

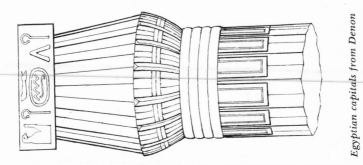

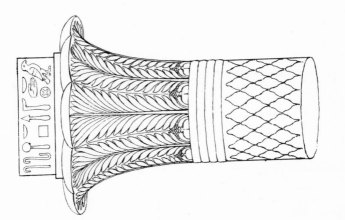

Egyptian capitals from Denon

Plate 8

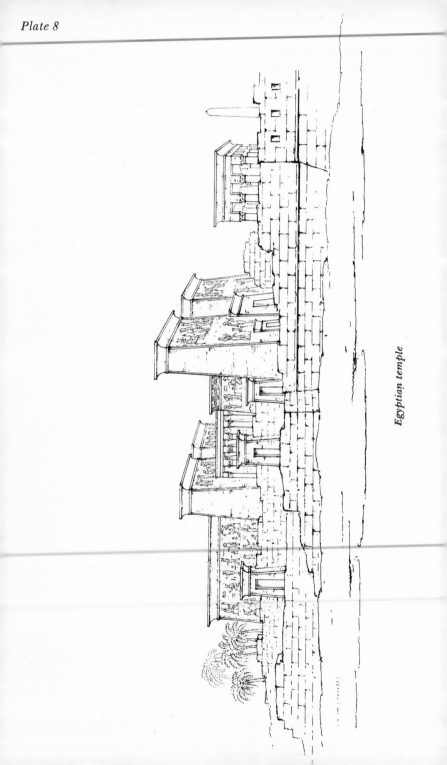

Egyptian temple

Plate 9

Egyptian priest from a statue in the Capitol

Plate 10

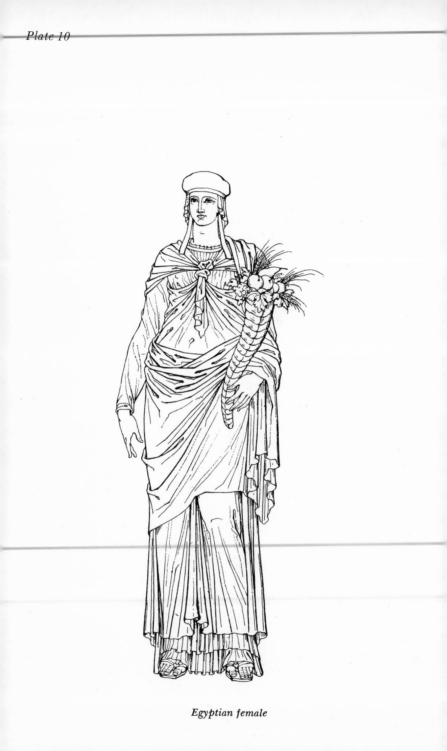

Egyptian female

Plate 11

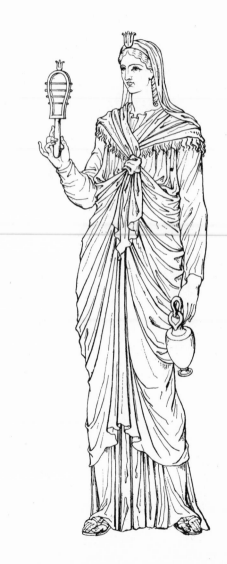

Isis with her sistrum

Plate 12

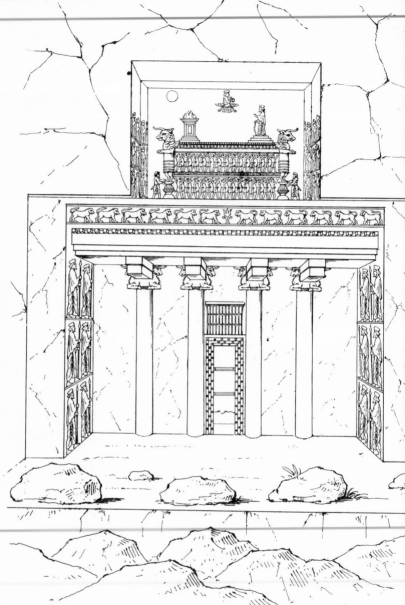

Fronts of sepulchral monuments excavated in the rocks near Persepolis

Plate 13

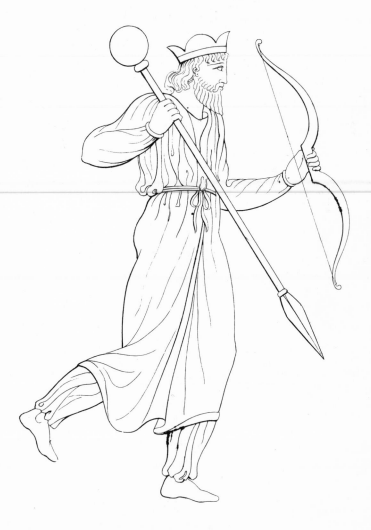

Parthian with his bow and javelin

Plate 14

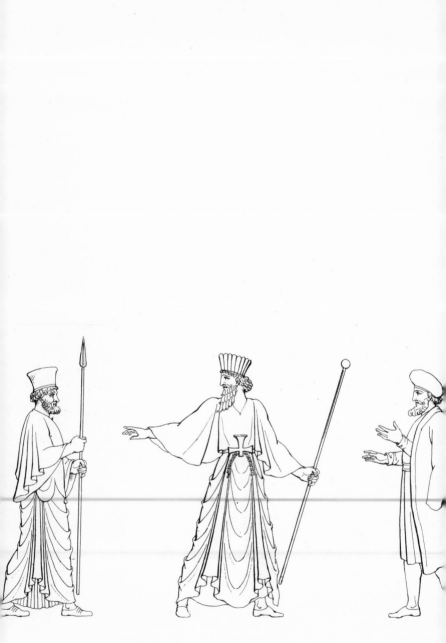

Persians from the monuments of Persepolis

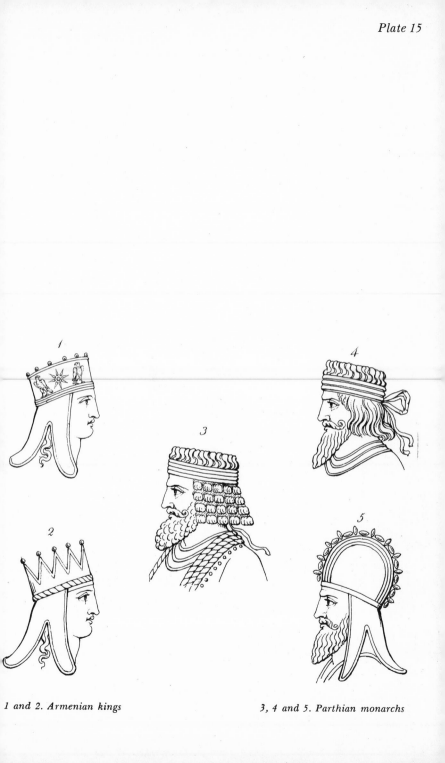

Plate 15

1 and 2. Armenian kings

3, 4 and 5. Parthian monarchs

Plate 16

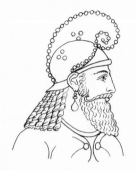
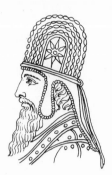
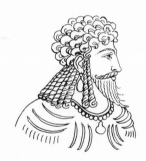
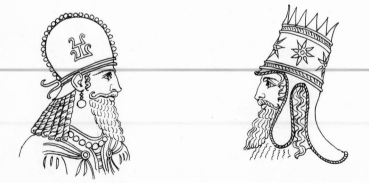

Heads of Parthian, Persian, and Armenian kings from coins and gems

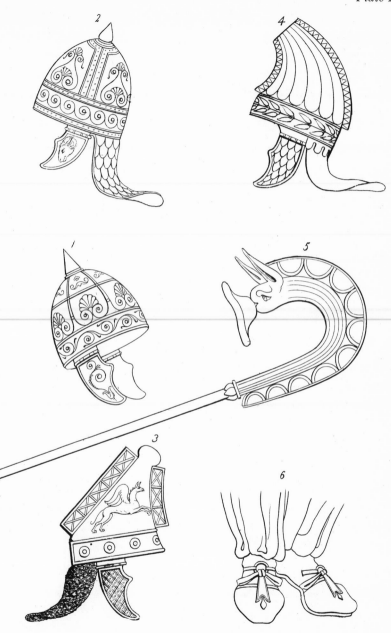

Plate 17

1 and 2. Dacian helmets *3 and 4. Phrygian helmets* *5. Dacian standard*
6. Phrygian shoes

Plate 18

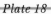

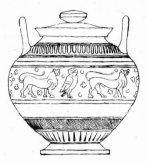

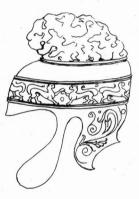

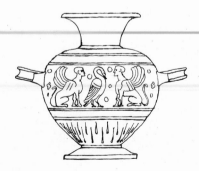

Phrygian helmet and vases. The latter in my collection

Plate 19

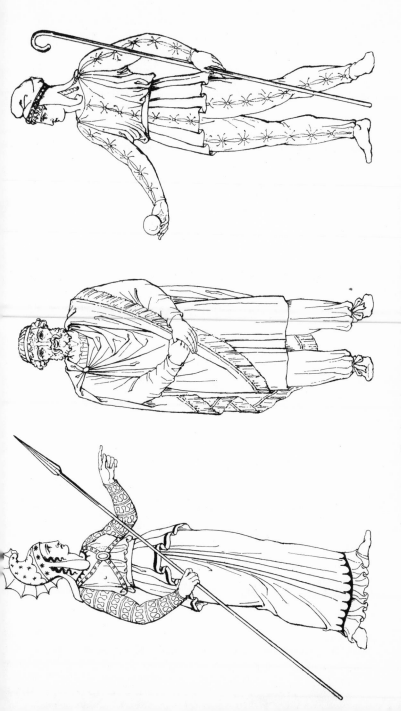

Amazon from a Greek vase in my possession. Dacian king from a statue in the Capitol. Paris on Mount Ida from a cameo.

Plate 20

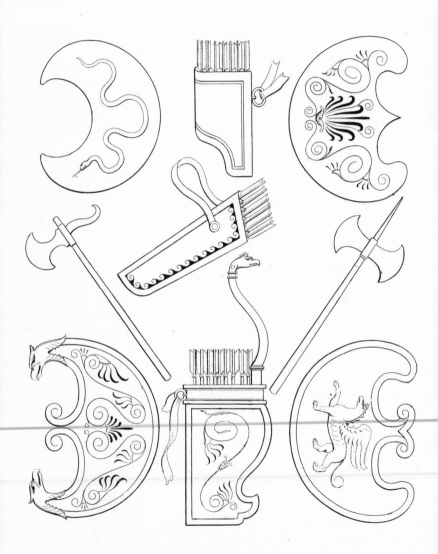

Phrygian shields, quivers, and bipennes, or battle axes

Plate 21

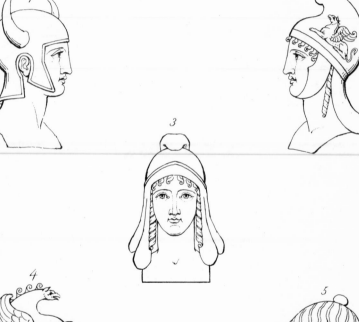

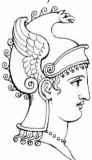

1. Head of Amazon 2. of Paris 3. of Trojan 4. of Roma with the
 Trojan helmet 5. of Phrygian

Plate 22

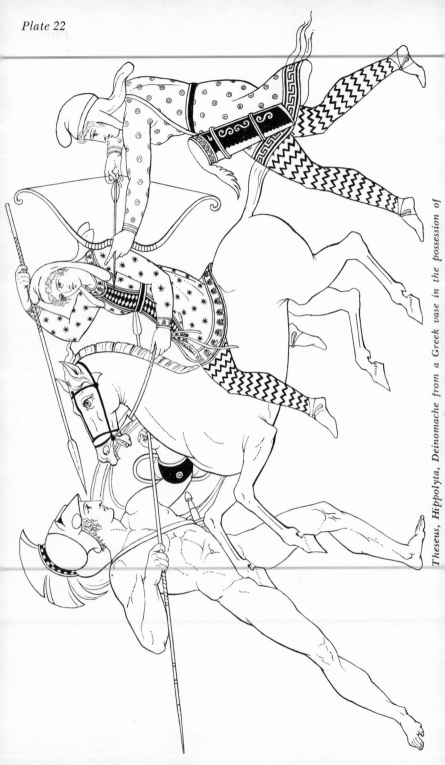

Theseus, Hippolyta, Deinomache from a Greek vase in the possession of

Plate 23

Phrygian attired for religious rites, from a Greek vase

Plate 24

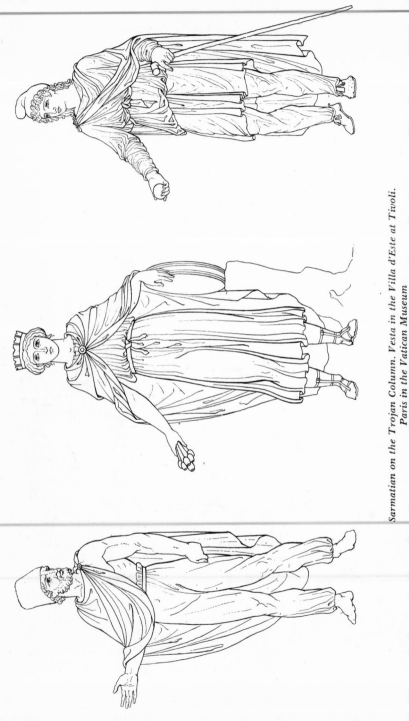

Sarmatian on the Trojan Column. Vesta in the Villa d'Este at Tivoli. Paris in the Vatican Museum

Plate 25

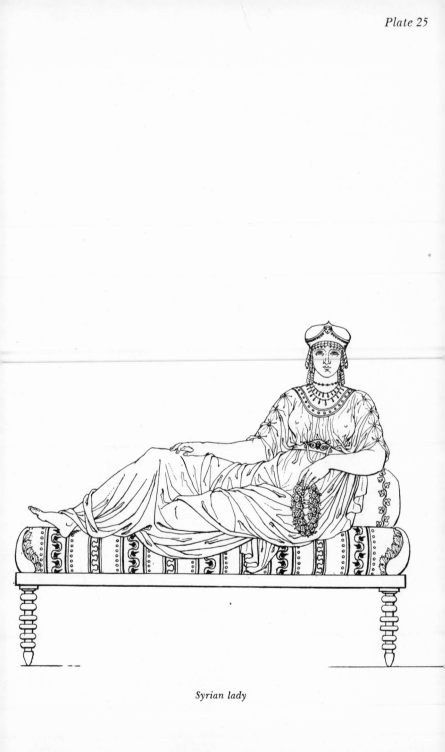

Syrian lady

Plate 26

Dacian warrior on horseback, covered, as well as his horse, with a coat of mail, or scales: from the Trajan Column

Plate 27

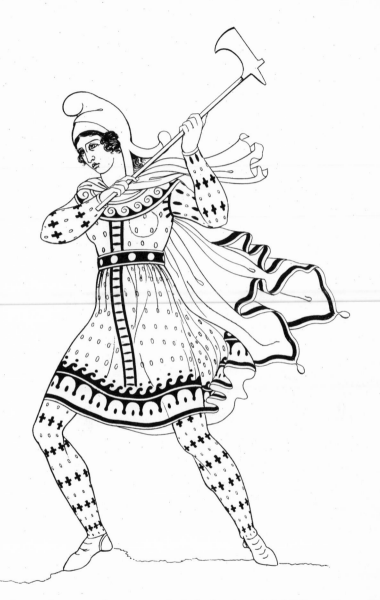

*Amazon from one of my vases, where she is represented fighting with a griffin.
The round disks on the belt perhaps represent coins, like those which to this day
the inhabitants of the borders of the Black Sea stud their leather belts with.*

Plate 28

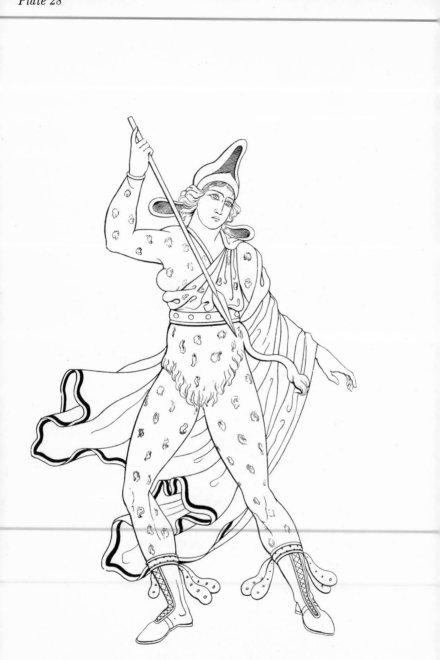

Amazon clothed in leopard skin: from a Greek vase in my possession

Plate 29

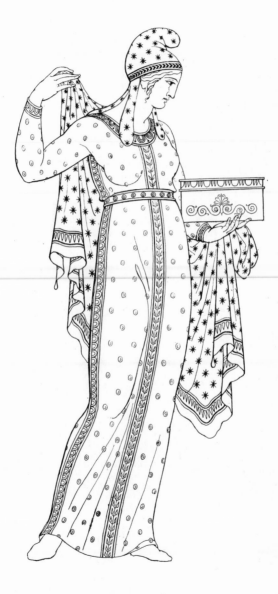

Phrygian lady

Plate 30

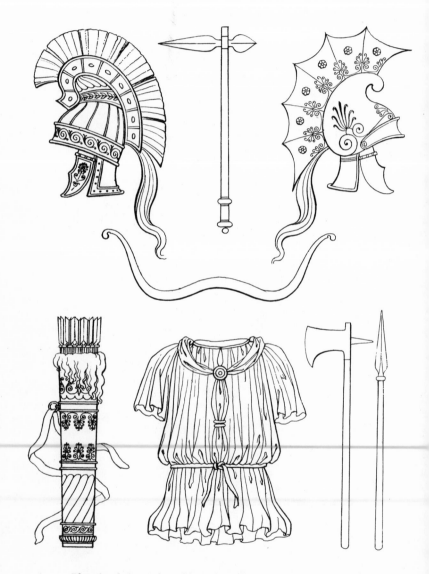

Phrygian helmets, bow, bipennis, quiver, tunic, axe, and javelin

Plate 31

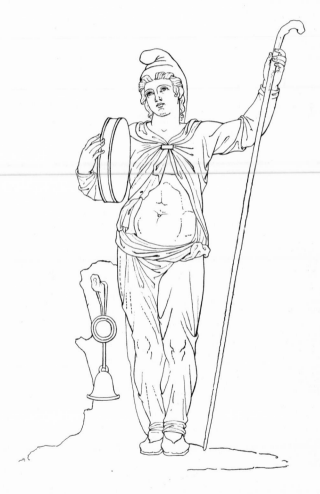

Atys the Phrygian shepherd: from a statue in the Altieri Palace

Plate 32

Phrygian with his coat of mail thrown across his shoulder: from an antique bronze in the possession of Isaac Hawkins, Esq.

Plate 33

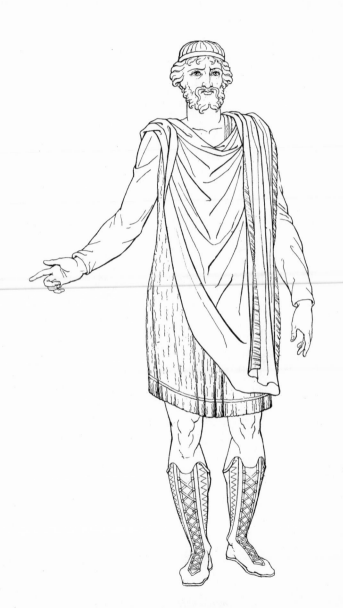

Asiatic monarch from a statue at Petworth

Plate 34

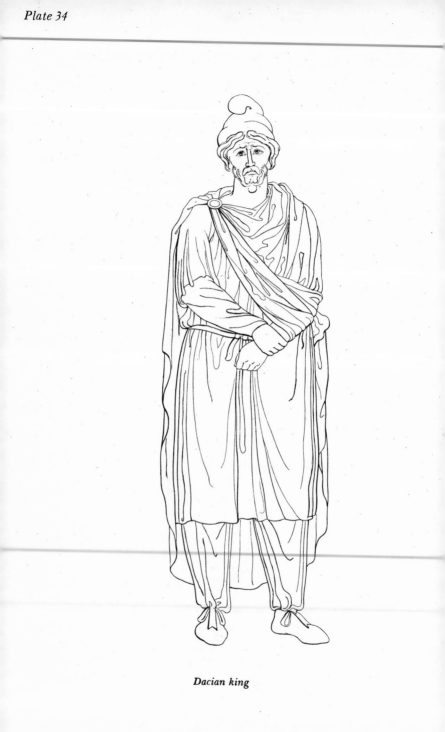

Dacian king

Plate 35

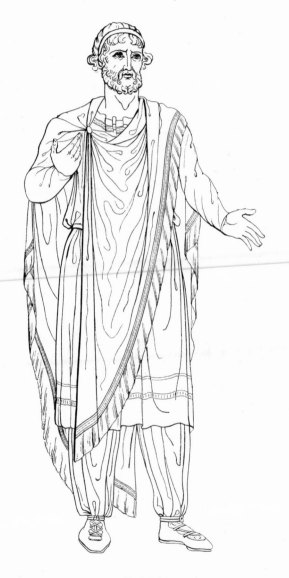

Dacian king

Plate 36

Amazon from a fictile vase

Plate 37

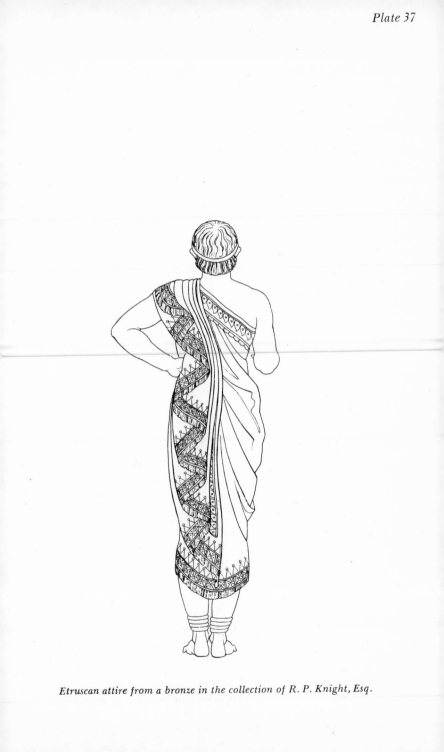

Etruscan attire from a bronze in the collection of R. P. Knight, Esq.

Plate 38

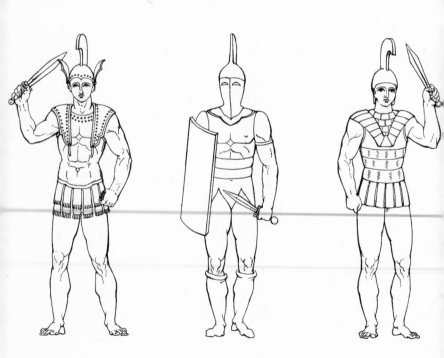

Etruscan warriors. Caylus, vol. 3

Plate 39

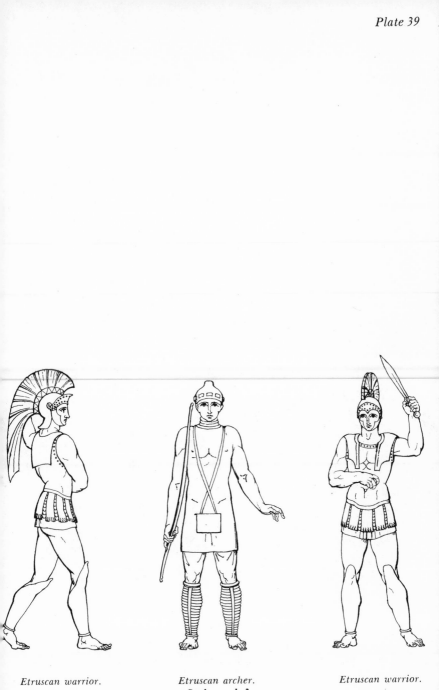

Etruscan warrior. *Etruscan archer.* *Etruscan warrior.*
Caylus, vol. 3

Plate 40

Etruscan attire. Caylus, vol. 7

Plate 41

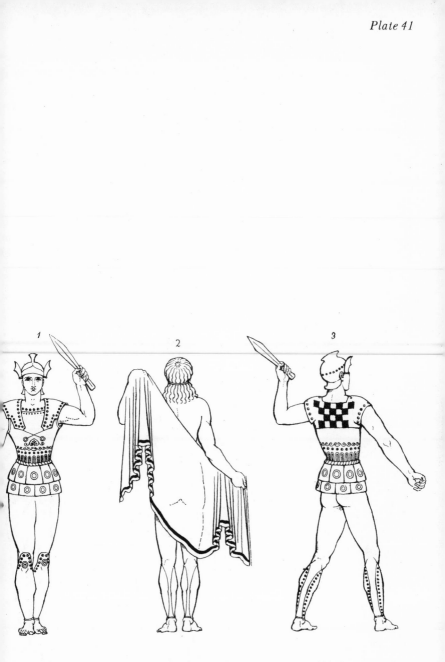

Etruscan warriors. Caylus, vol. 6. NB. The drapery of No. 2 evidently represents a piece of cloth in the shape of a crescent, and forming the parallel folds, observable near the extremities, by being drawn straight.

Plate 42

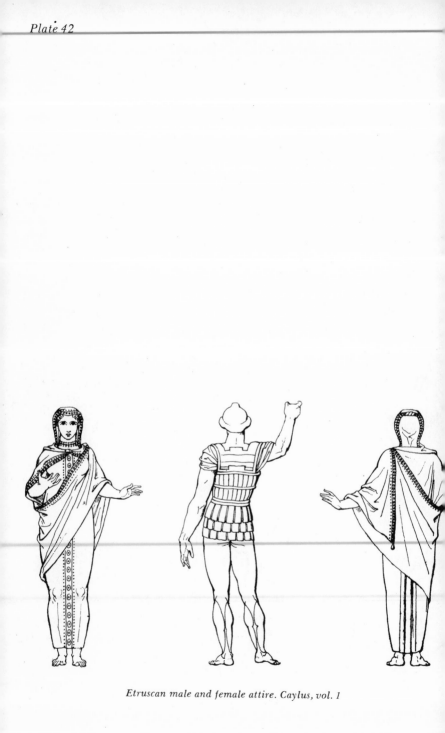

Etruscan male and female attire. Caylus, vol. 1

Plate 43

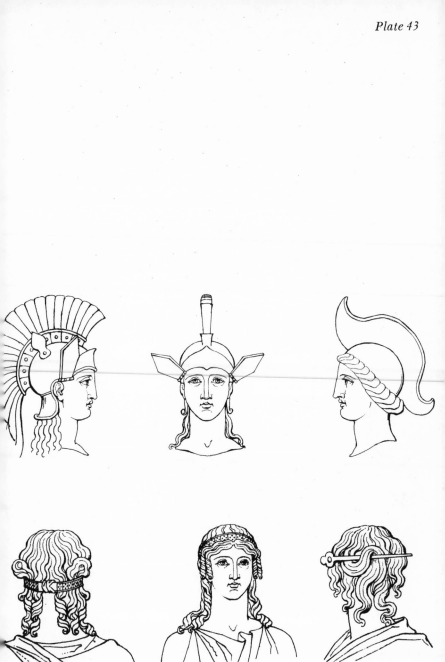

Etruscan helmets and headdresses

Plate 44

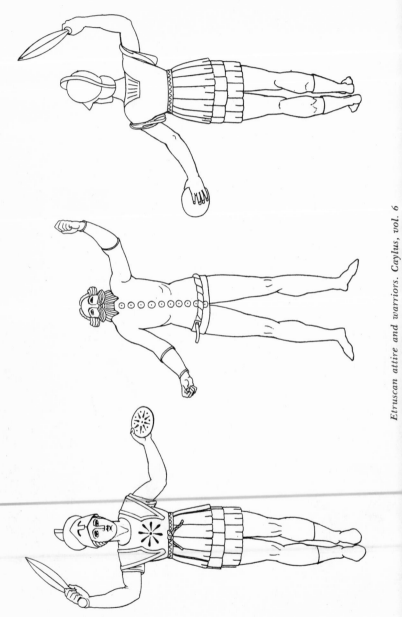

Etruscan attire and warriors. Caylus, vol. 6

Plate 45

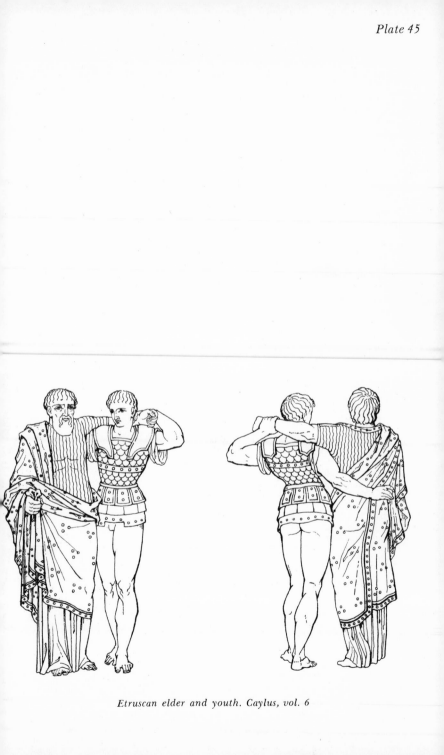

Etruscan elder and youth. Caylus, vol. 6

Plate 46

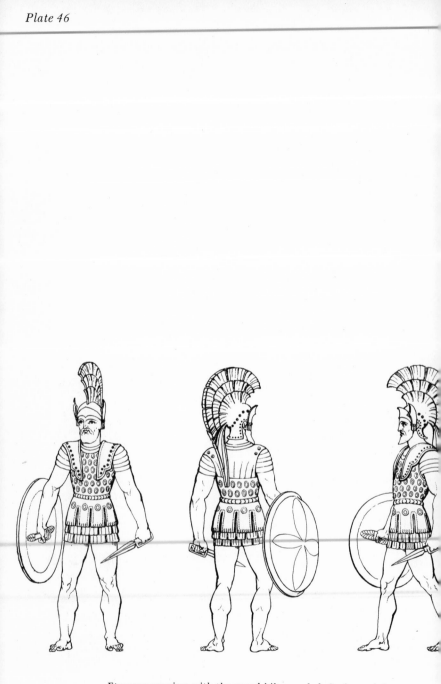

Etruscan warriors with the sword hilt guarded. Caylus, vol. 5

Plate 47

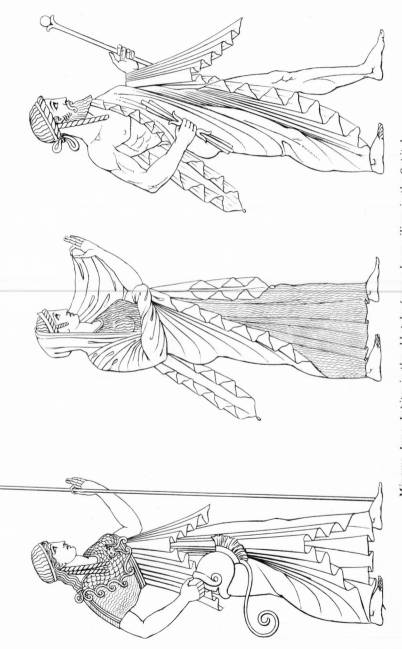

Minerva, Juno, Jupiter in the old style: from a basso-rilievo in the Capitol

Plate 48

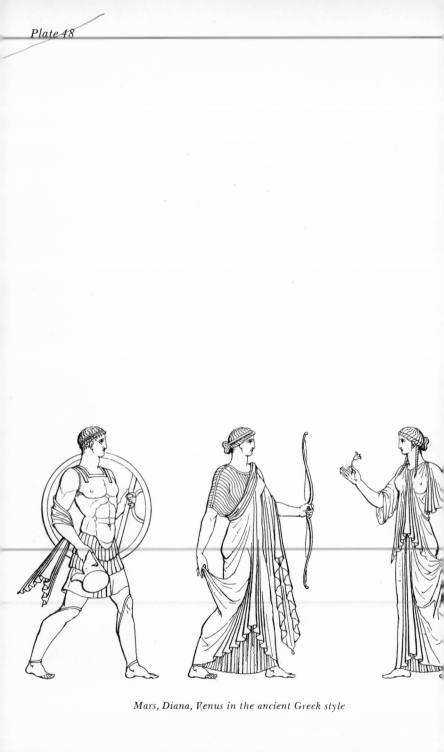

Mars, Diana, Venus in the ancient Greek style

Plate 49

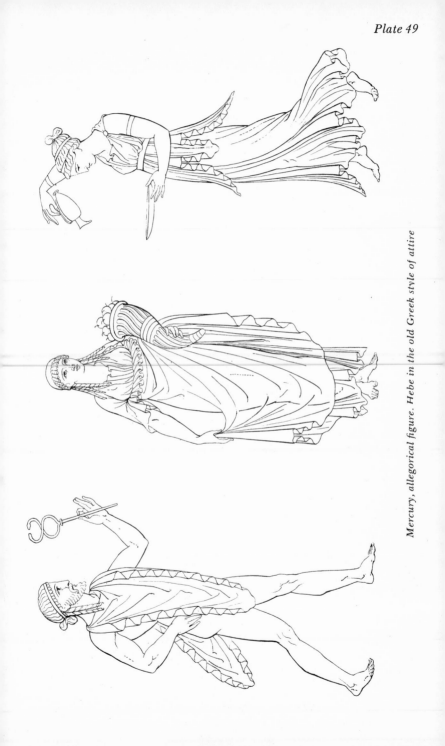

Mercury, allegorical figure. Hebe in the old Greek style of attire

Plate 50

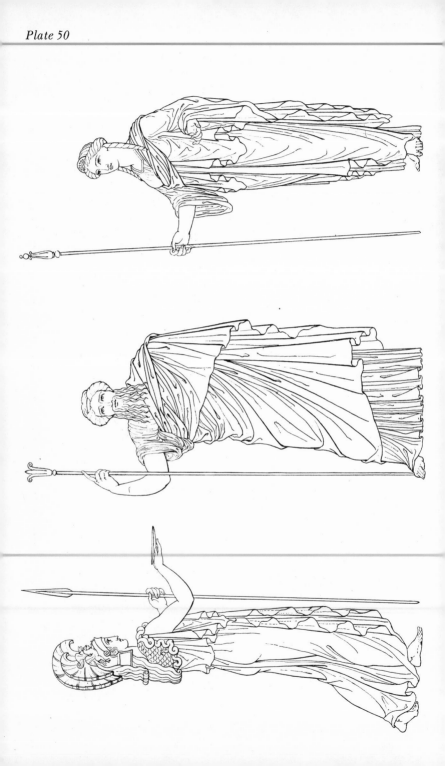

Plate 51

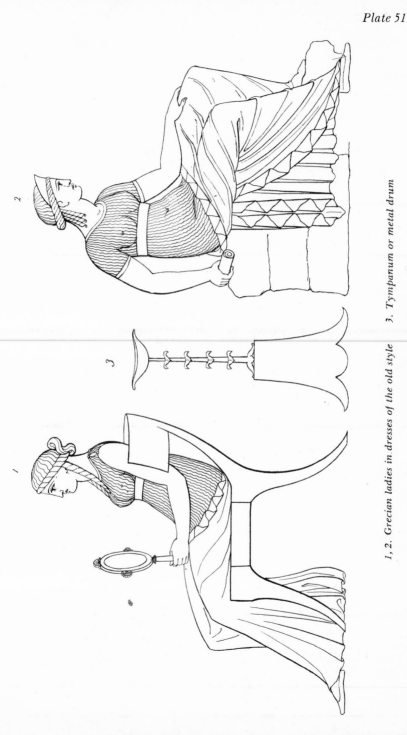

1, 2. Grecian ladies in dresses of the old style

3. Tympanum or metal drum

Plate 52

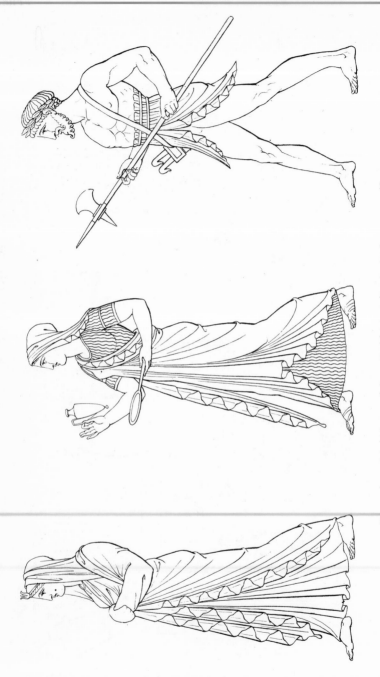

*Procession of priestes and her attendants going to perform a sacrifice:
from a basso-rilievo at Berlin*

Plate 53

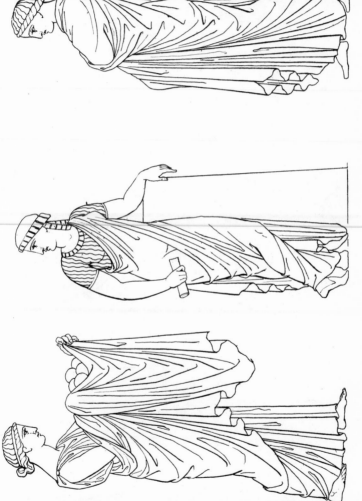

Grecian females

Plate 54

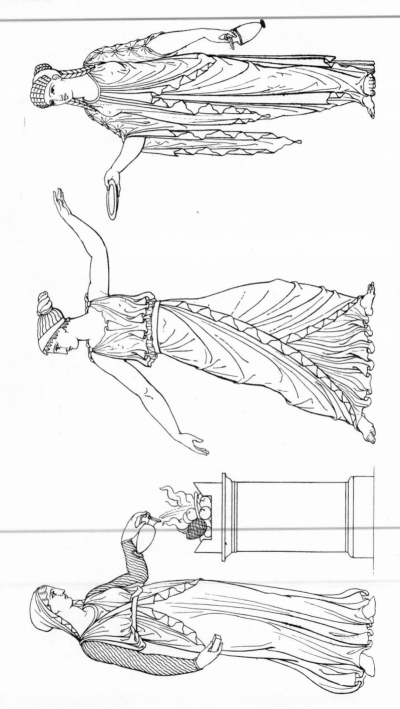

Grecian priestesses performing offerings and libations

Plate 55

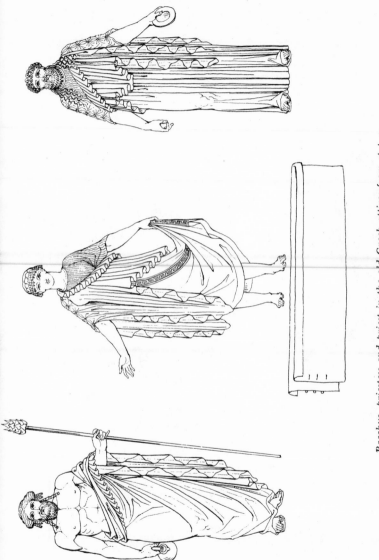

Bacchus, priestess and priest in the old Greek attire: from statues in different collections

Plate 56

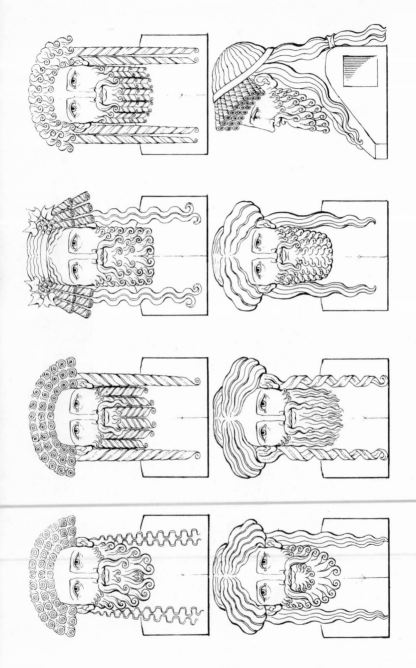

Various busts of the Indian or bearded Bacchus from different collections in Italy

Plate 57

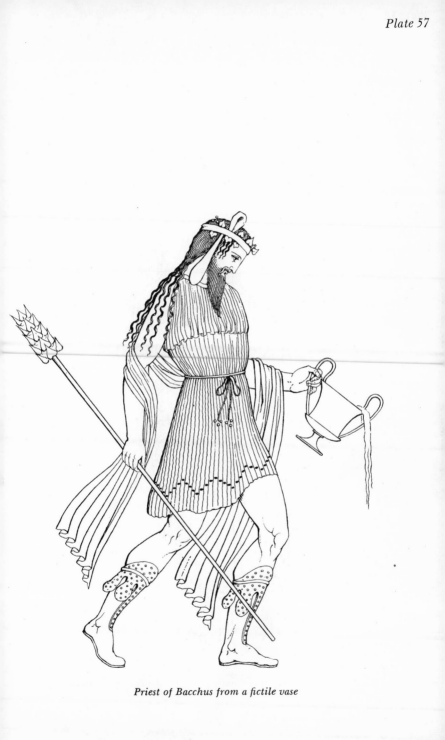

Priest of Bacchus from a fictile vase

Plate 58

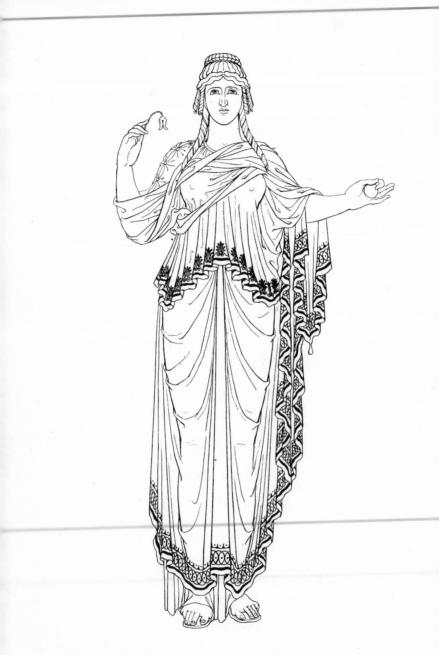

Nymph in the old style of attire: from a small statue in my possession

Plate 59

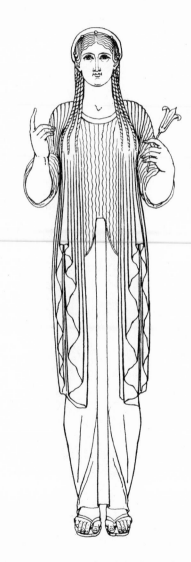

Grecian female from a statue in my possession

Plate 60

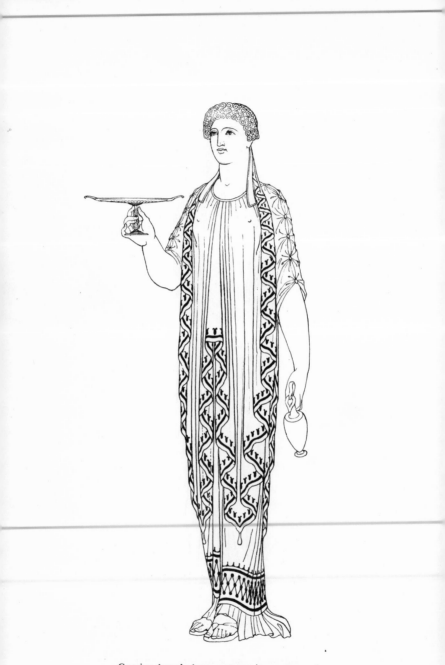

Grecian female from a statue in my possession

Plate 61

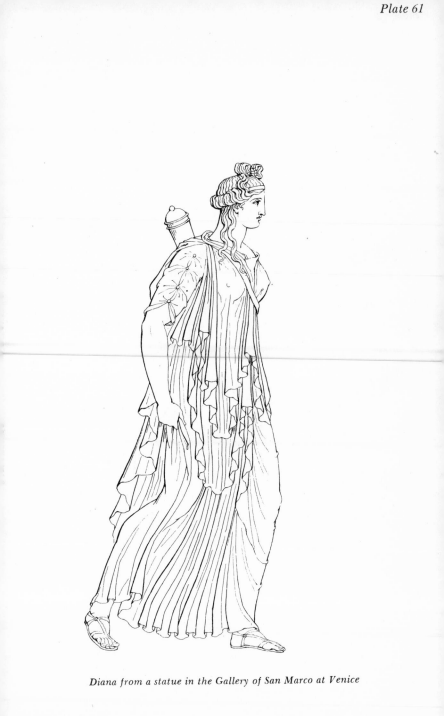

Diana from a statue in the Gallery of San Marco at Venice

Plate 62

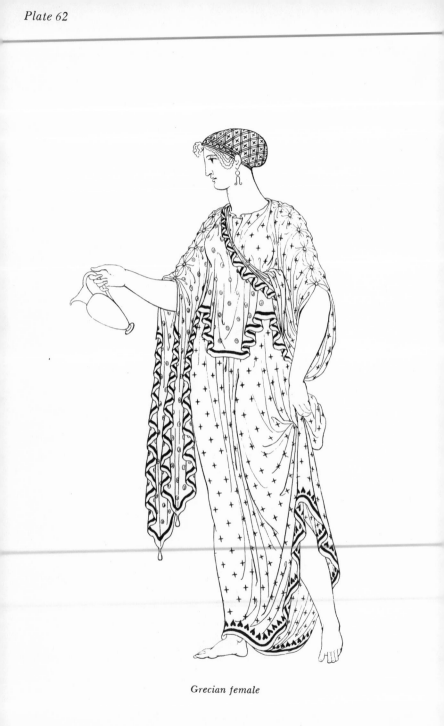

Grecian female

Plate 65

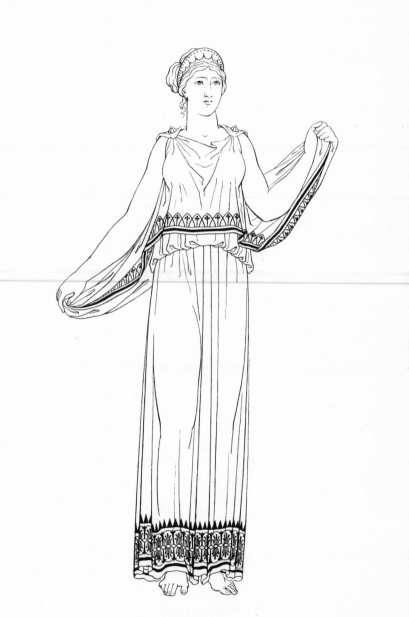

Grecian lady

Plate 66

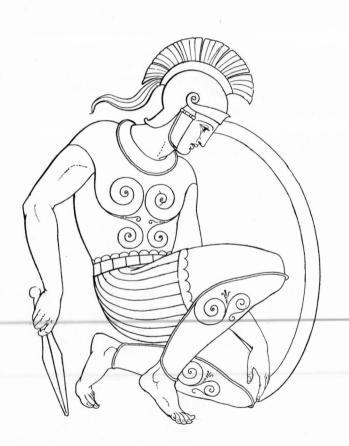

Greek warrior skulking behind his shield: from an intaglio

Plate 67

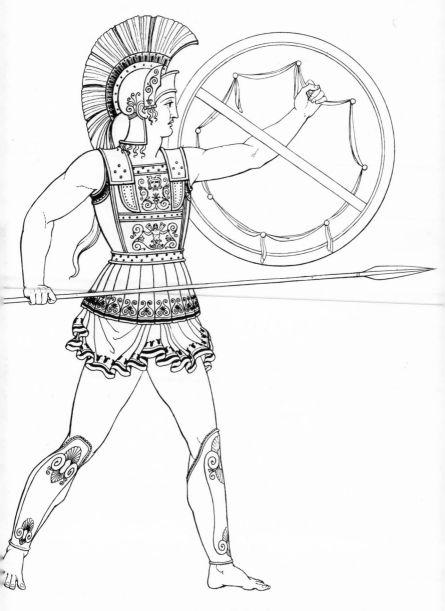

Greek warrior from a fictile vase

Plate 68

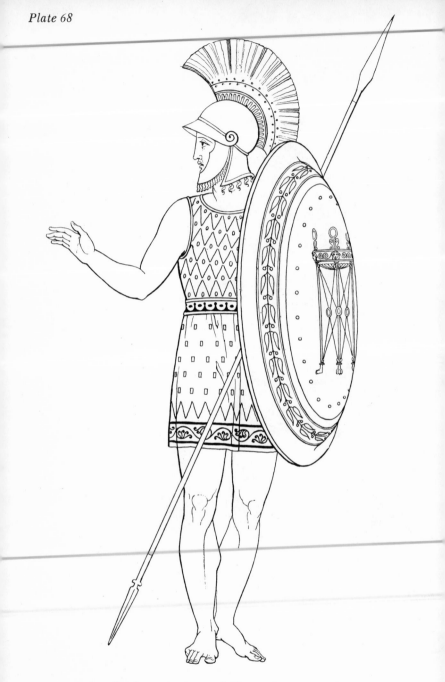

Greek warrior from a fictile vase in my possession

Plate 69

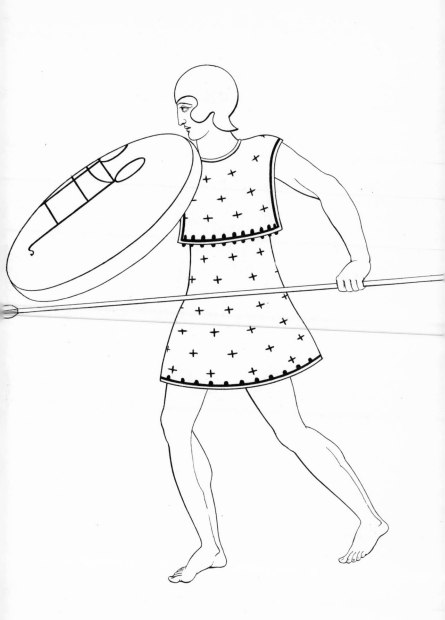

Greek herald from a fictile vase in my possession

Plate 70

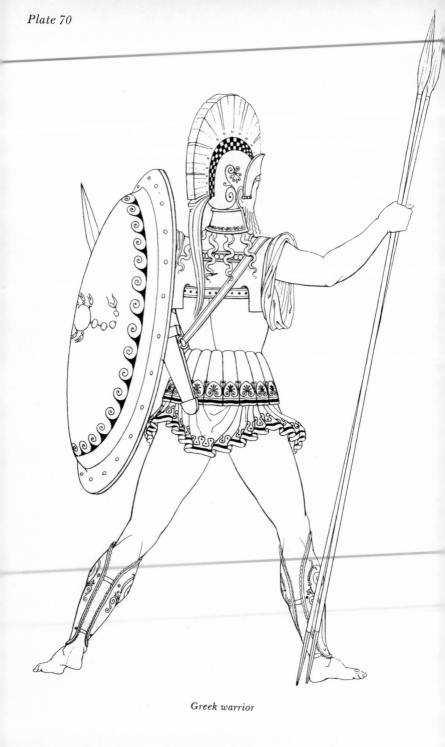

Greek warrior

Plate 71

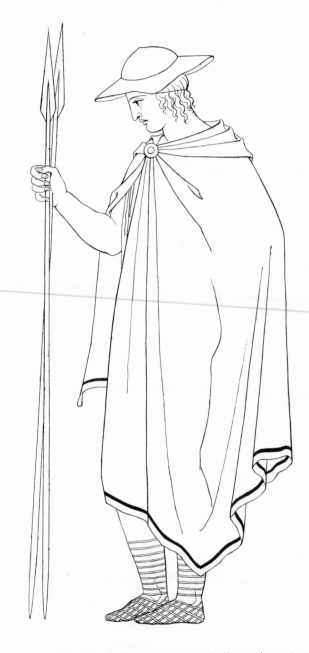

Greek warrior in his travelling dress: from a fictile vase in my possession

Plate 72

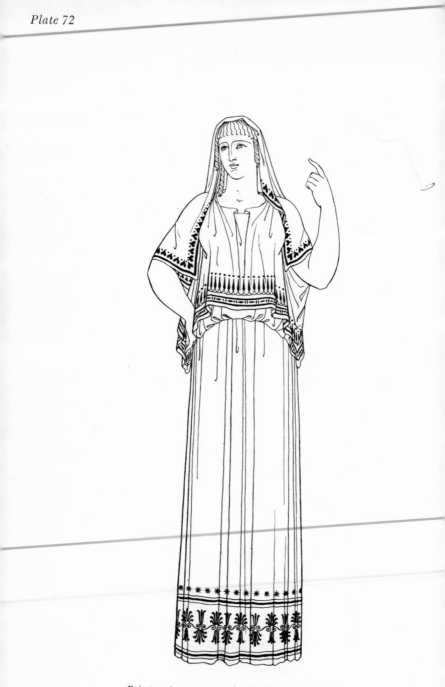

Priestess from a statue in the Giustiniani Gallery

Plate 73

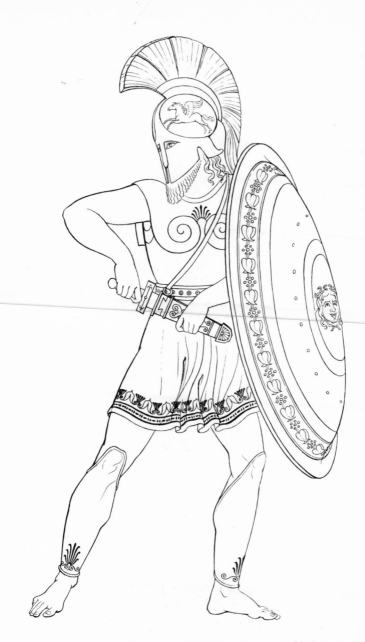

Greek warrior with the visor of his helmet drawn over his face

Plate 74

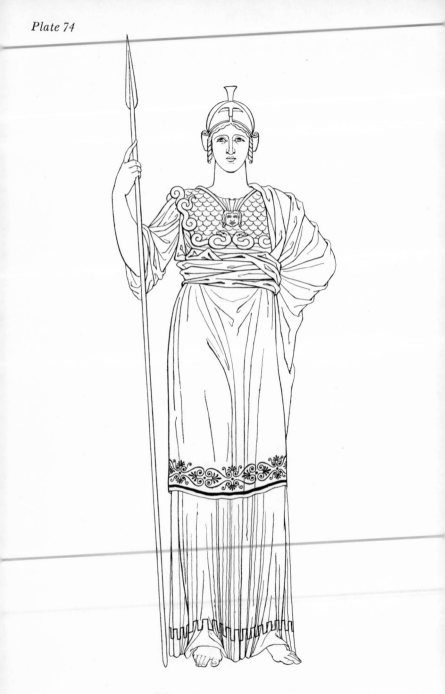

Minerva from a statue at Florence

Plate 75

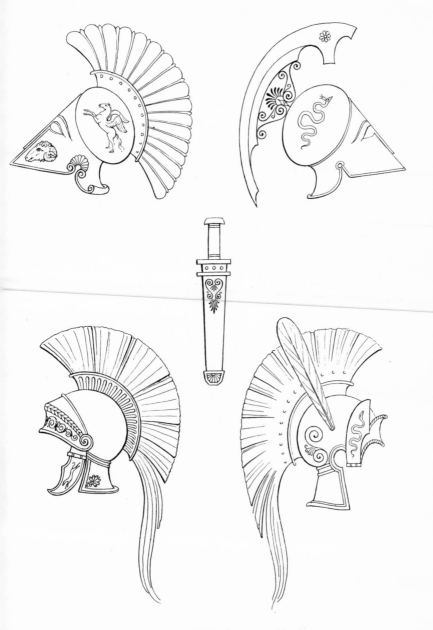

Various helmets with fixed or moveable visors

Plate 76

Theban shield and bow-cases

Plate 77

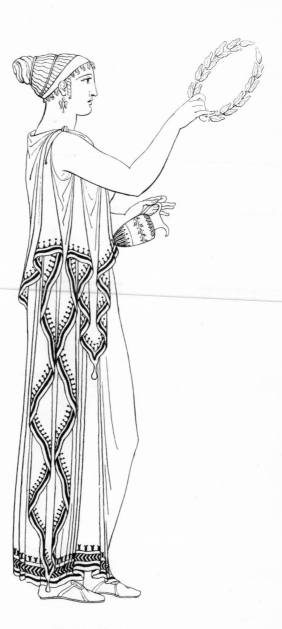

Grecian female

Plate 78

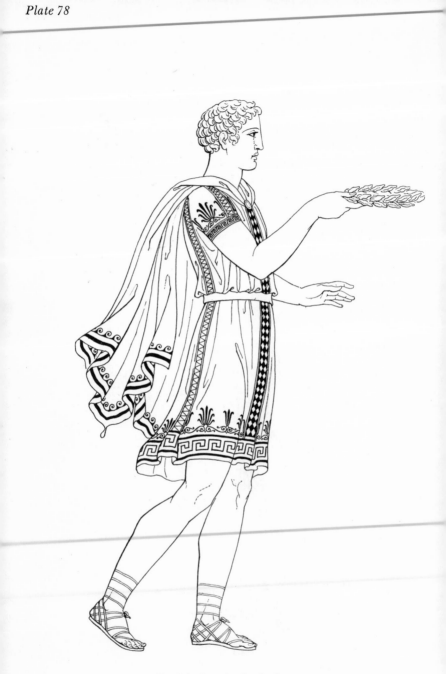

Grecian victor in the chariot race

Plate 79

Greek car or chariot used in the games

Plate 80

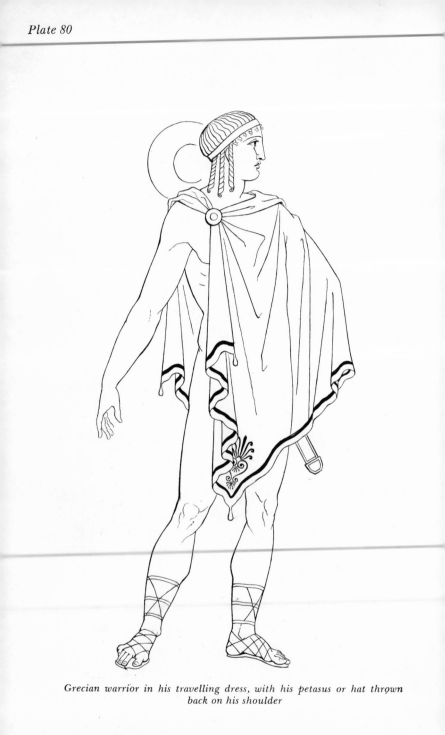

*Grecian warrior in his travelling dress, with his petasus or hat thrown
back on his shoulder*

Plate 81

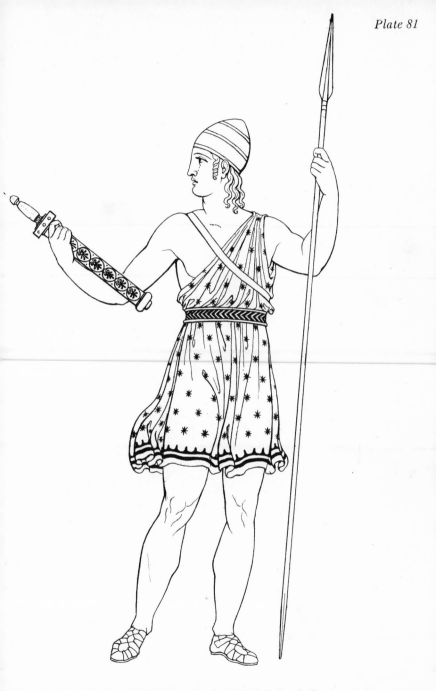

Squire or attendant on a Greek warrior: from a fictile vase

Plate 82

Female with lyre and plectrum

Plate 83

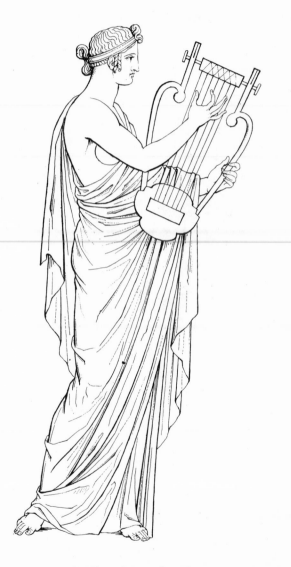

Erato from an intaglio

Plate 84

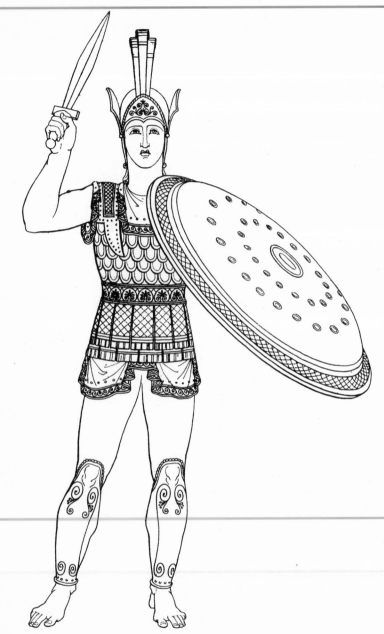

Greek warrior from a bronze in the Florentine Gallery

Plate 85

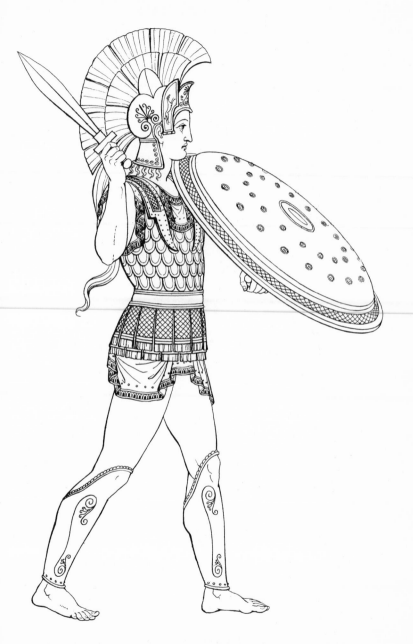

Greek warrior

Plate 86

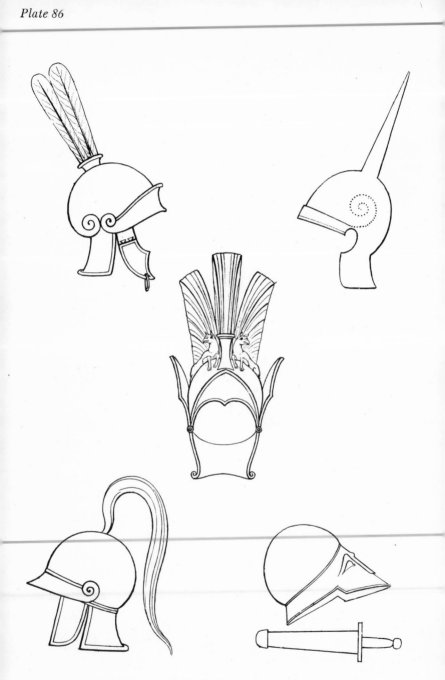

Grecian helmets

Plate 87

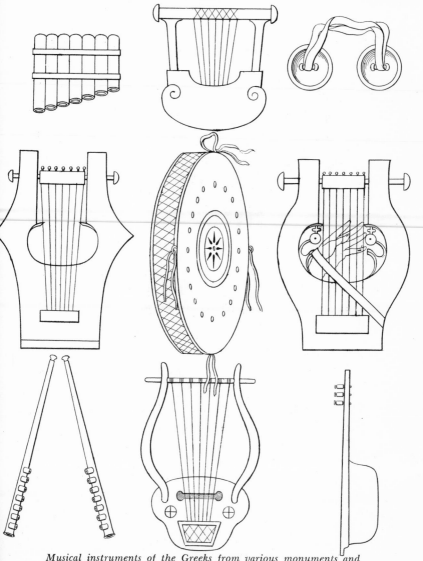

Musical instruments of the Greeks from various monuments and paintings at Herculaneum

Plate 88

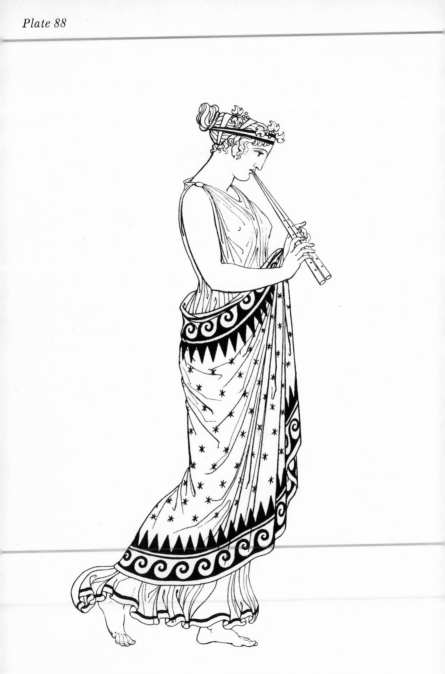

*Female flute player such as went about playing at entertainments:
from a vase in my possession*

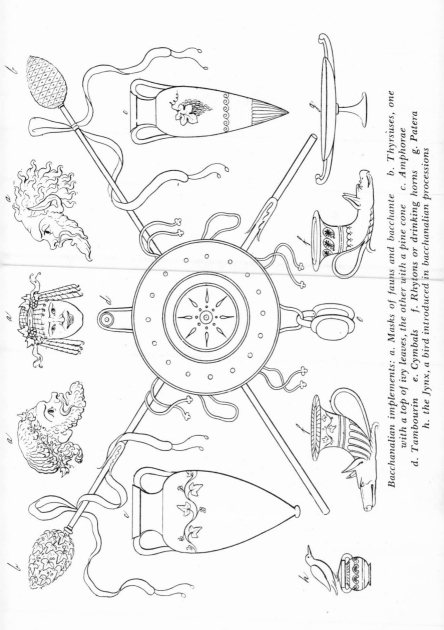

Plate 89

Bacchanalian implements: *a.* Masks of fauns and bacchante *b.* Thyrsiuses, one
with a top of ivy leaves, the other with a pine cone *c.* Amphorae
d. Tambourin *e.* Cymbals *f.* Rhytons or drinking horns *g.* Patera
h. the Jynx, a bird introduced in bacchanalian processions

Plate 90

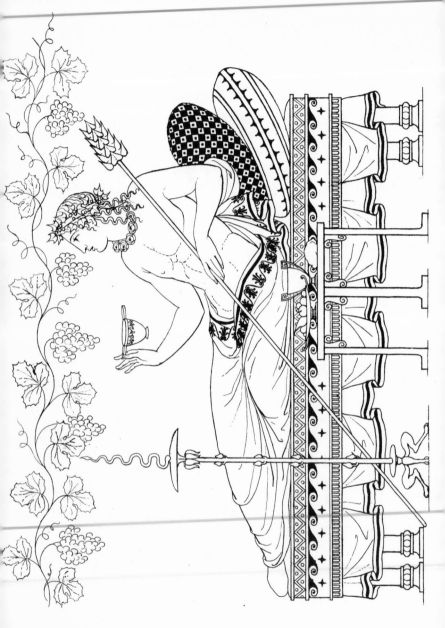

Plate 91

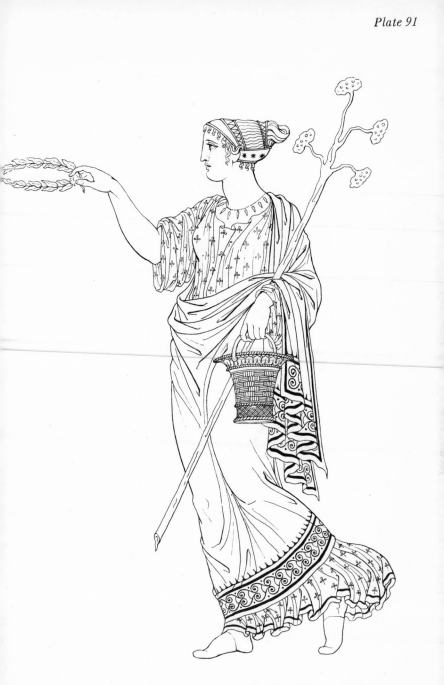

Bacchante with the rod of sesamum: from a Greek vase in my possession

Plate 92

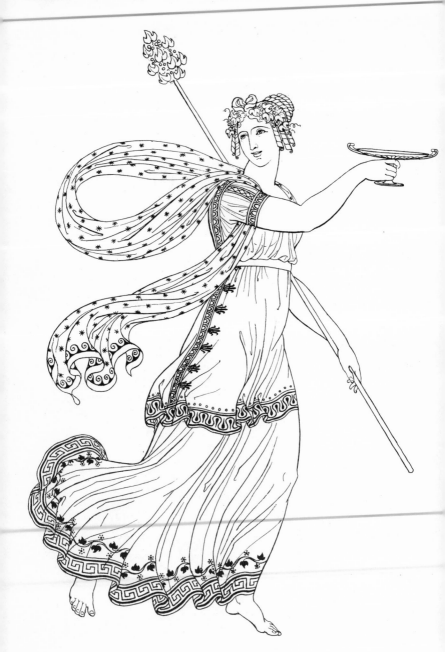

Bacchante with the thyrsus

Plate 93

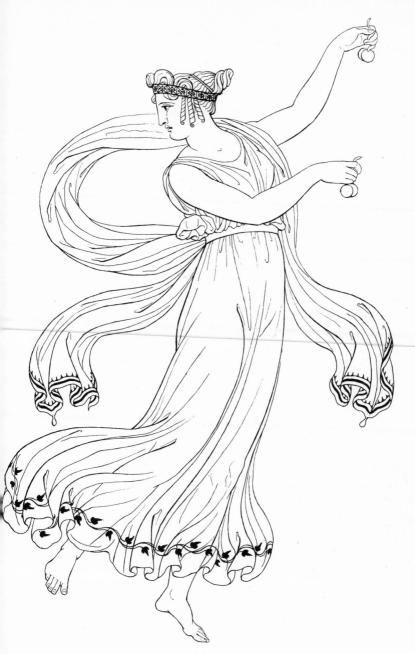

Bacchante sounding the crotals

Plate 94

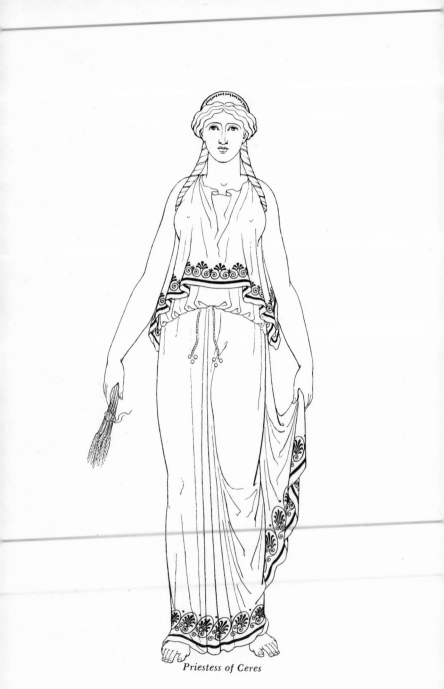

Priestess of Ceres

Plate 95

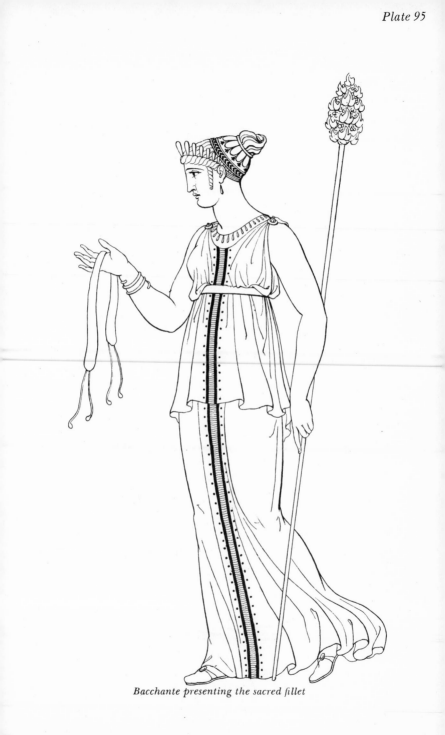

Bacchante presenting the sacred fillet

Plate 96

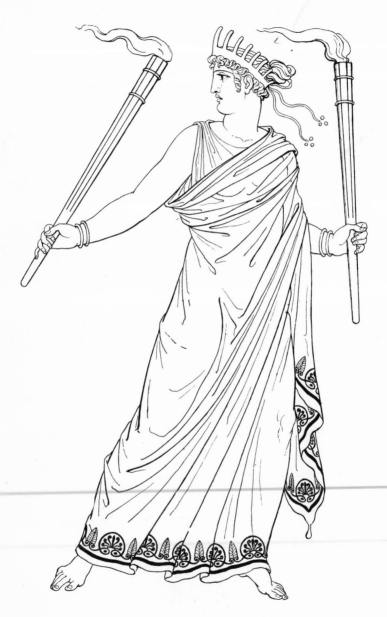

Bacchante carrying torches

Plate 97

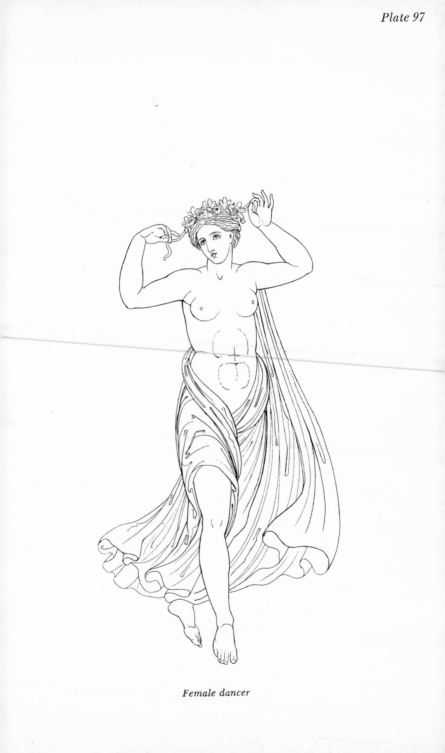

Female dancer

Plate 98

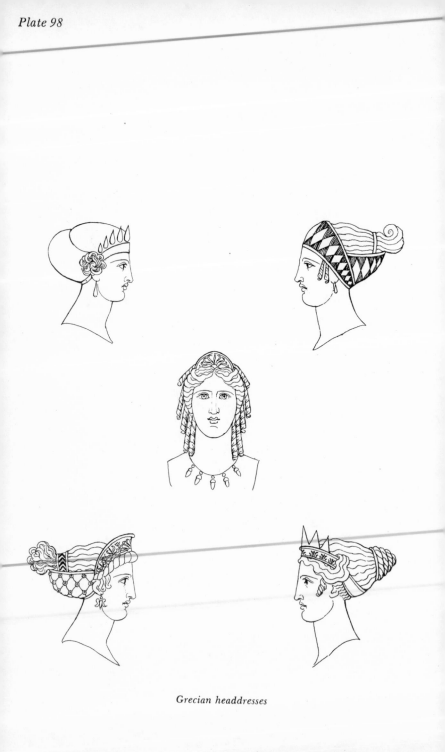

Grecian headdresses

Plate 99

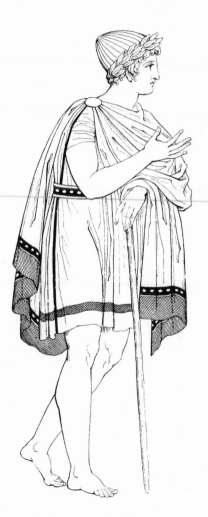

Grecian youth crowned at the games: from a fictile vase

Plate 100

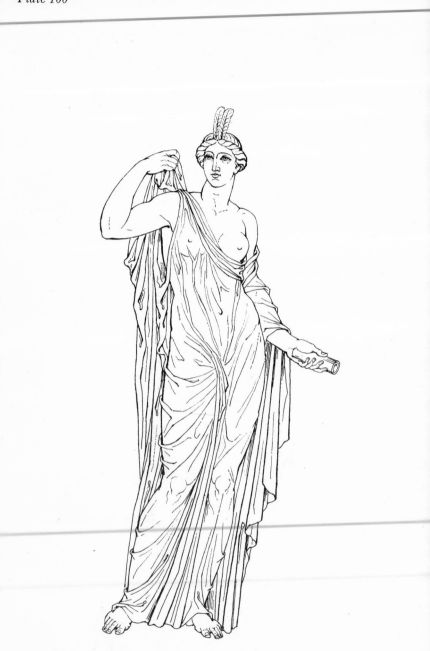

Muse from a statue in the gallery at Florence

Plate 101

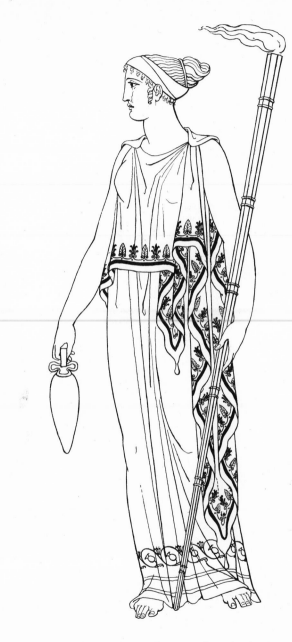

Priestess of Ceres carrying a torch

Plate 102

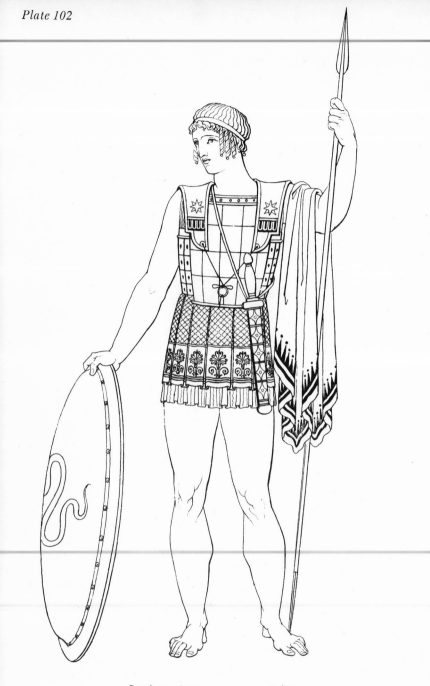

Greek warrior from one of my fictile vases

Plate 103

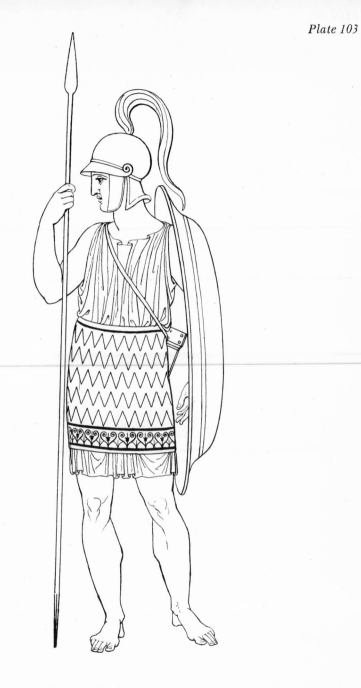

Greek warrior from one of my fictile vases

Plate 104

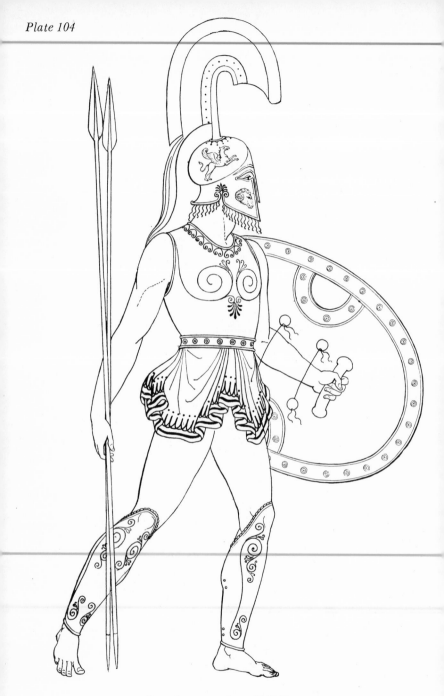

Eneas from one of my old Sicilian vases

Plate 105

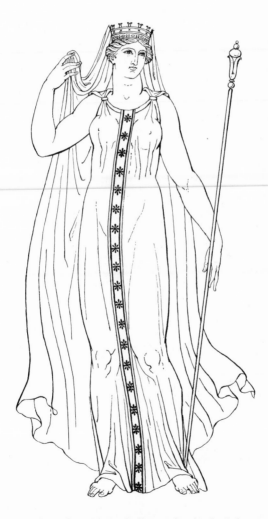

Ceres with her mitra: from a fictile vase lost in the Colossus

Plate 106

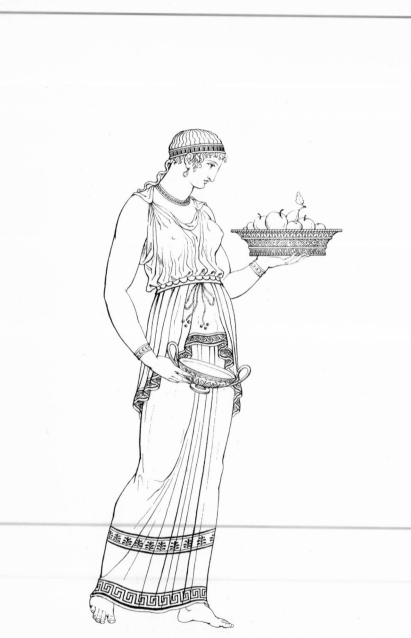

Greek female from a fictile vase

Plate 107

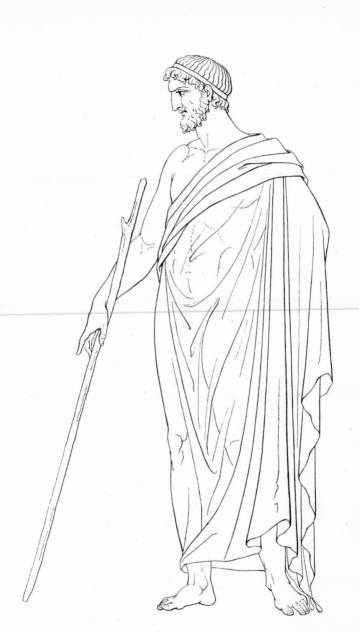

Greek philosopher

Plate 108

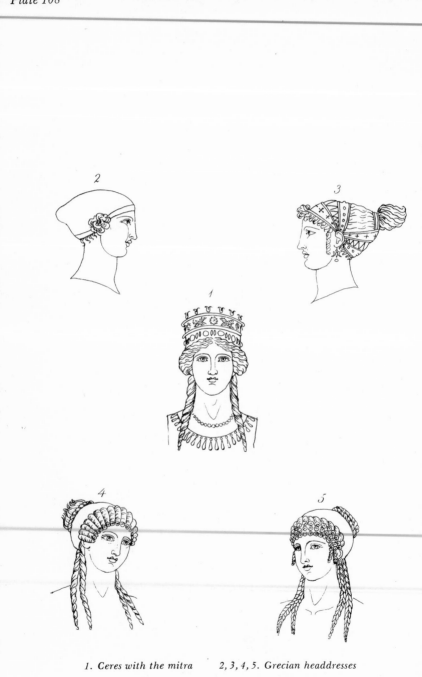

1. *Ceres with the mitra* 2, 3, 4, 5. *Grecian headdresses*

Plate 109

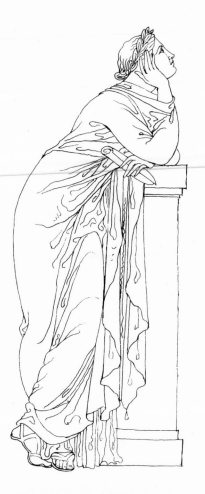

Clio from a statue in the Villa Borghese

Plate 110

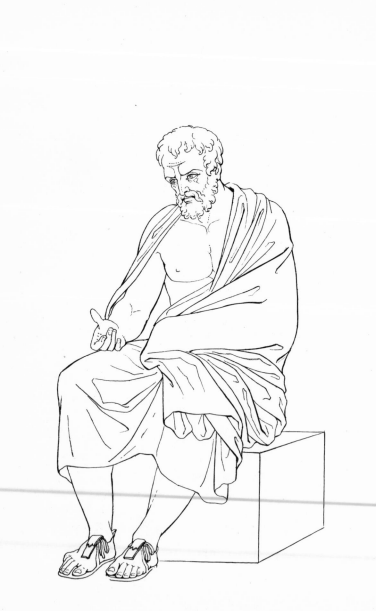

Greek philosopher from the Villa Borghese

Plate 111

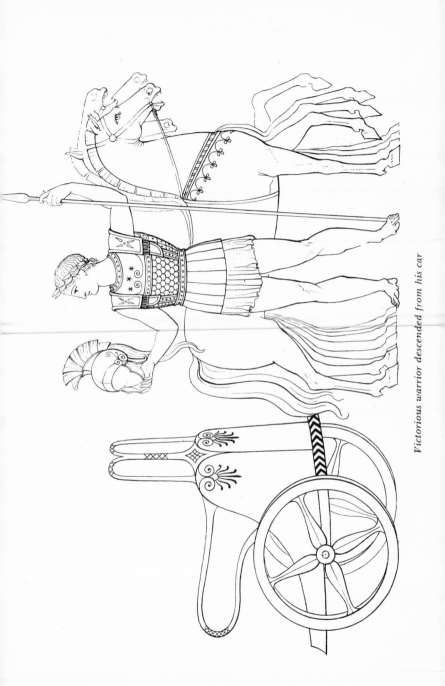

Victorious warrior descended from his car

Plate 112

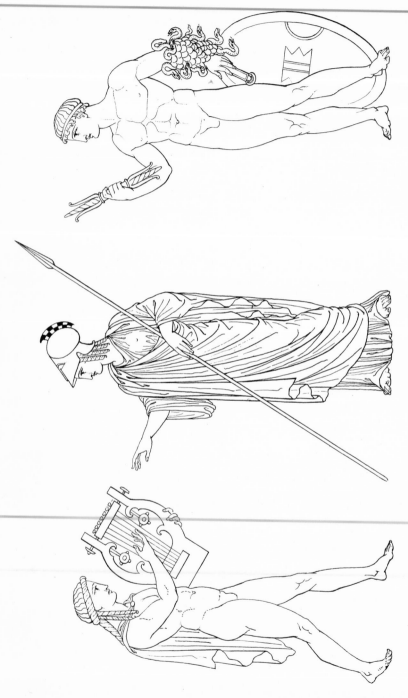

Apollo, Minerva, Jupiter

Plate 113

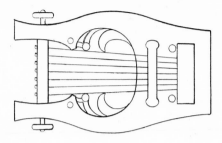

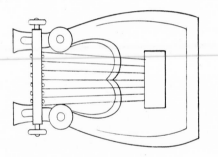

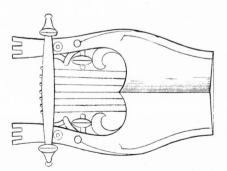

Lyres

Plate 114

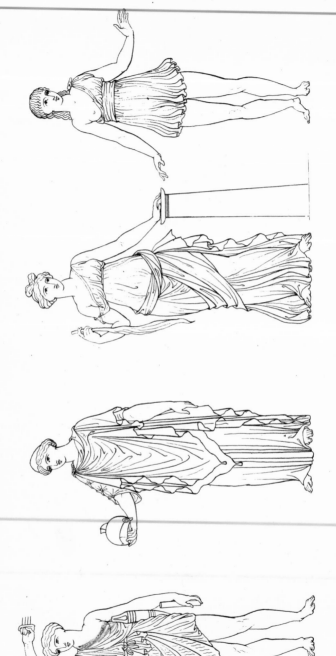

Amazon, Minerva Pacifera, Venus Pacifera, Spartan virgin

Plate 115

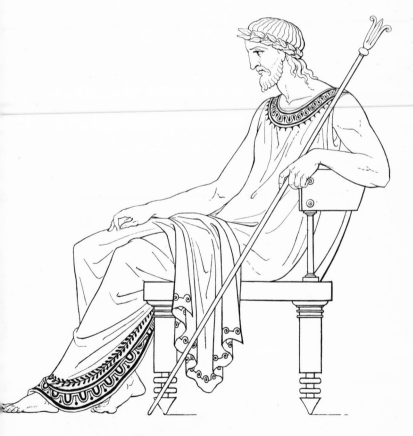

Jupiter from a Greek vase

Plate 116

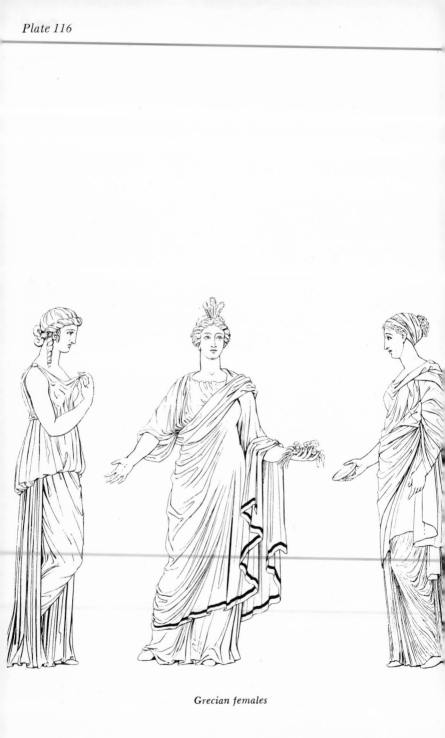

Grecian females

Plate 117

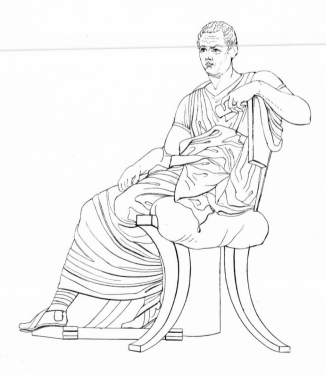

Greek poet from a statue now at Paris

Plate 118

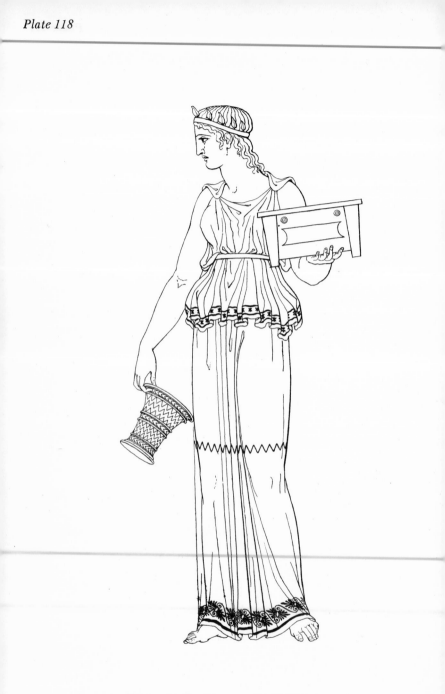

Grecian female from one of my fictile vases

Plate 119

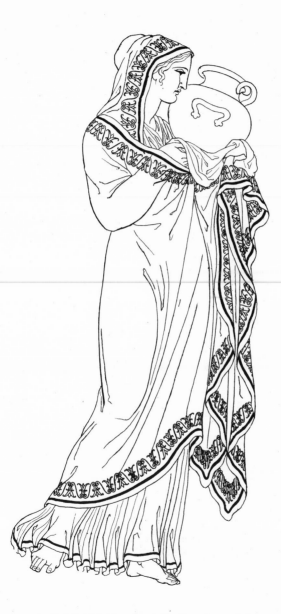

Grecian female going to perform funeral rites

Plate 120

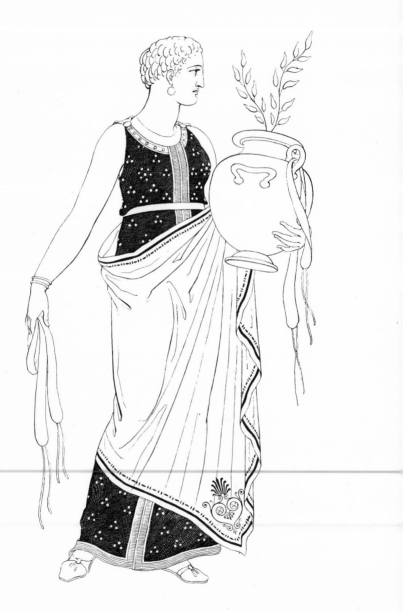

Electra in mourning for Orestes: from one of my fictile vases

Plate 121

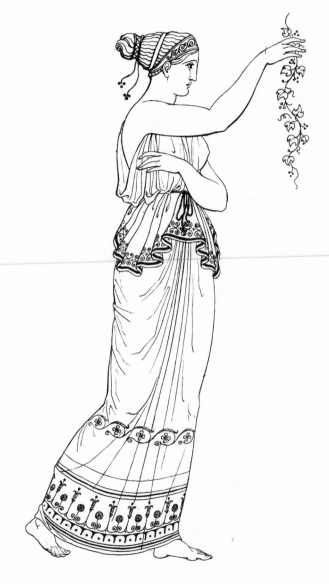

Grecian female

Plate 122

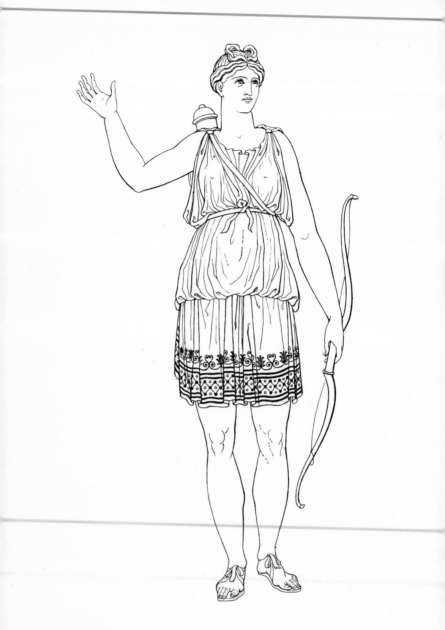

Diana from a statue

Plate 123

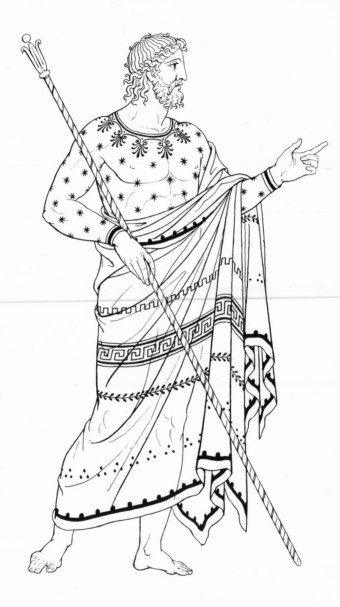

Jupiter from a Greek vase

Plate 124

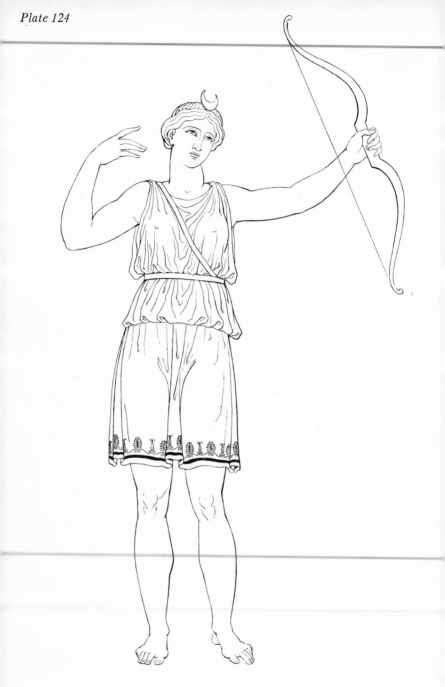

Diana

Plate 125

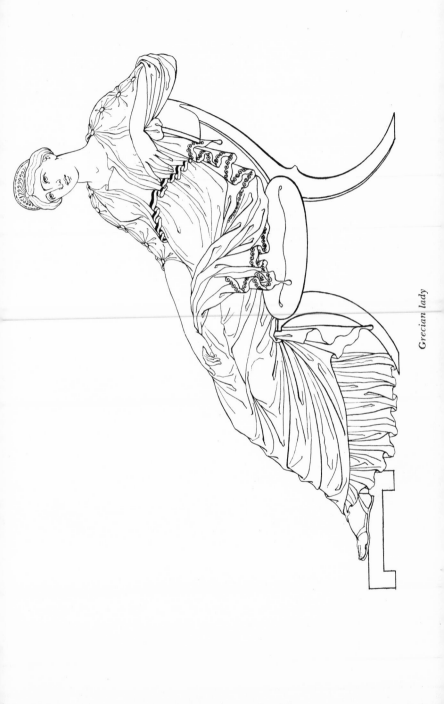

Grecian lady

Plate 126

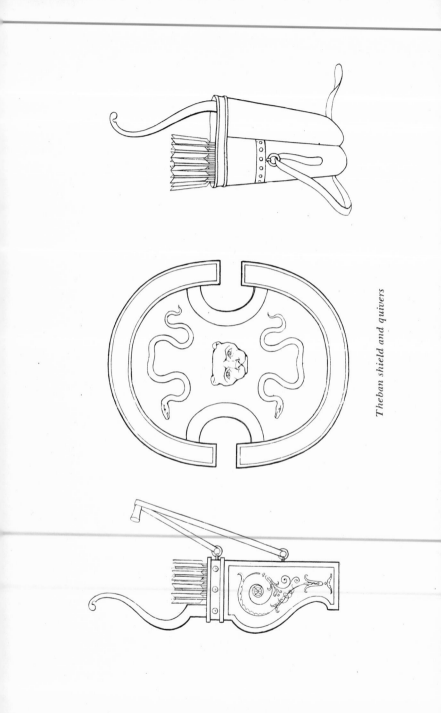

Theban shield and quivers

Plate 127

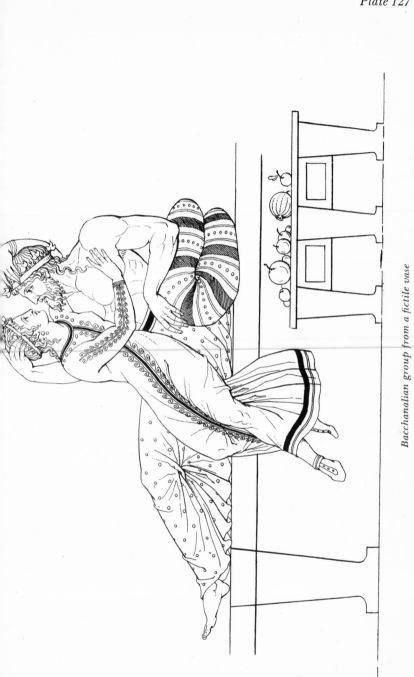

Bacchanalian group from a fictile vase

Plate 128

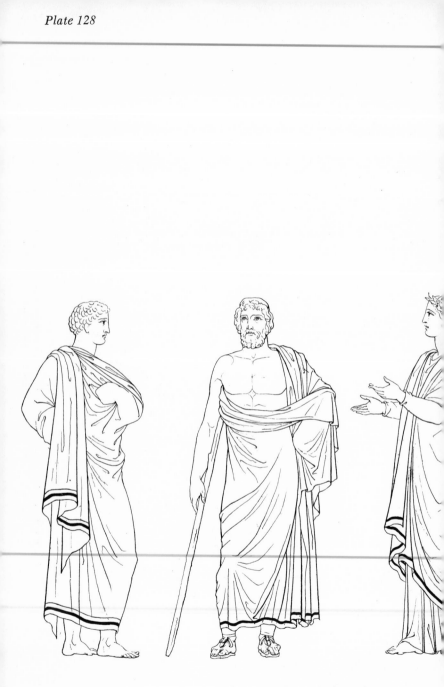

Grecian youth, philosopher and damsel in the peplum

Plate 129

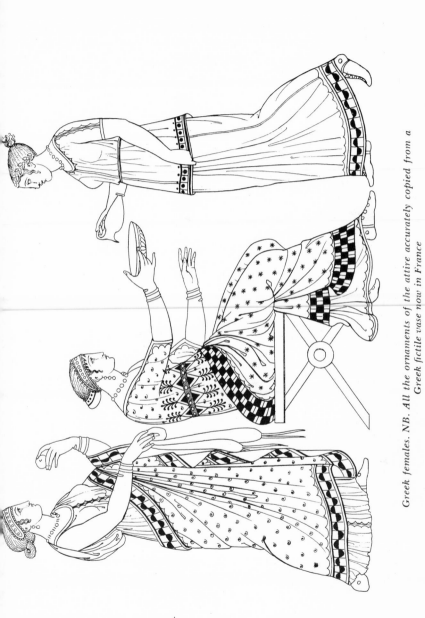

Greek females. NB. All the ornaments of the attire accurately copied from a Greek fictile vase now in France

Plate 130

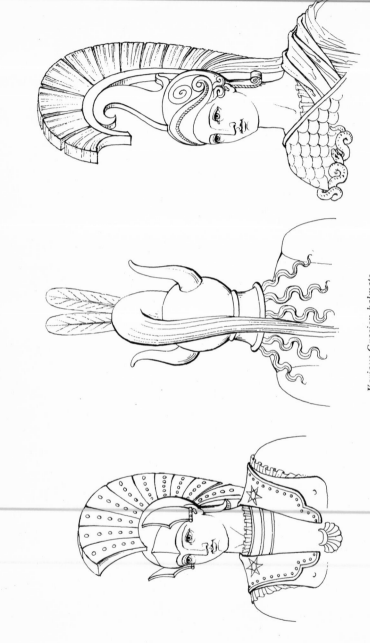

Various Grecian helmets

Costumes of the
Greeks and Romans

VOLUME TWO

Plate 131

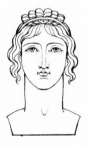

Grecian headdresses

Plate 132

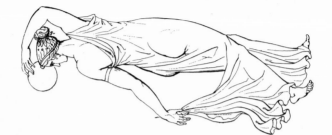

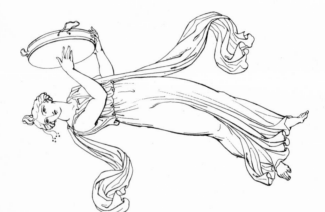

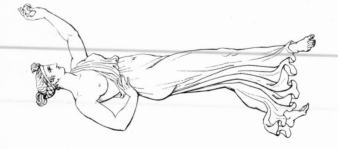

Females dancing

Plate 133

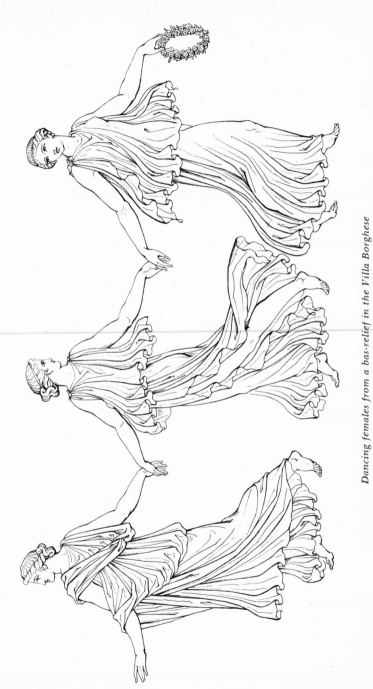

Dancing females from a bas-relief in the Villa Borghese

Plate 134

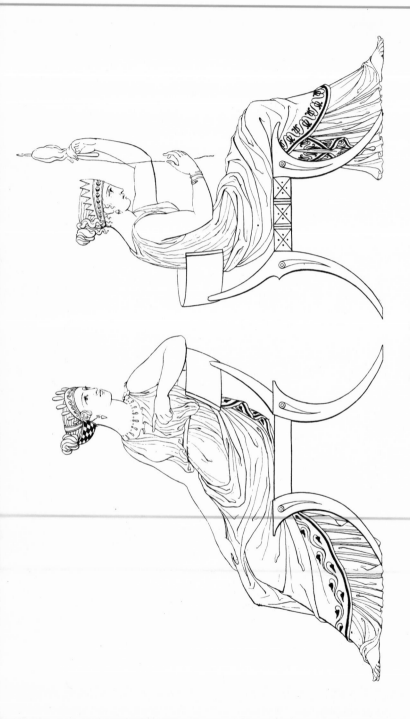

Grecian ladies

Plate 135

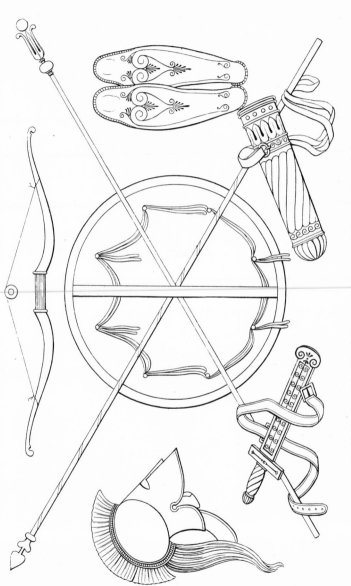

Greek shield viewed inside, helmet, greaves, sword, bow, quiver, and two heralds' staffs or sceptres

Plate 136

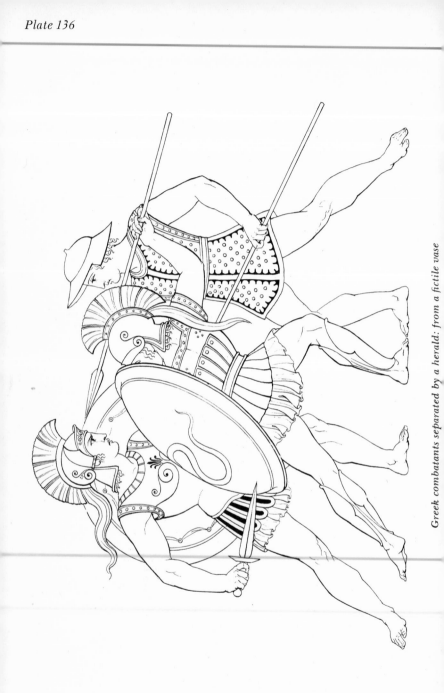

Greek combatants separated by a herald: from a fictile vase

Plate 137

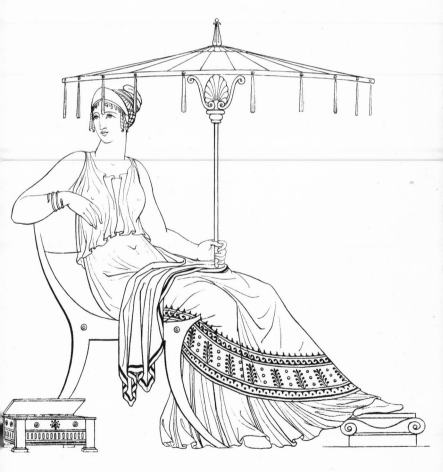

Lady seated, with her umbrella, footstool, and pyxis or jewel box:
from a Greek vase

Plate 138

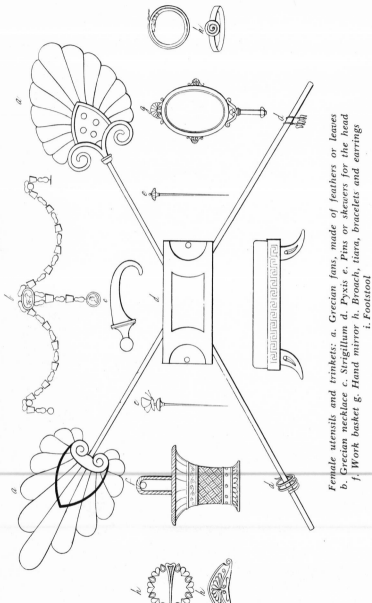

Female utensils and trinkets: a. Grecian fans, made of feathers or leaves
b. Grecian necklace c. Strigillum d. Pyxis e. Pins or skewers for the head
f. Work basket g. Hand mirror h. Broach, tiara, bracelets and earrings
i. Footstool

Plate 139

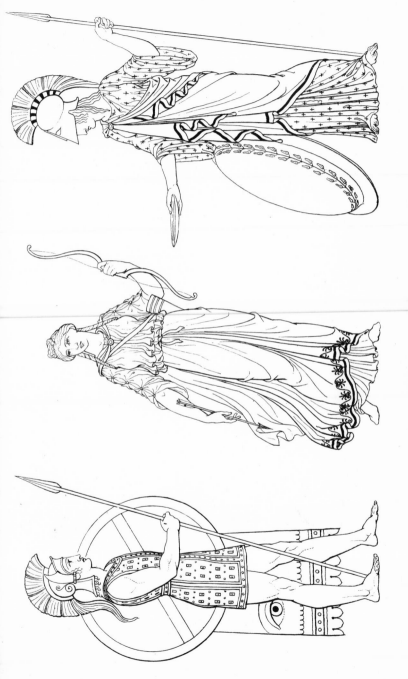

Plate 140

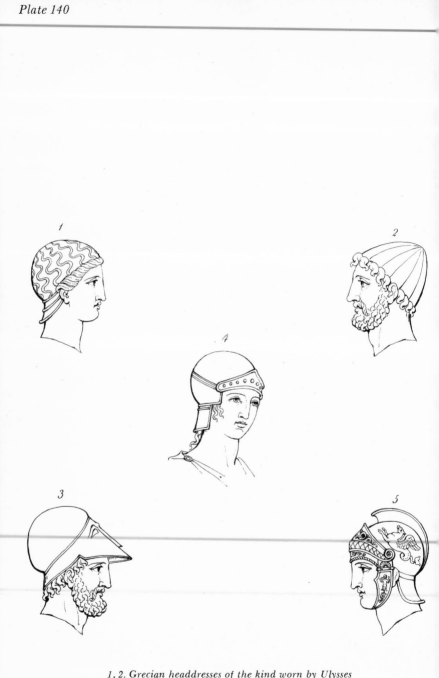

1, 2. *Grecian headdresses of the kind worn by Ulysses*
3, 4, and 5. *Grecian helmets*

Plate 141

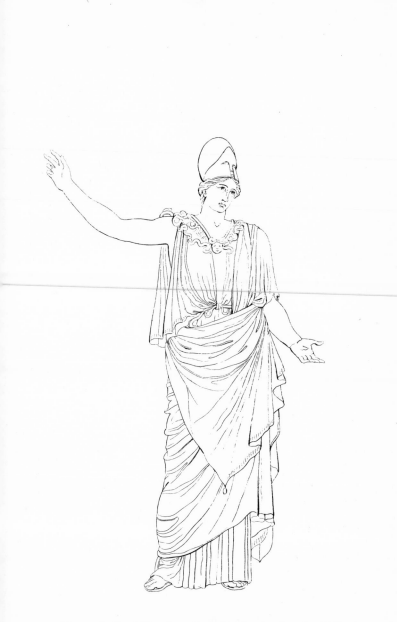

Minerva in the diplax: from the colossal statue found at Velletri

Plate 142

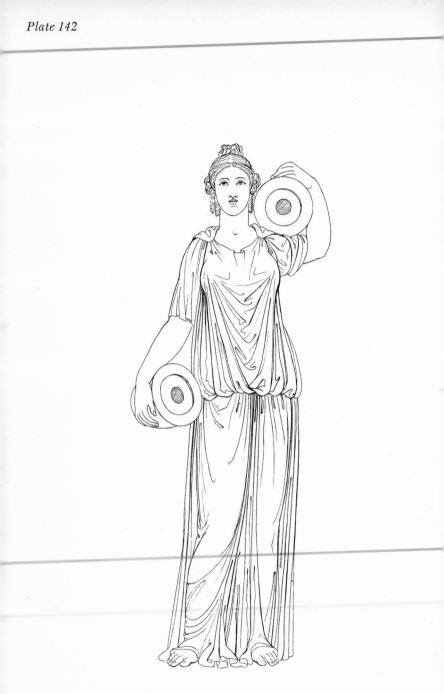

Danaïd from a statue formerly in the Giustiniani collection

Plate 143

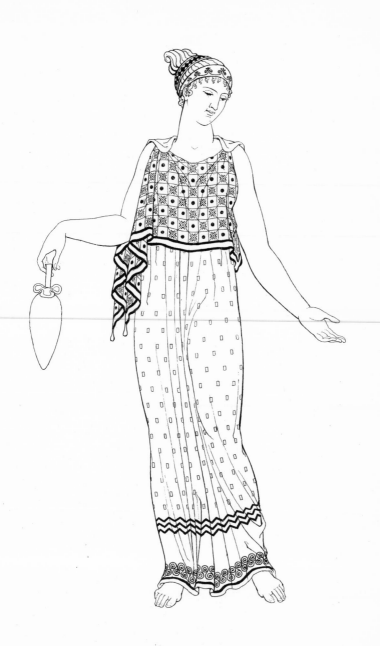

Grecian female

Plate 144

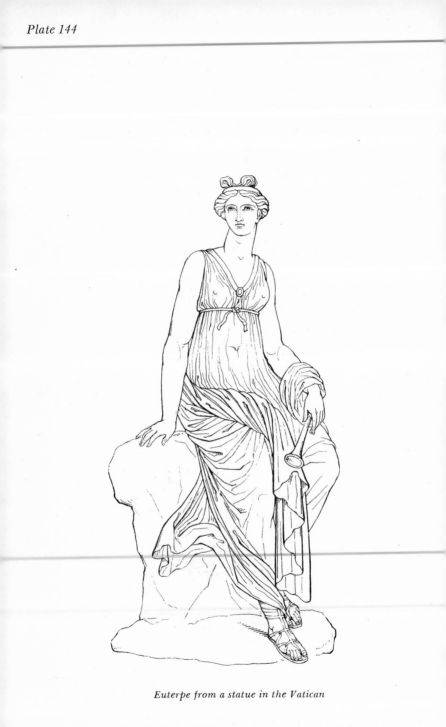

Euterpe from a statue in the Vatican

Plate 145

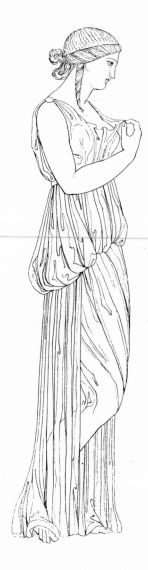

Greek female

Plate 146

Cybele from an antique bas-relief

Plate 147

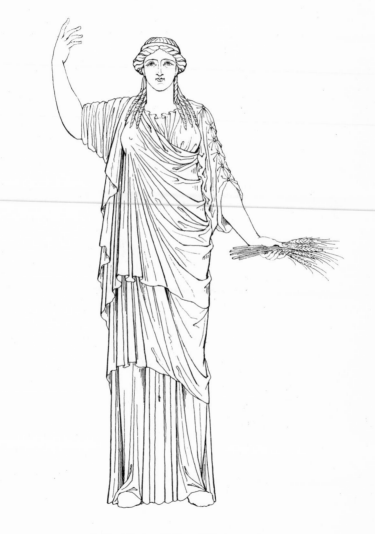

Ceres from a statue at Venice

Plate 148

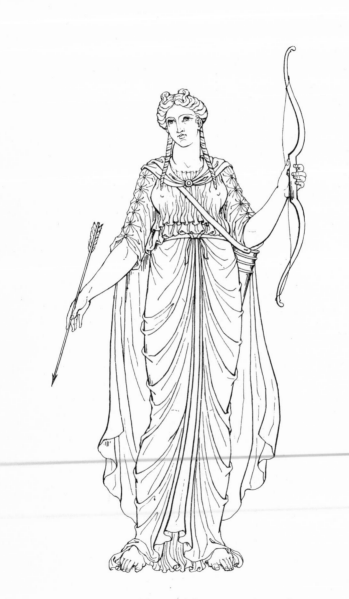

Diana with her garment loosened

Plate 149

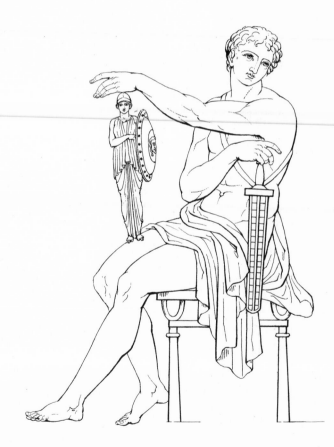

Diomedes from an antique gem

Plate 150

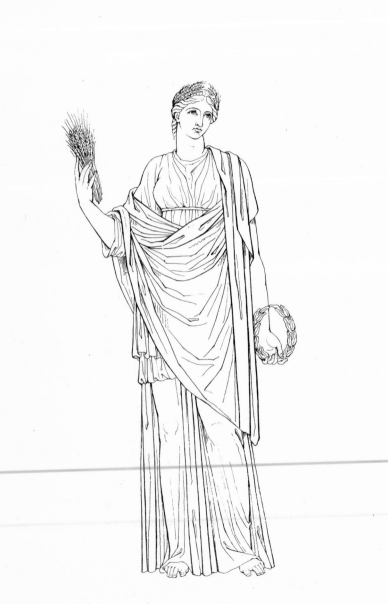

Ceres

Plate 151

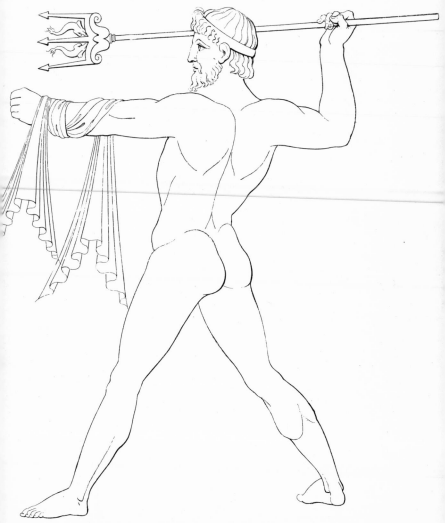

Neptune from an intaglio

Plate 152

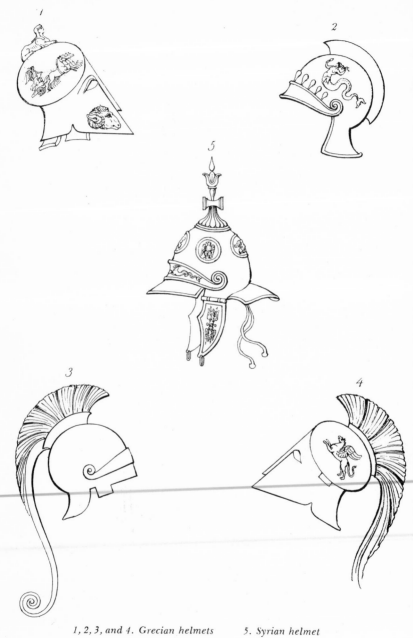

1, 2, 3, and 4. Grecian helmets 5. Syrian helmet

Plate 153

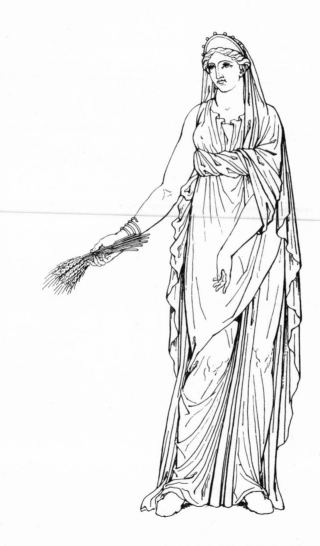

Ceres from a bronze found at Herculaneum

Plate 154

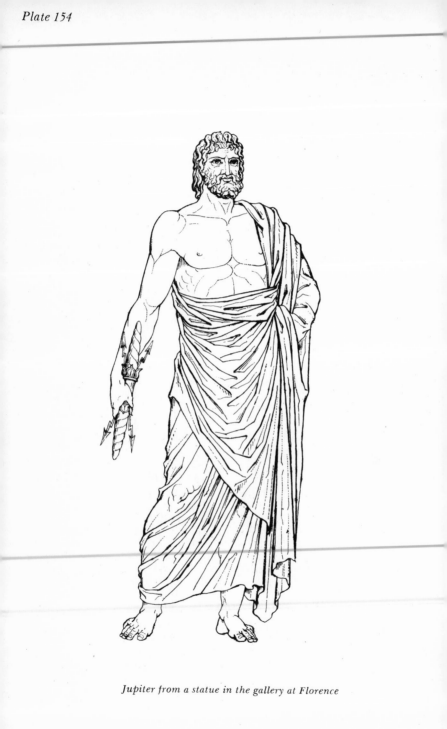

Jupiter from a statue in the gallery at Florence

Plate 155

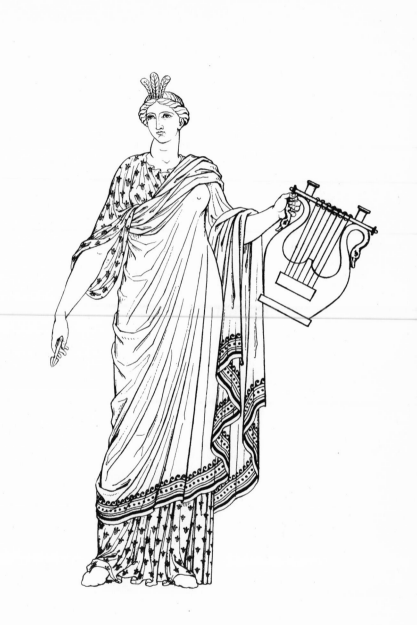

Erato

Plate 156

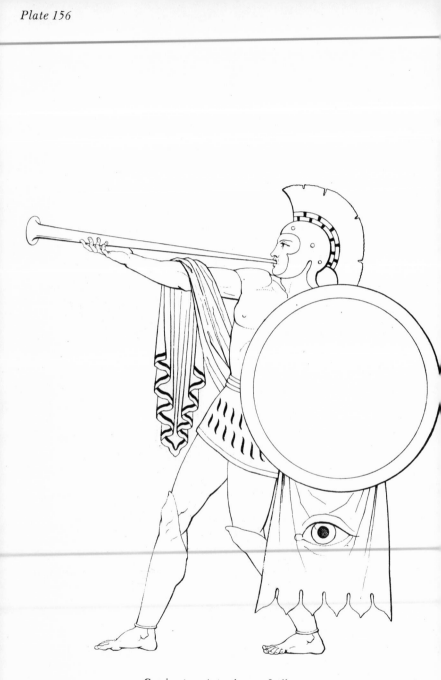

Grecian trumpeter from a fictile vase

Plate 157

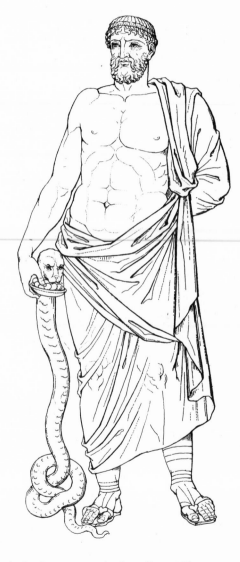

Aesculapius from a statue in the gallery at Florence

Plate 158

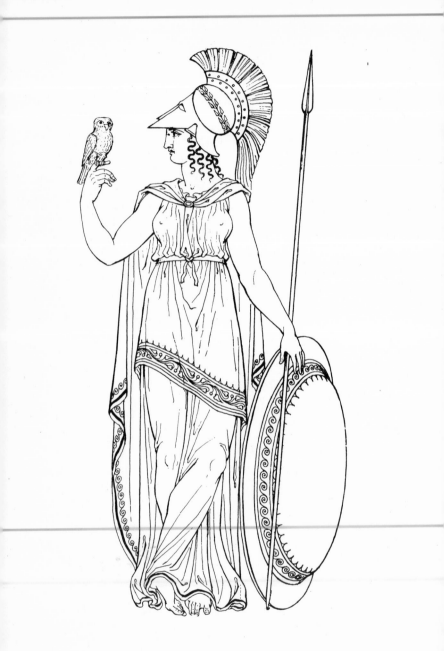

Minerva from a fictile vase

Plate 159

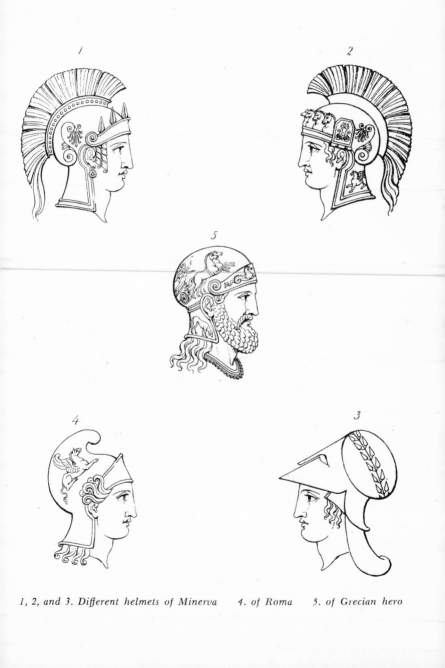

1, 2, and 3. Different helmets of Minerva 4. of Roma 5. of Grecian hero

Plate 160

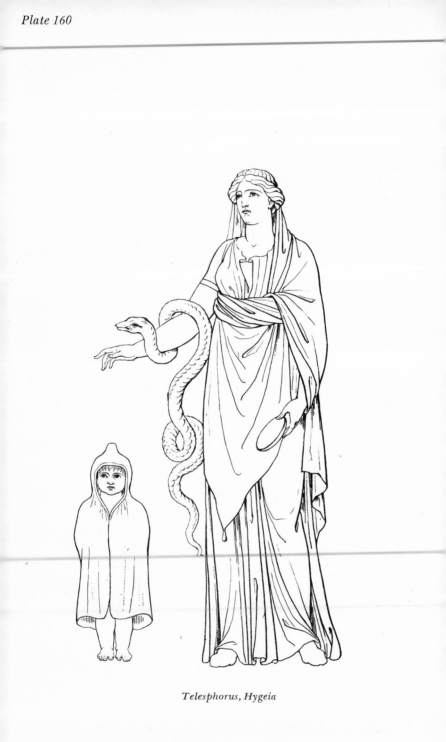

Telesphorus, Hygeia

Plate 161

Grecian female from a bas-relief in the Capitol

Plate 162

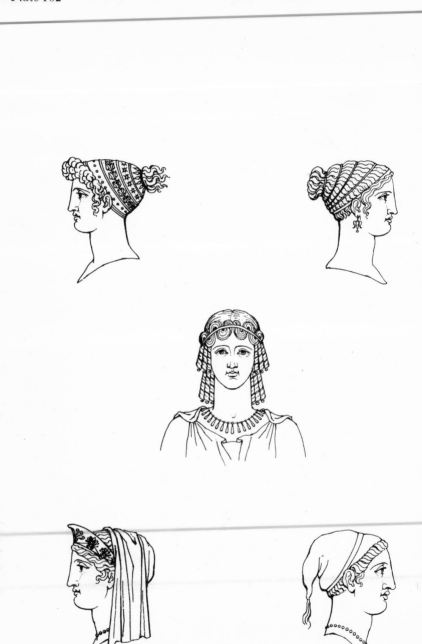

Grecian headdresses

Plate 163

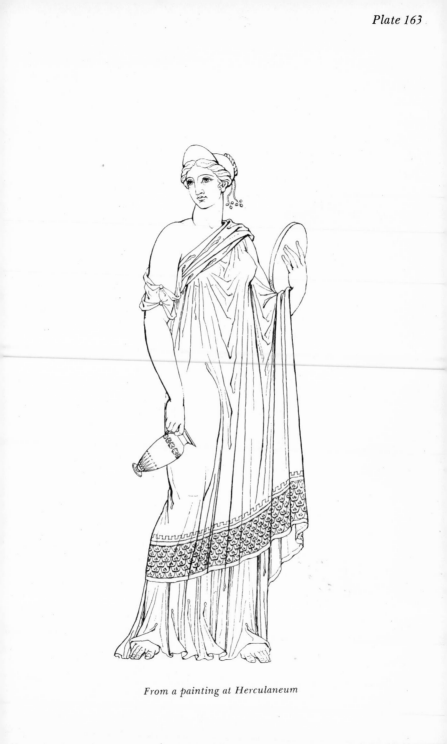

From a painting at Herculaneum

Plate 164

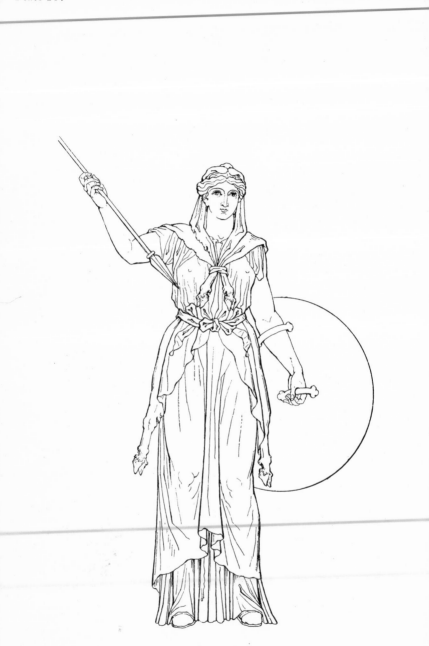

Juno Lanuvina from a statue in the Vatican

Plate 16.

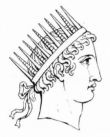

Different Ptolemies and their Queens

Grecian headdresses

Plate 167

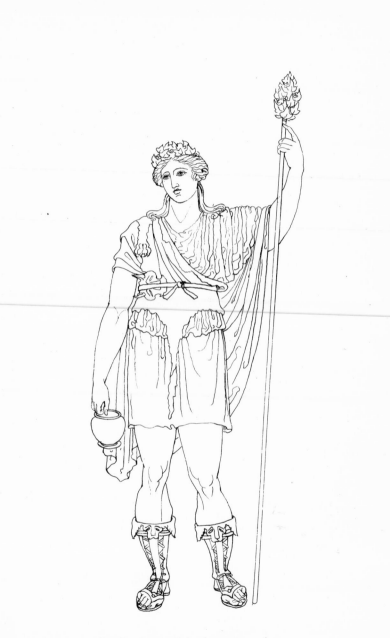

Bacchus from a statue in my possession

Plate 168

Grecian ornaments and scrolls

Plate 169

Greek fictile vases

Plate 170

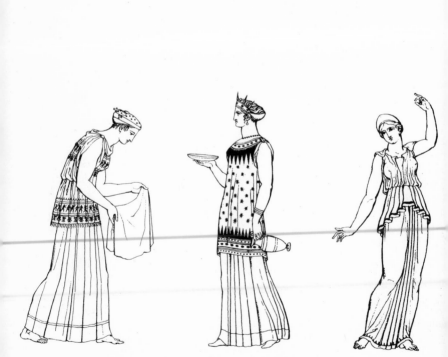

Greek females from fictile vases

Plate 171

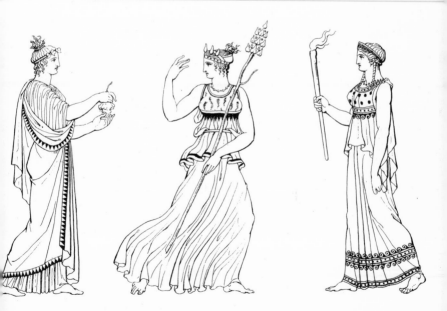

Bacchanalian figures from fictile vases

Plate 172

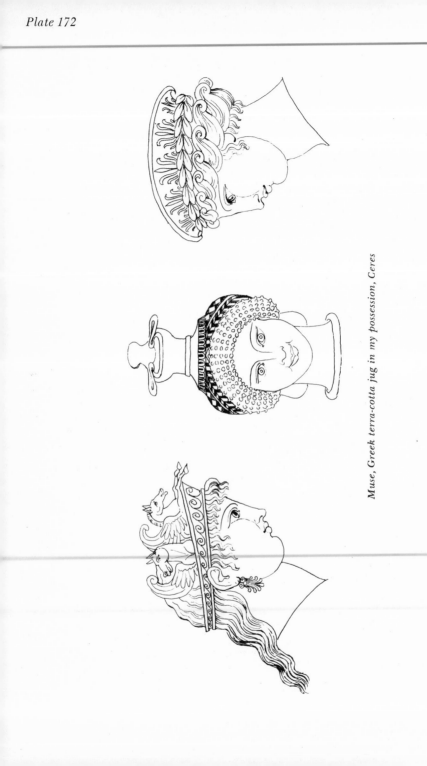

Muse, Greek terra-cotta jug in my possession, Ceres

Plate 173

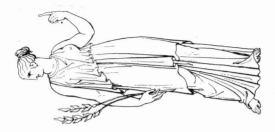

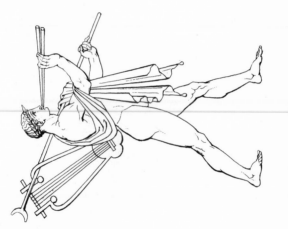

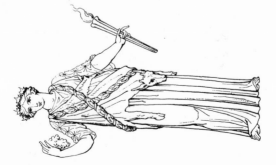

Bacchanalian personages

Plate 174

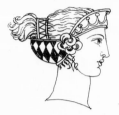

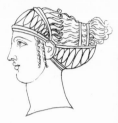

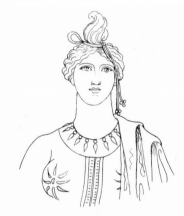

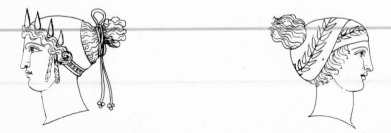

Grecian headdresses

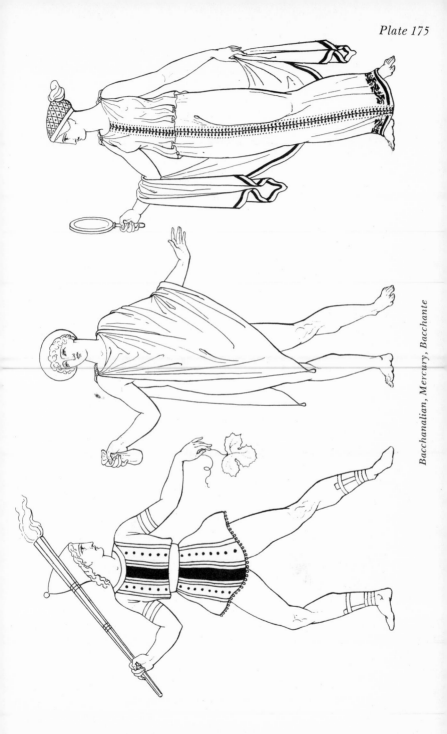

Plate 175

Bacchanalian, Mercury, Bacchante

Plate 176

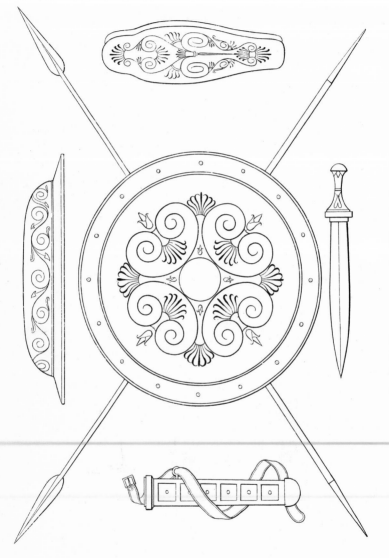

Greek shields, spears, sword, scabbard and greaves

Plate 177

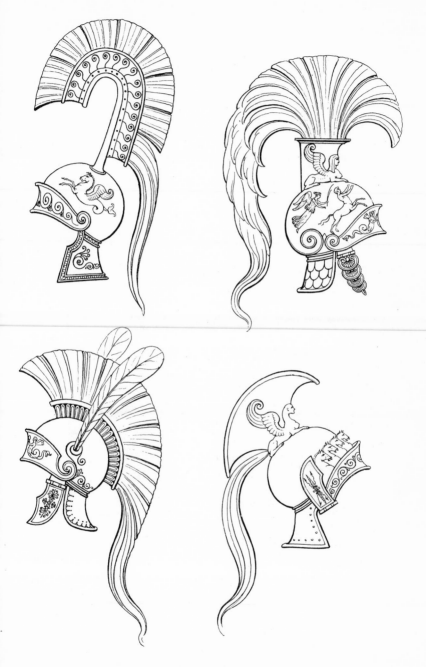

Grecian helmets

Plate 178

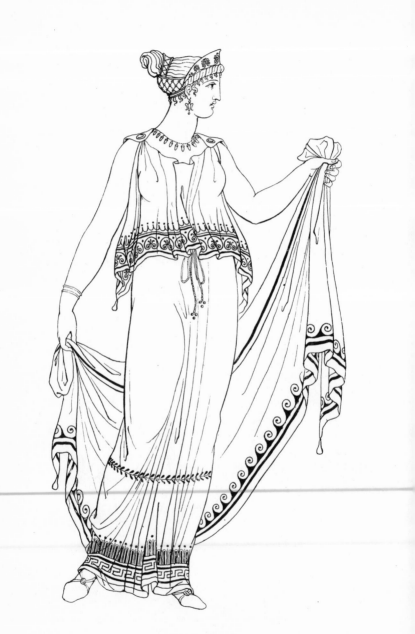

Grecian female

Plate 179

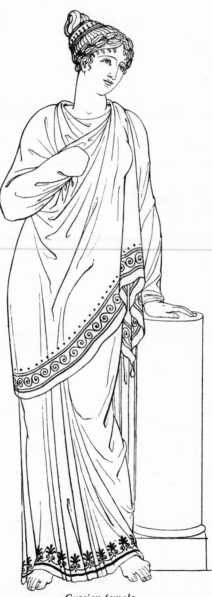

Grecian female

Plate 180

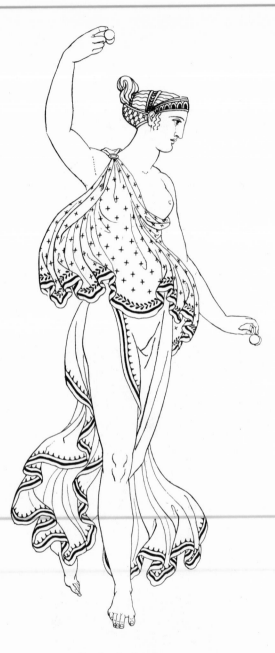

Bacchante dancing

Plate 181

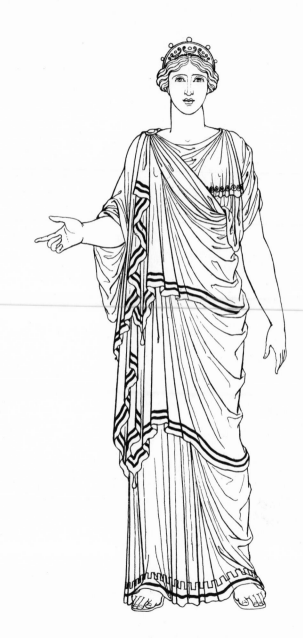

Juno wearing the diplax

Plate 182

Greek poet

Plate 183

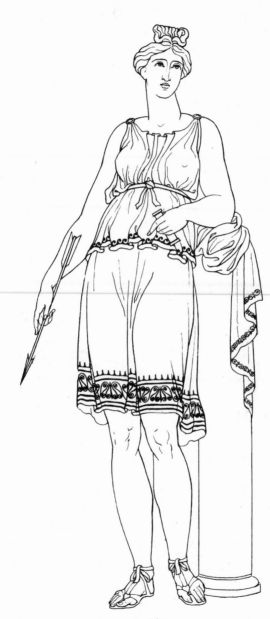

Diana

Plate 184

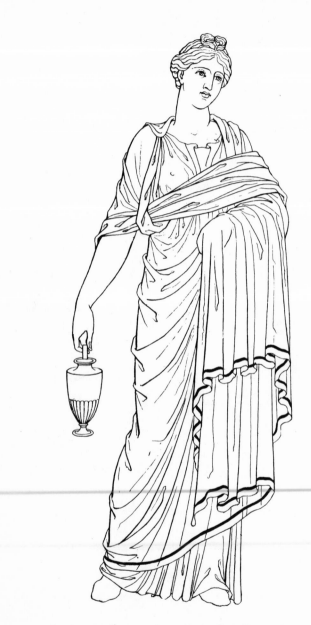

Grecian female from a bas-relief in the Villa Borghese

Plate 185

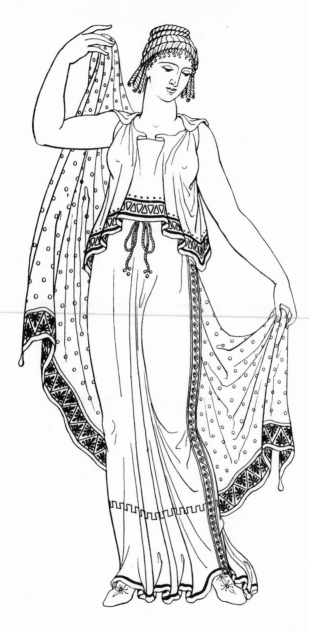

Grecian female from a fictile vase

Plate 186

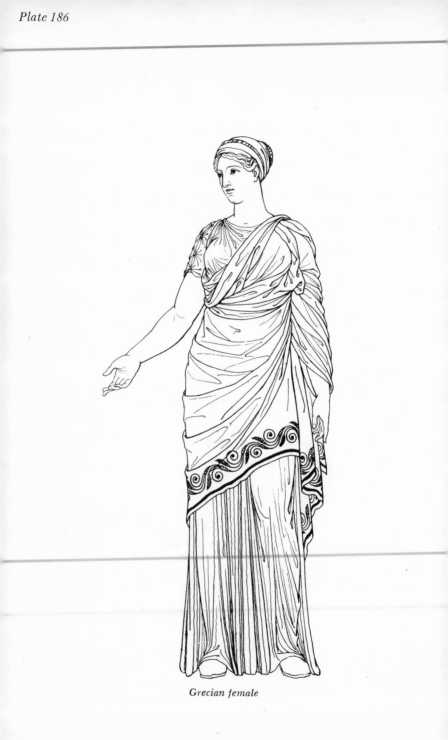

Grecian female

Plate 187

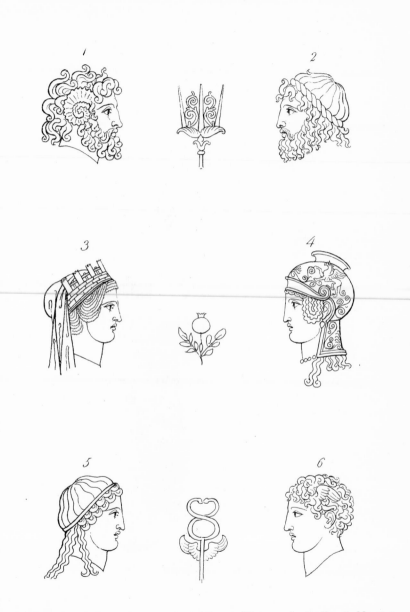

1. Jupiter Ammon 2. Neptune 3. Cybele 4. Minerva 5. Apollo 6. Mercury

Plate 188

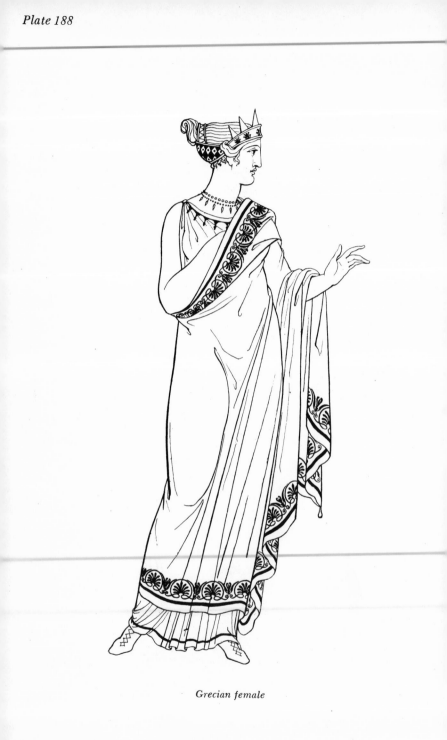

Grecian female

Plate 189

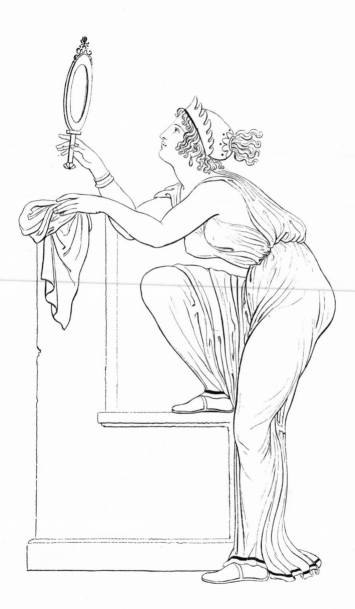

Grecian female from a fictile vase in my possession

Plate 190

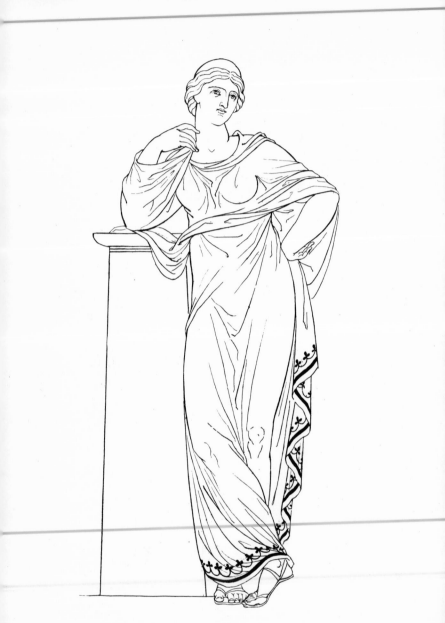

Grecian female

Plate 191

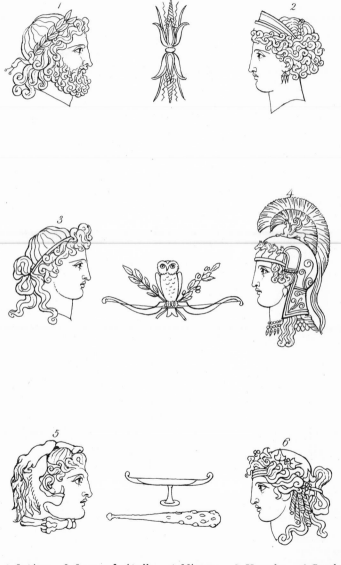

1. Jupiter 2. Juno 3. Apollo 4. Minerva 5. Hercules 6. Bacchus

Plate 192

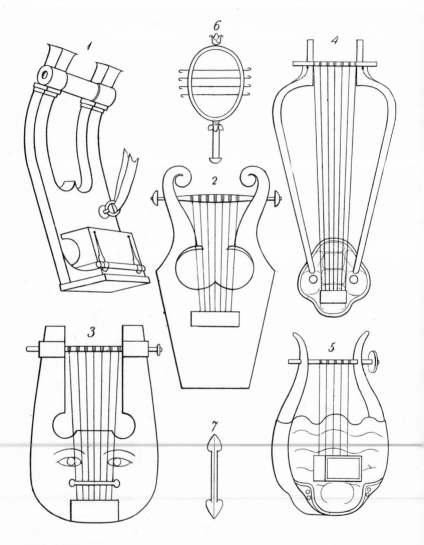

Musical instruments: 1 and 2. Varieties of the phorminx 3. The cithara 4. The psaltery or long lyre 5. The chelys or testudo 6. The sistrum 7. The plectrum to strike the lyre with

Plate 193

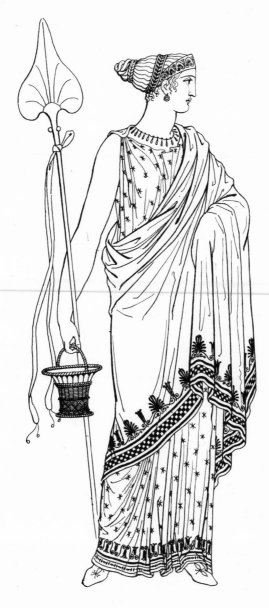

Grecian female

Plate 194

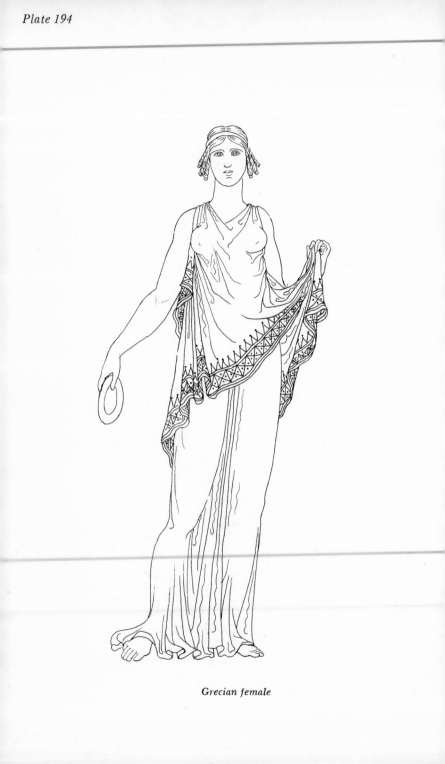

Grecian female

Plate 195

Females dancing and playing on the lyre

Plate 196

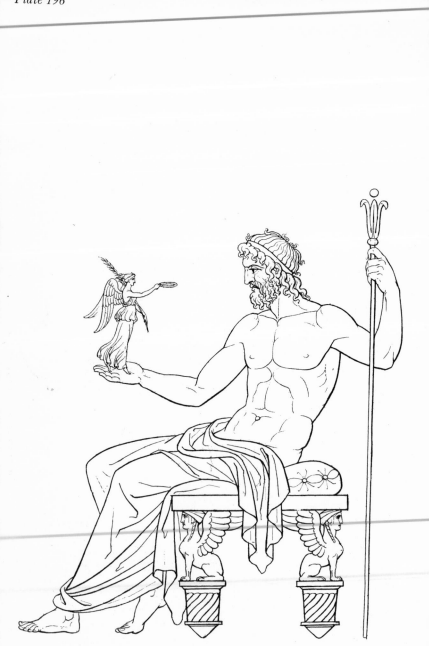

Jupiter

Plate 197

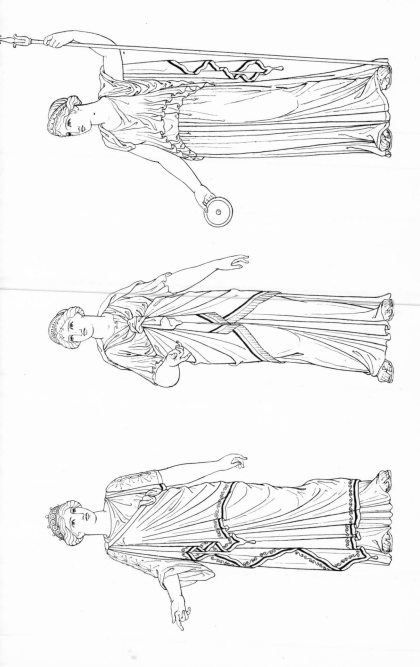

Juno attired in various ways: from antique statues

Plate 198

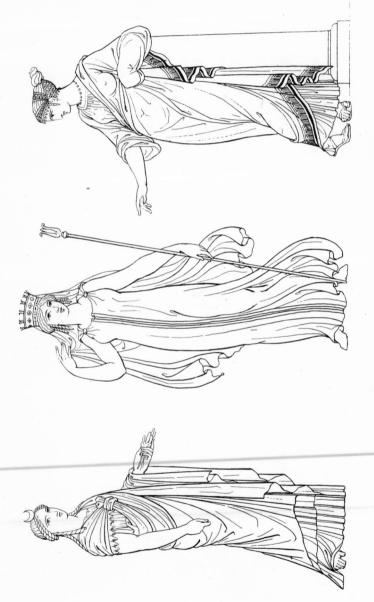

Diana, Ceres, Venus

Plate 199

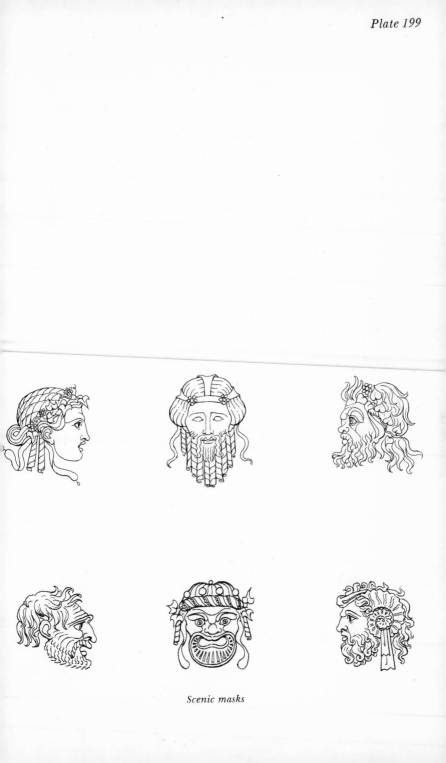

Scenic masks

Plate 200

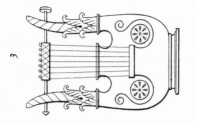

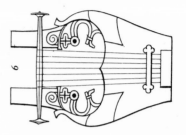

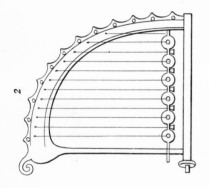

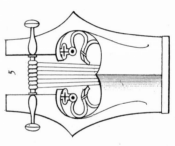

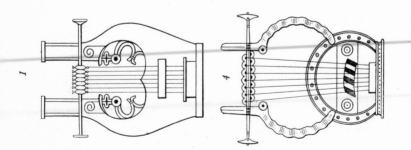

1, 3, 4, 5 and 6. Varieties of the great lyre or phorminx 2. The trigonon

Plate 201

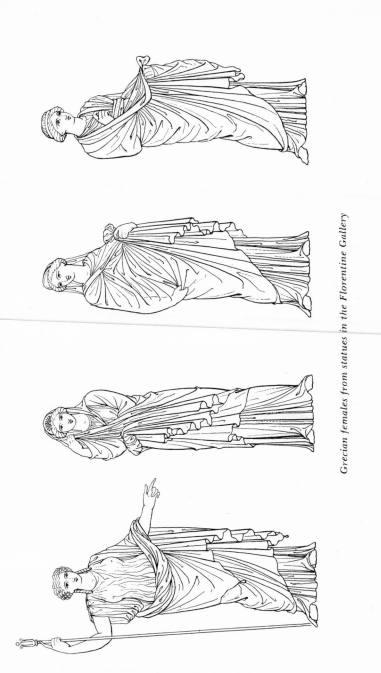

Grecian females from statues in the Florentine Gallery

Plate 202

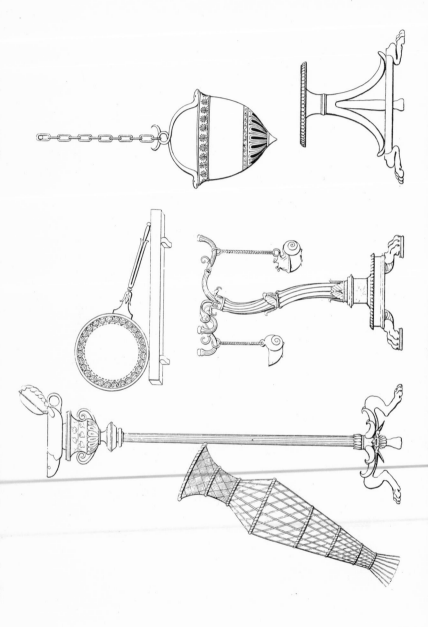

Grecian lamps, candelabra, tatara, basket, and other utensils

Plate 203

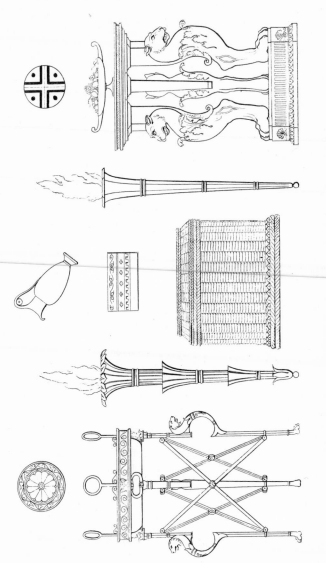

Torches, tripods, cista, pyxis, simpulum, patera and consecrated cake

Plate 204

Grecian peasants

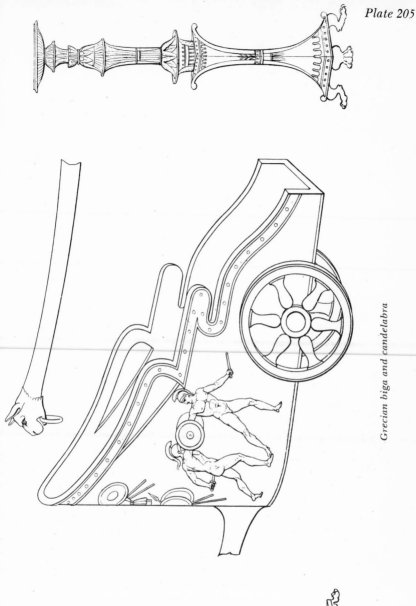

Grecian biga and candelabra

Plate 205

Plate 206

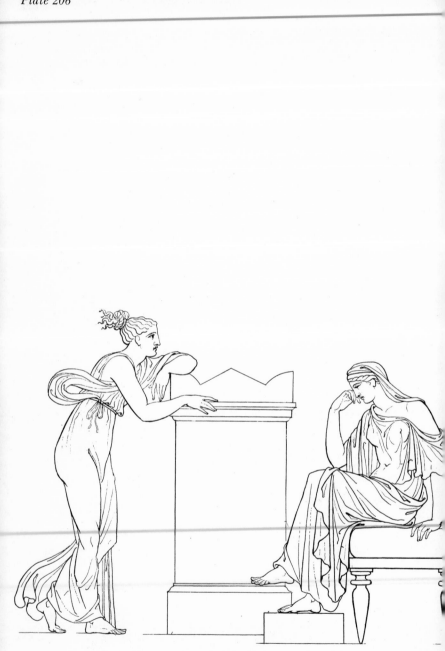

Grecian females

Plate 207

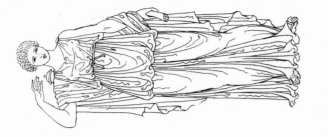

Diana

Muse

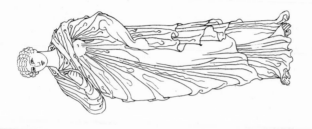

Muse

Muse

Plate 208

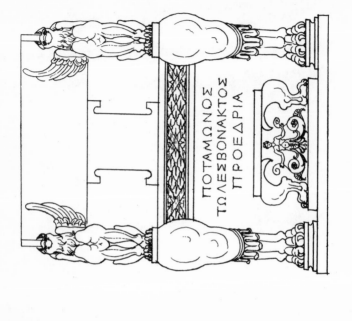

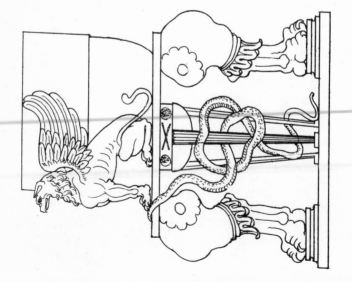

ΠΟΤΑΜΩΝΟΣ
ΤΩΛΕΣΒΩΝΑΚΤΩΣ
ΠΡΟΕΔΡΙΑ

Marble chair of Potamon, the Lesbian rhetorician, still existing in Mitylene

Plate 209

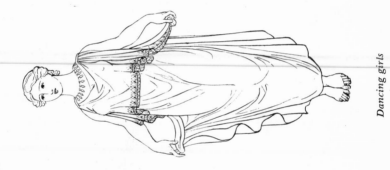

Dancing girls

Plate 210

Diana

Muse

Venus

Plate 211

Apollo Musagetes, Diana Succincta, Ceres

Plate 212

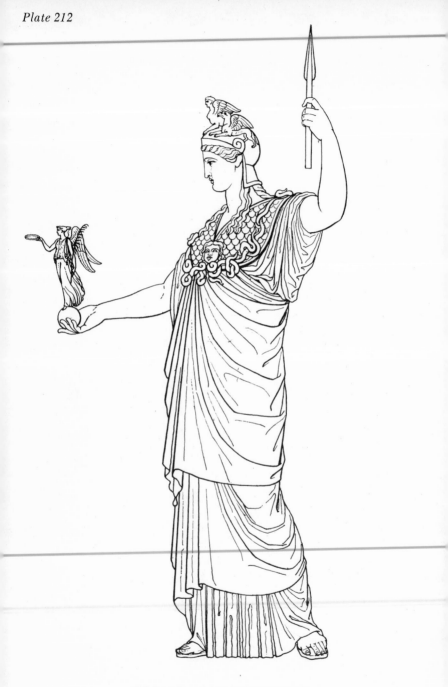

Minerva from a statue in my possession

Plate 213

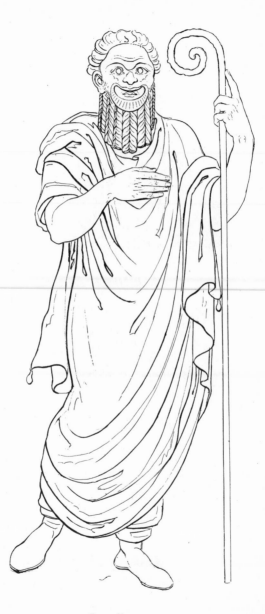

Comedian

Plate 214

Grecian female from a statue at Florence

Plate 215

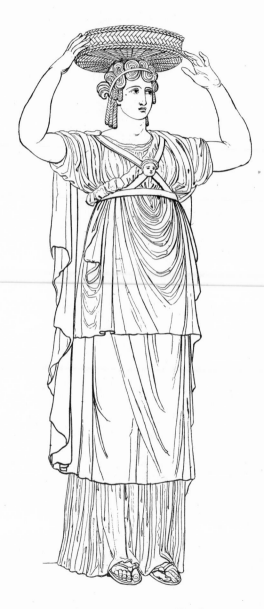

Canephora from a statue at Dresden

Plate 216

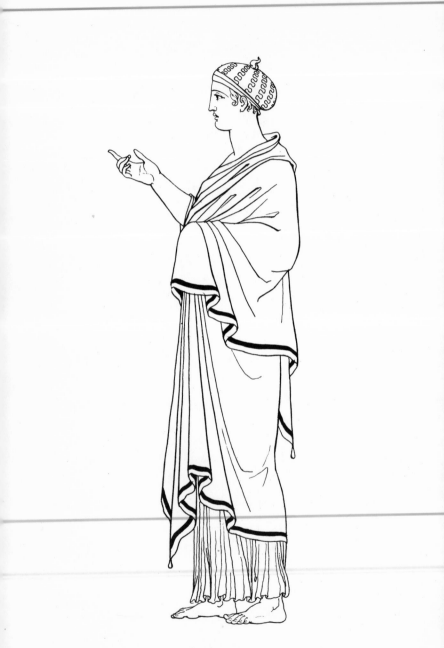

Grecian female

Plate 217

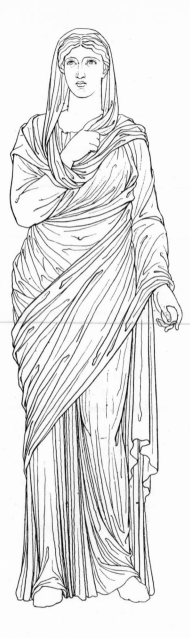

Grecian lady

Plate 218

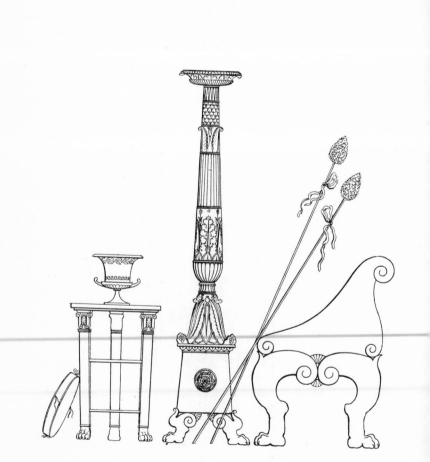

Tripod, candelabrum, chair

Plate 219

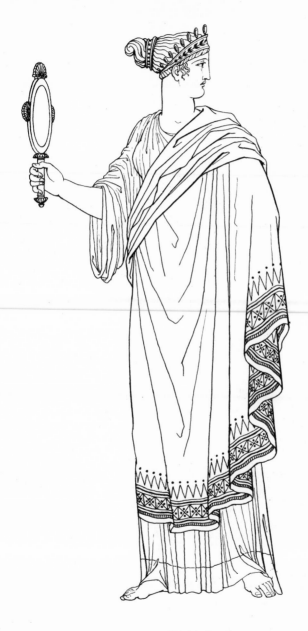

Grecian female

Plate 220

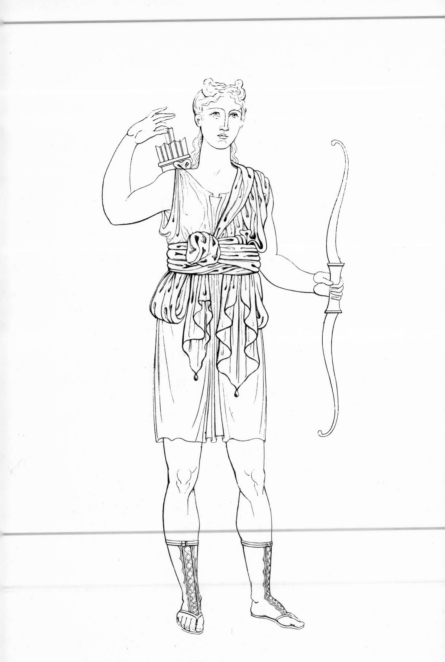

Diana Succincta

Plate 221

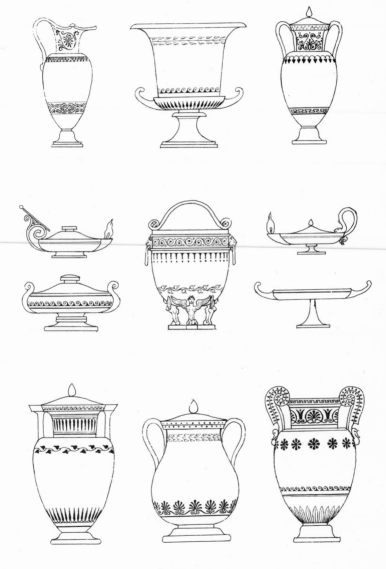

Greek vases

Plate 222

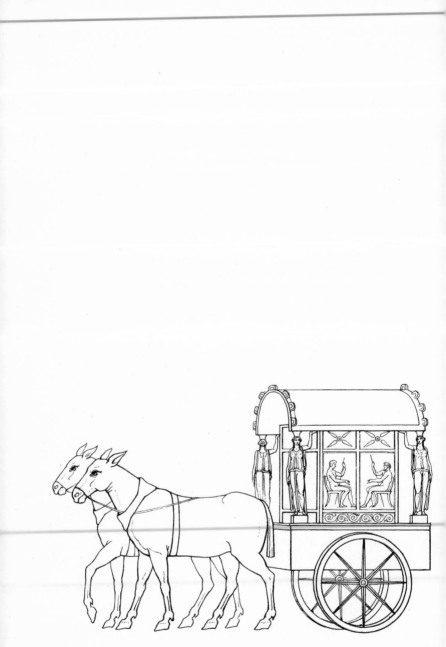

Itinerant sanctuary

Plate 223

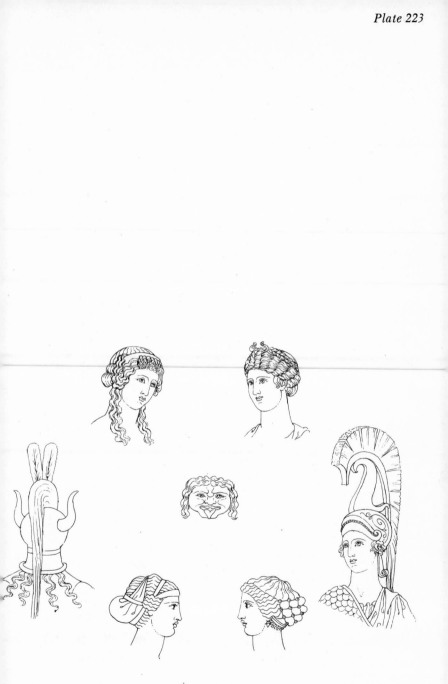

Grecian heads

Plate 224

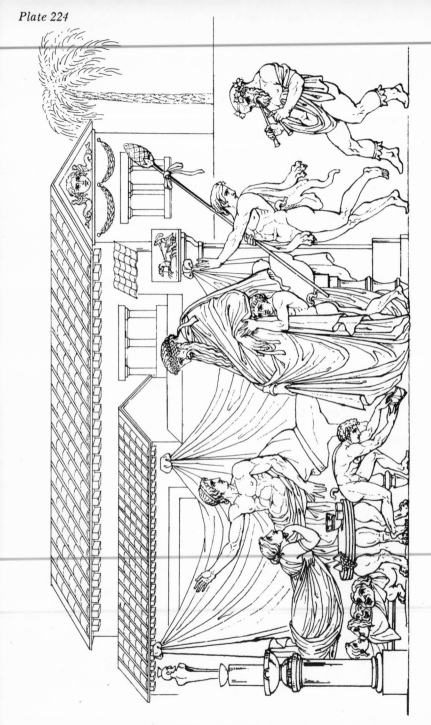

Reception of Bacchus

Plate 225

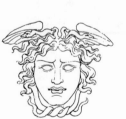

Gorgons

Plate 226

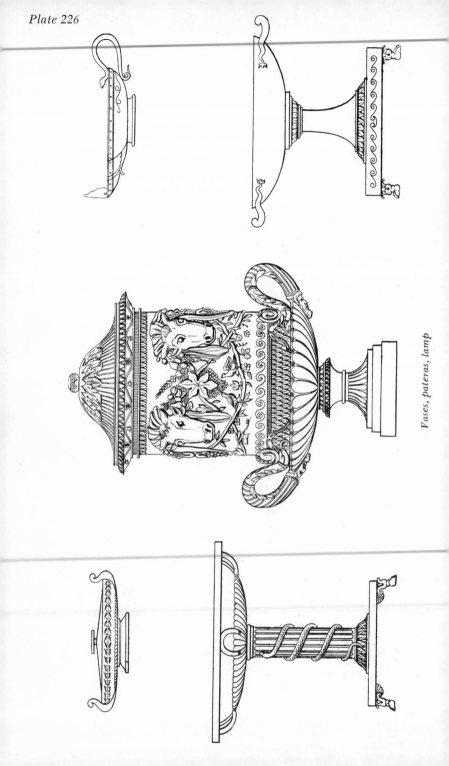

Vases, pateras, lamp

Plate 227

Chair of state and other pieces of furniture

Plate 228

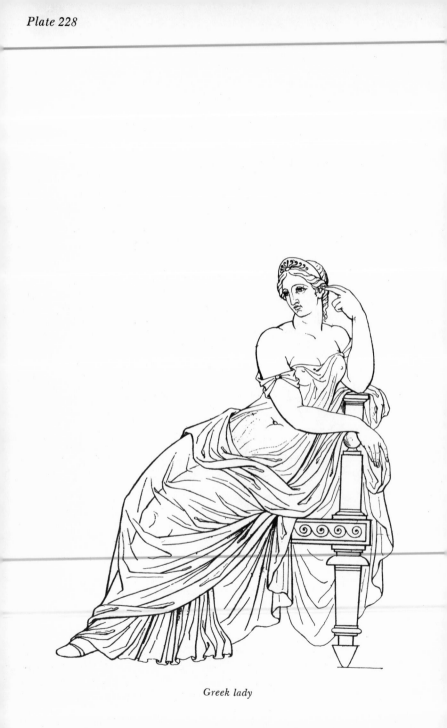

Greek lady

Plate 229

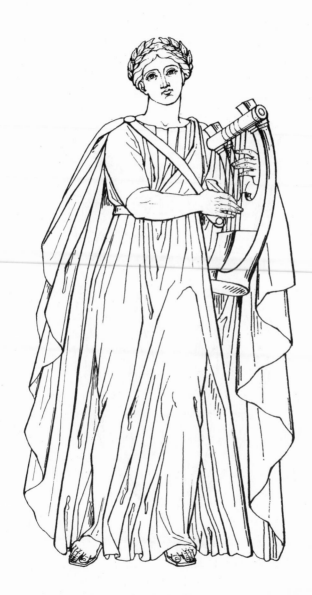

Apollo Musagetes from the Vatican

Plate 230

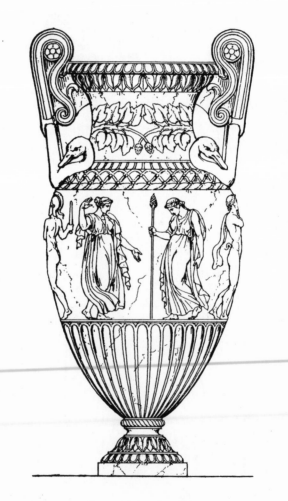

Vase with bacchanalian

Plate 231

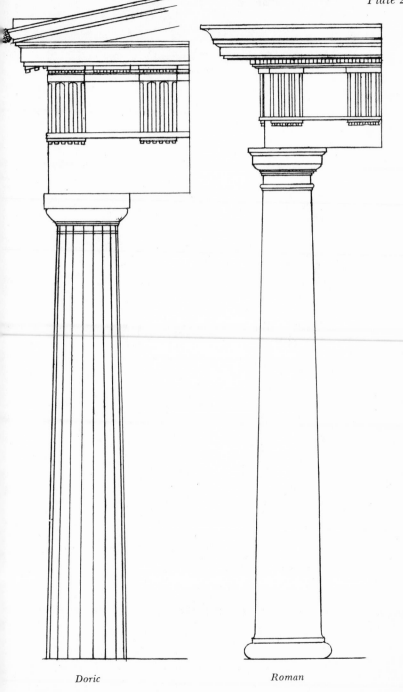

Doric *Roman*

Architectural orders

Plate 232

Faustina, wife of Antoninus Pius, from a staue in the Vatican

Plate 233

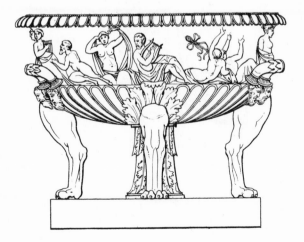

Roman cisterns

Plate 234

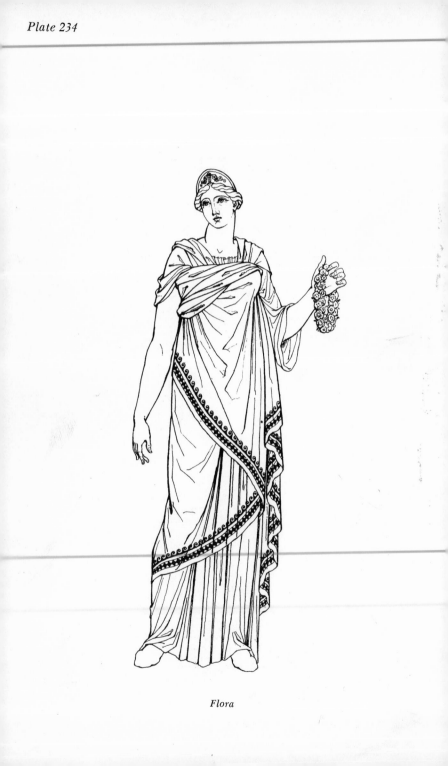

Flora

Plate 235

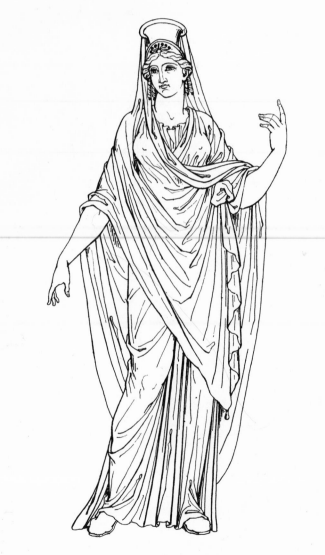

Fortune. Montfaucon, vol. 2

Plate 236

Car of bronze dug up some years ago near Rome

Plate 237

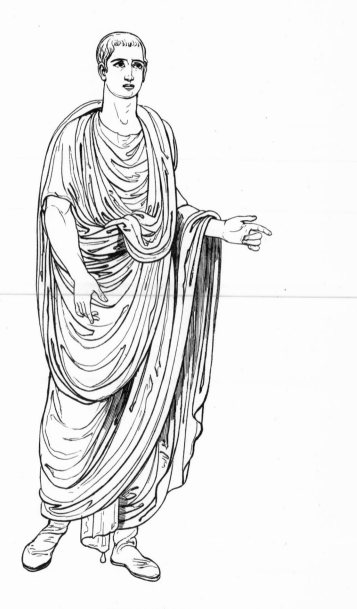

Roman in his toga

Plate 238

Roman youth with the bulla

Plate 239

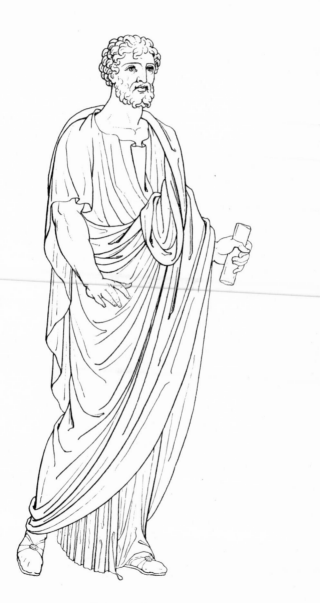

Roman orator

Plate 240

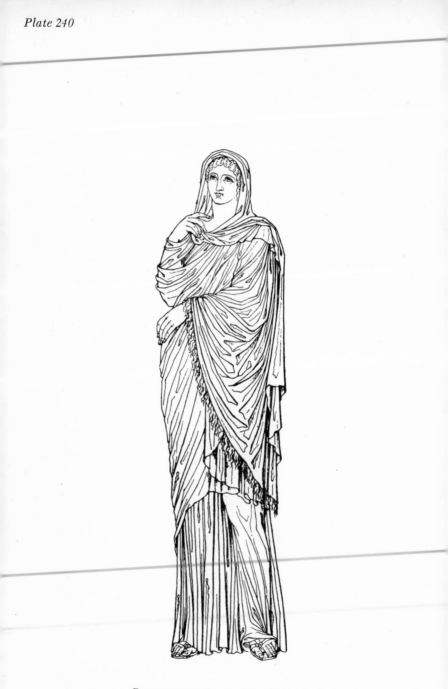

Roman matron from a statue in the Capitol

Plate 241

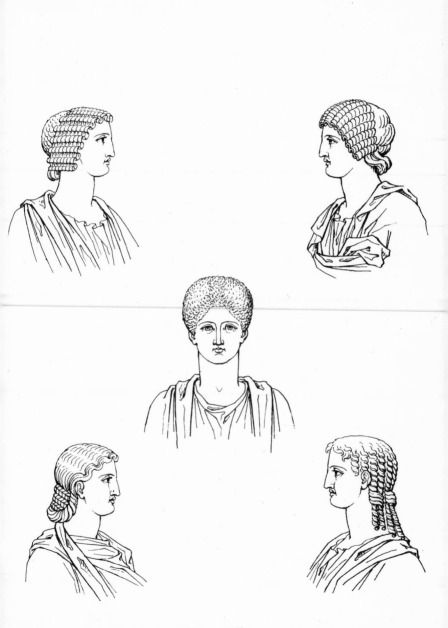

Roman ladies

Plate 242

Marcus Aurelius from a statue at Venice

Plate 243

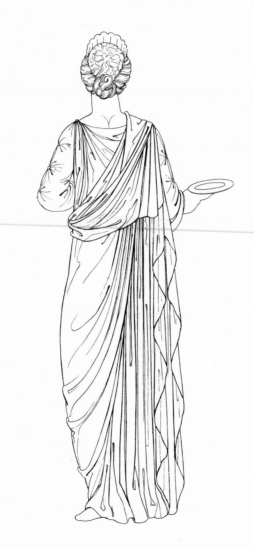

Roman empress

Plate 244

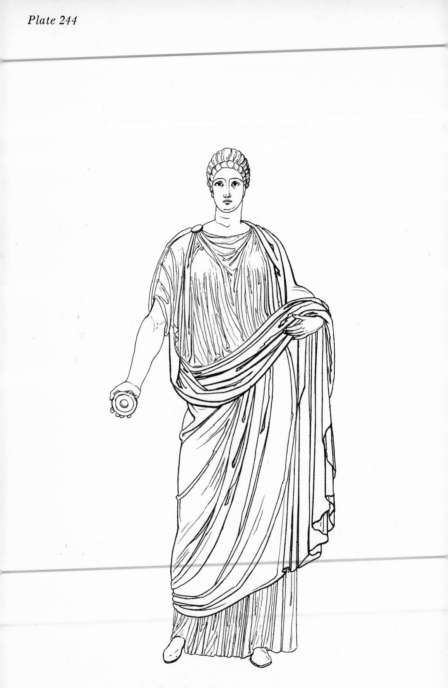

Faustina, wife of Antoninus Pius

Plate 245

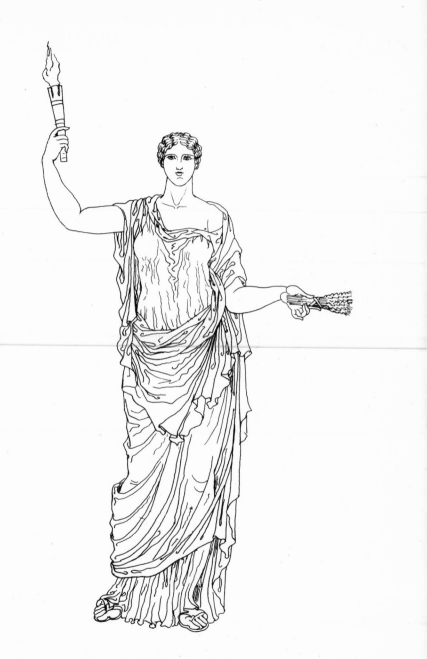

Roman empress in the character of Ceres

Plate 246

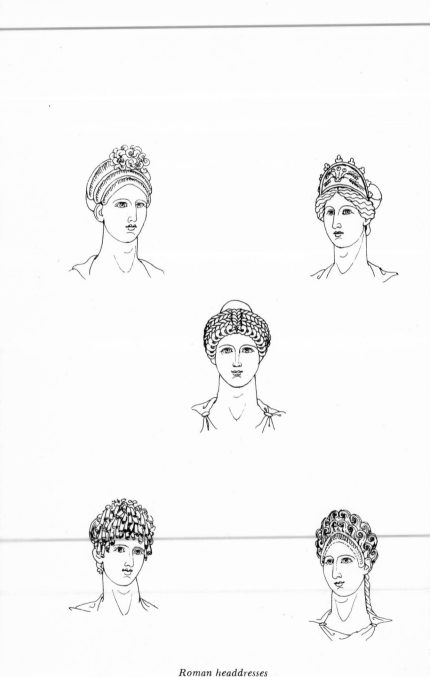

Roman headdresses

Plate 247

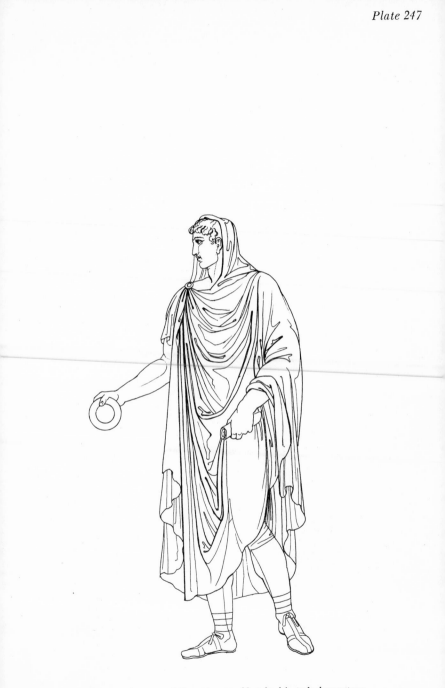

Roman emperor assisting at a sacrifice in his paludamentum

Plate 248

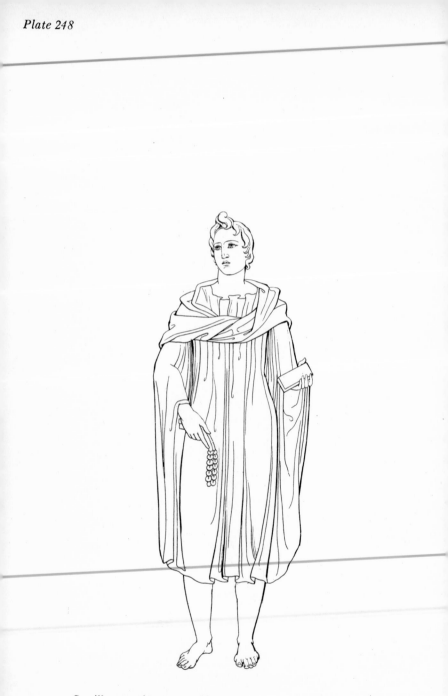

Camillus or assistant at sacrifices: from a statue in the Villa Borghese

Plate 249

*Roman emperor in his military tunic and paludamentum, unarmed:
from the Trajan Column*

Plate 250

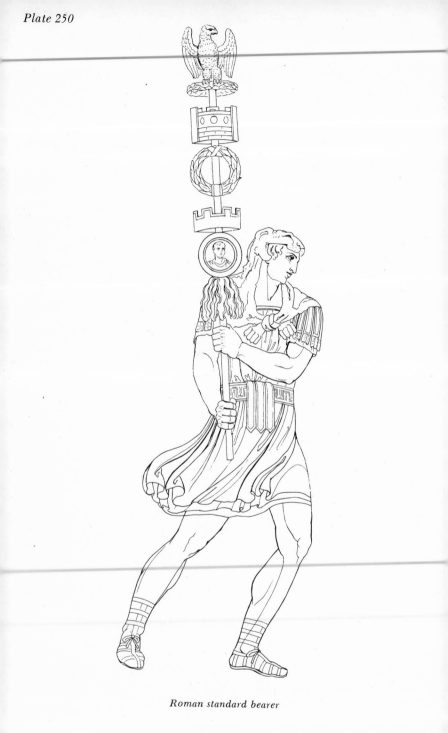

Roman standard bearer

Plate 251

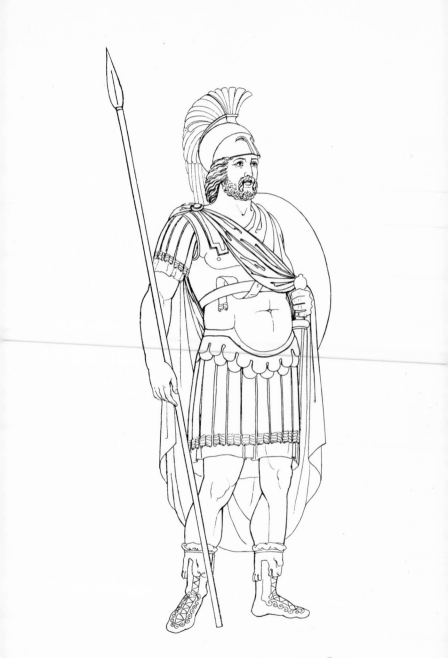

Roman general from the Arch of Constantine at Rome

Plate 252

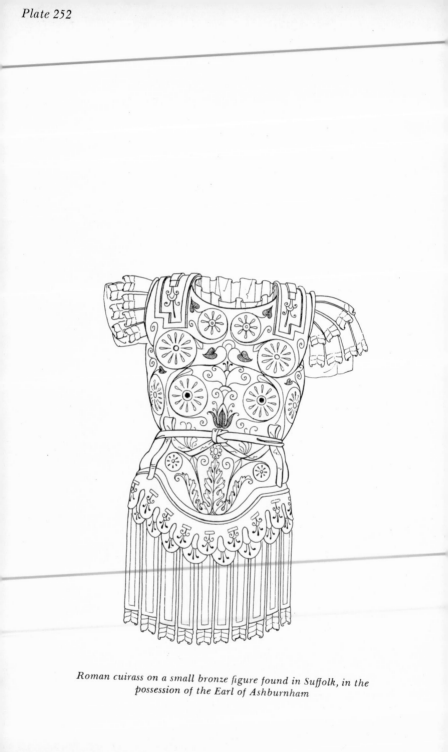

Roman cuirass on a small bronze figure found in Suffolk, in the possession of the Earl of Ashburnham

Plate 253

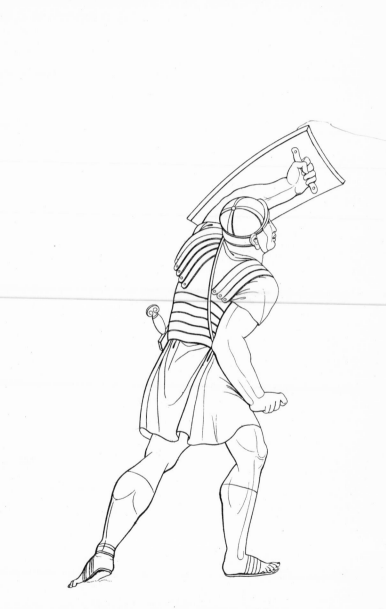

Roman soldier from the Trajan Column

Plate 254

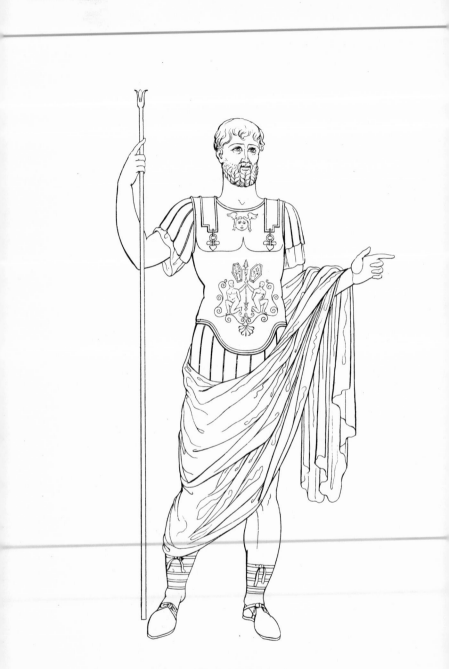

Roman emperor

Plate 255

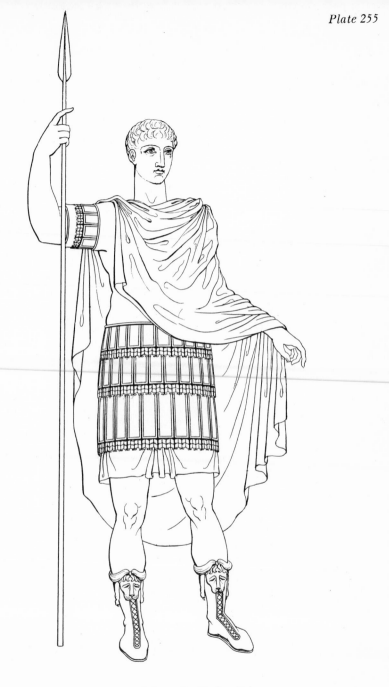

Roman general from the Trajan Column

Plate 256

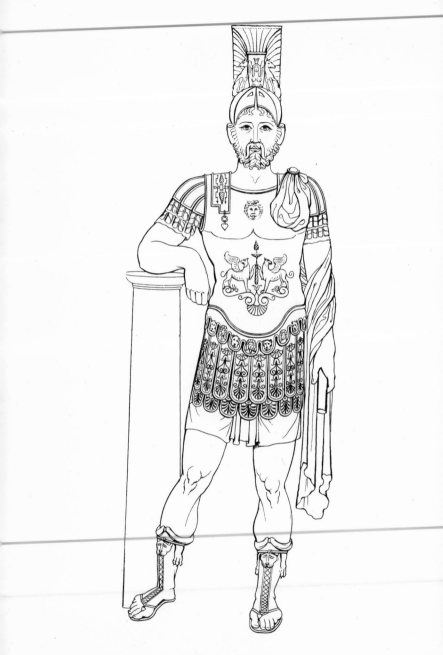

Roman general

Plate 257

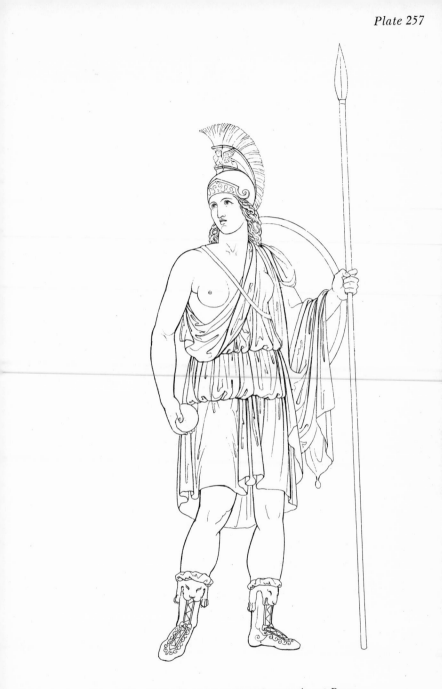

The goddess Roma from the Arch of Constantine at Rome

Plate 258

Nemesis from a statue in the Villa Borghese

Plate 259

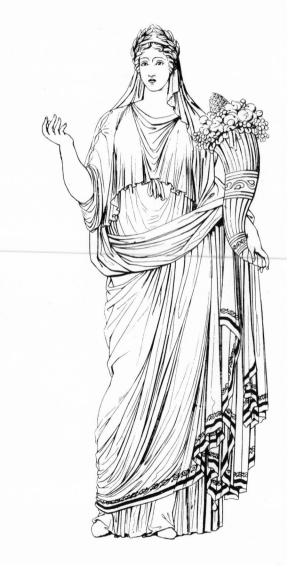

Roman empress with the attributes of plenty: from a statue in the Villa Borghese

Plate 260

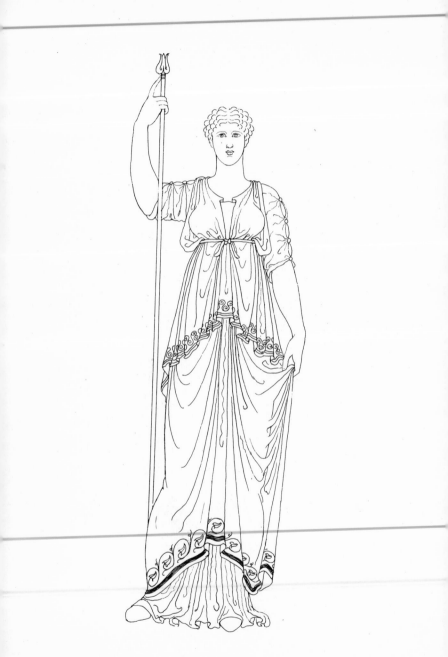

Roman empress

Plate 261

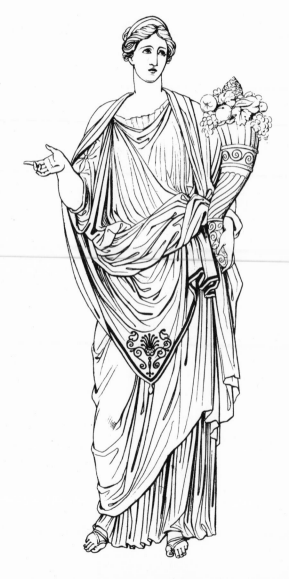

Roman empress

Plate 262

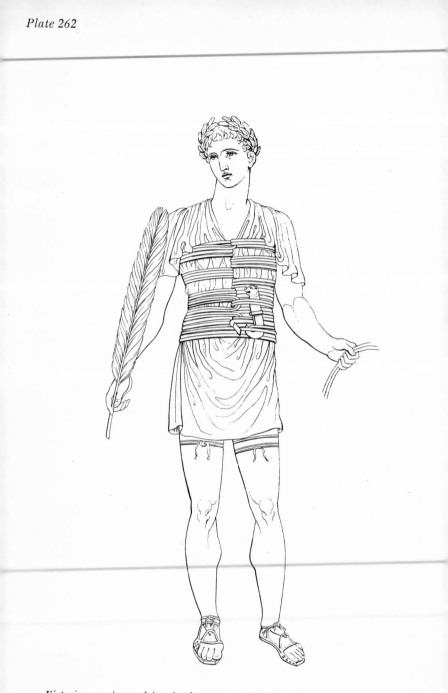

Victorious auriga or driver in the games of the circus: from a statue in the Vatican

Plate 263

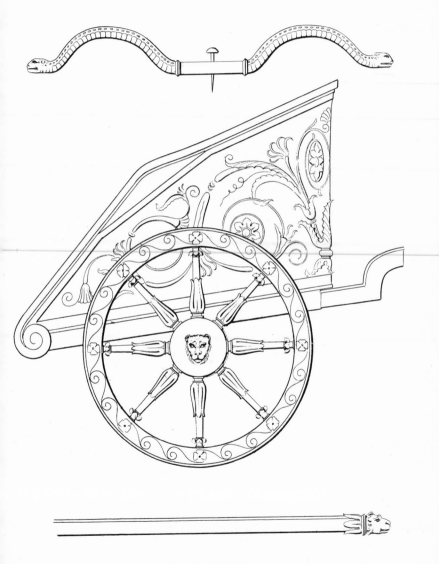

Biga in the Vatican

Plate 264

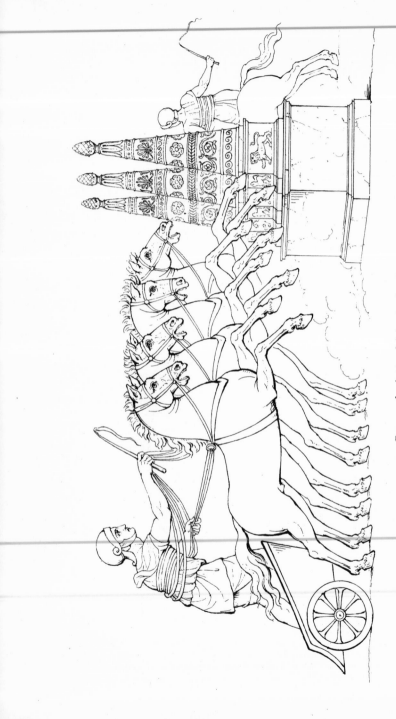

Roman charioteer driving in the circus

Plate 265

Bull adorned for sacrifice

Plate 266

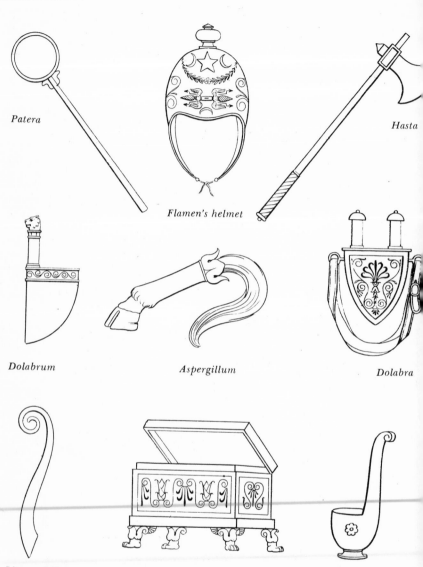

Patera

Flamen's helmet

Hasta

Dolabrum

Aspergillum

Dolabra

Lituus of the augurs

Acerra, or incense box

Simpulum for lustral water

Pontifical insignia and sacrificial instruments: from the frieze of the temple of Jupiter Tonans at Rome

Plate 267

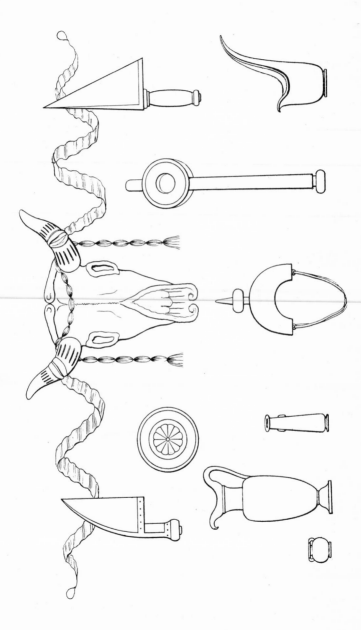

Sacrificial instruments

Plate 268

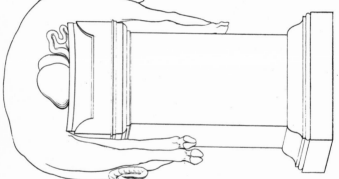

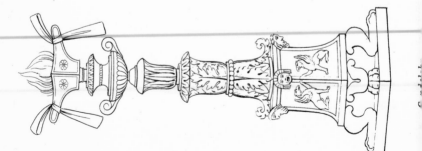

Plate 269

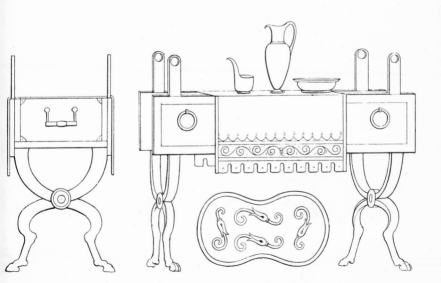

Lectisternium and ancile, or shield of the Salian priests

Plate 270

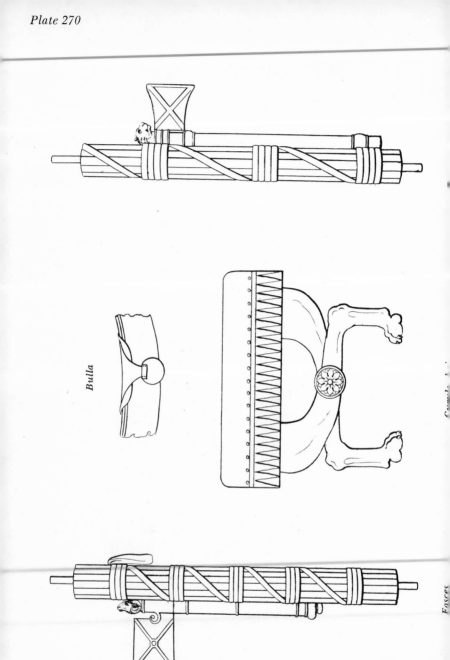

Bulla

Fasces

Plate 271

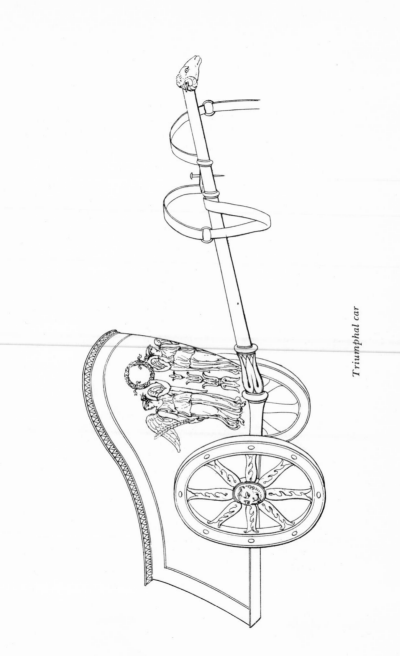

Triumphal car

Plate 272

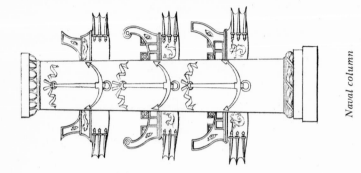

Naval column

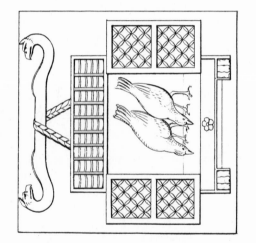

Cage of the sacred pullets

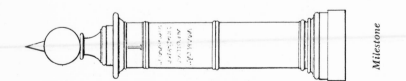

Milestone

Plate 273

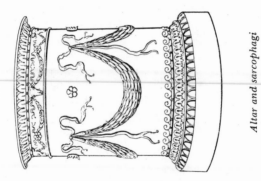

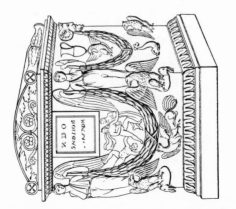

Altar and sarcophagi

Plate 274

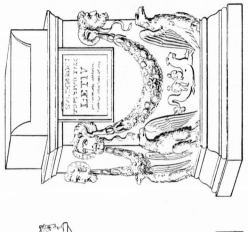

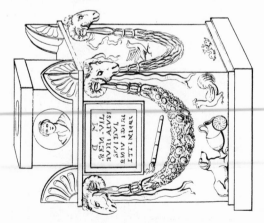

Altars and sarcophagus

Plate 275

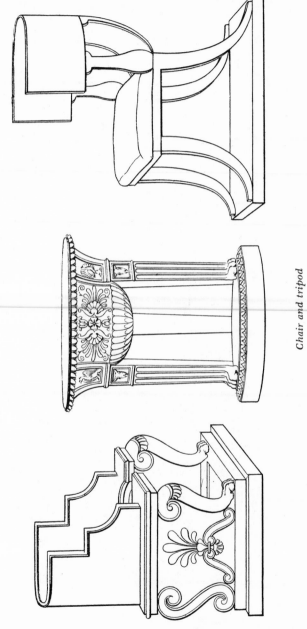

Chair and tripod

Plate 276

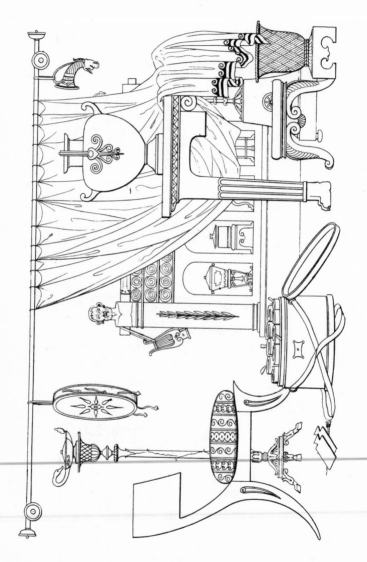

Roman study with scrolls or volumina, tablets for writing, chair, table, lamp, etc.

Plate 277

Lavacrum or bath

Plate 278

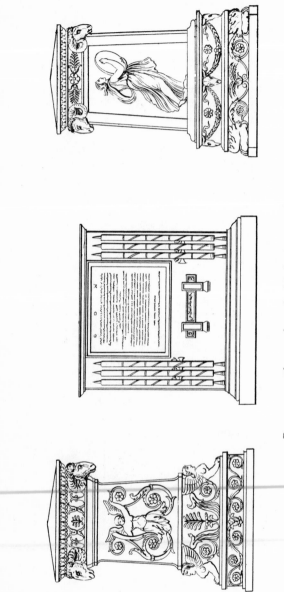

Roman sarcophagus adorned with the fasces, and altars

Plate 279

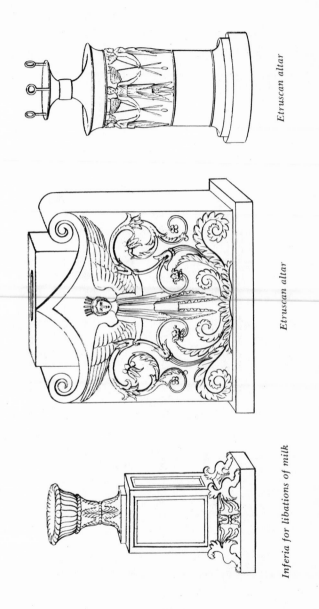

Etruscan altar

Etruscan altar

Inferia for libations of milk

Plate 280

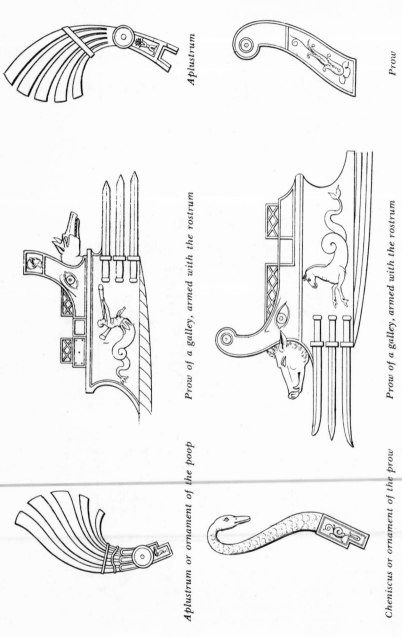

Aplustrum

Prow

Prow of a galley, armed with the rostrum

Prow of a galley, armed with the rostrum

Aplustrum or ornament of the poop

Cheniscus or ornament of the prow

Poops and prows of Roman galleys

Plate 281

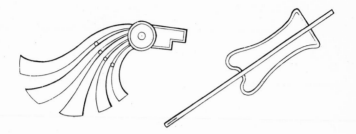

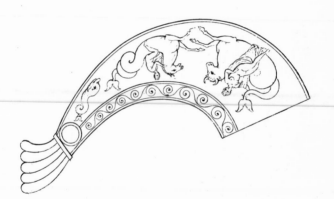

Poop, prow, anchor, and rudder of Roman galley

Plate 282

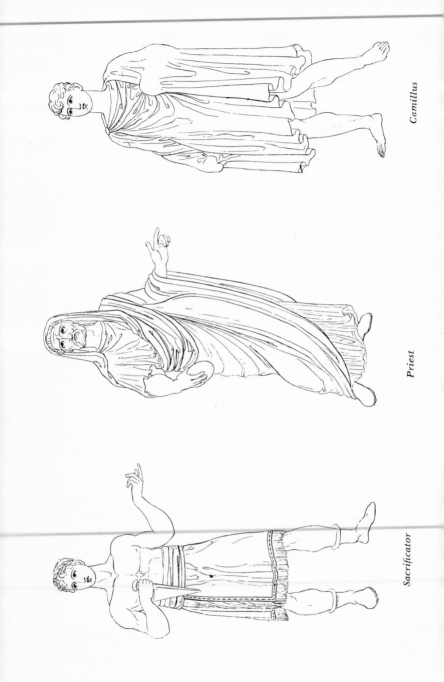

Camillus

Priest

Sacrificator

Plate 283

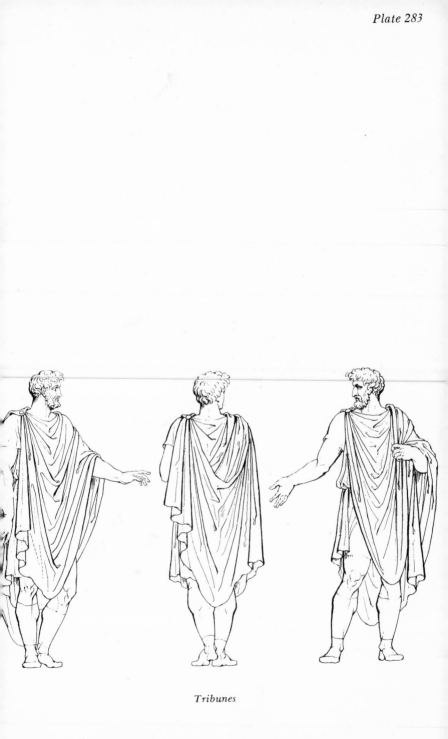

Tribunes

Plate 284

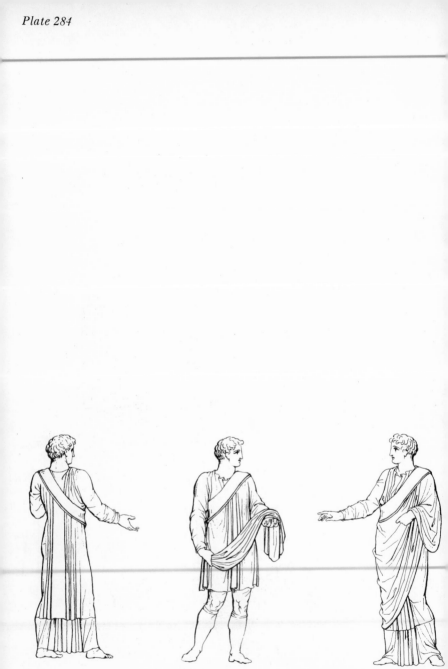

Senator, Knight, Senator, in the trabea: from the Arch of Constantine

Plate 285

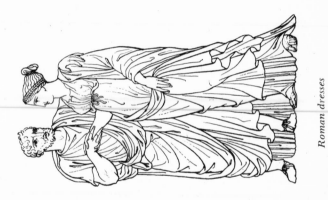

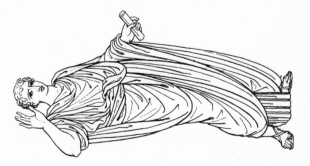

Roman dresses

Plate 286

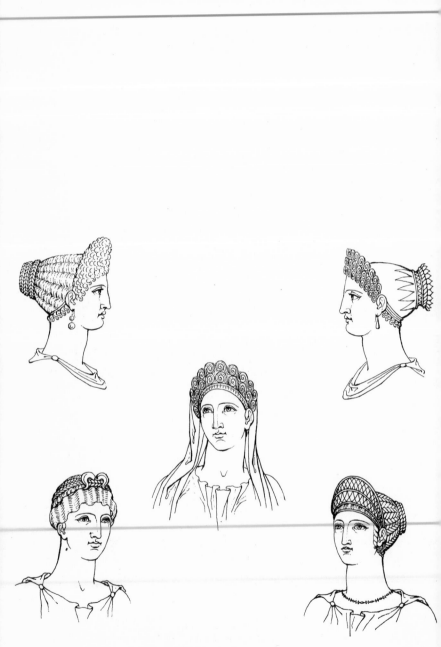

Roman empresses

Plate 287

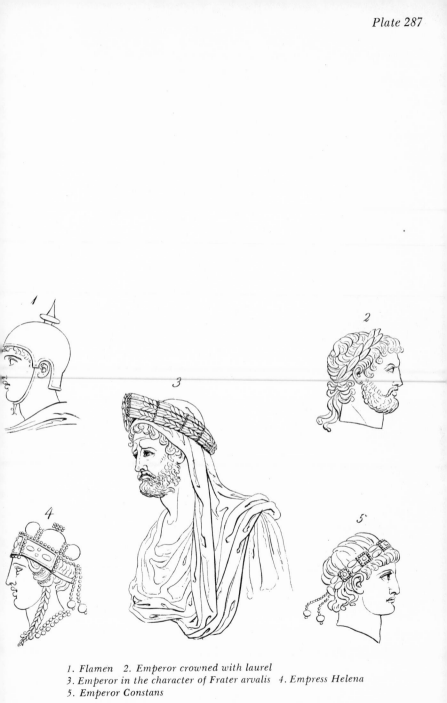

1. *Flamen* 2. *Emperor crowned with laurel*
3. *Emperor in the character of Frater arvalis* 4. *Empress Helena*
5. *Emperor Constans*

Plate 288

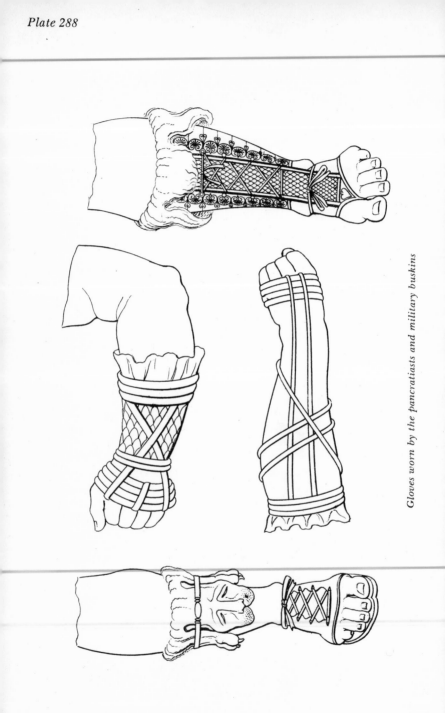

Gloves worn by the pancratiasts and military buskins

Plate 289

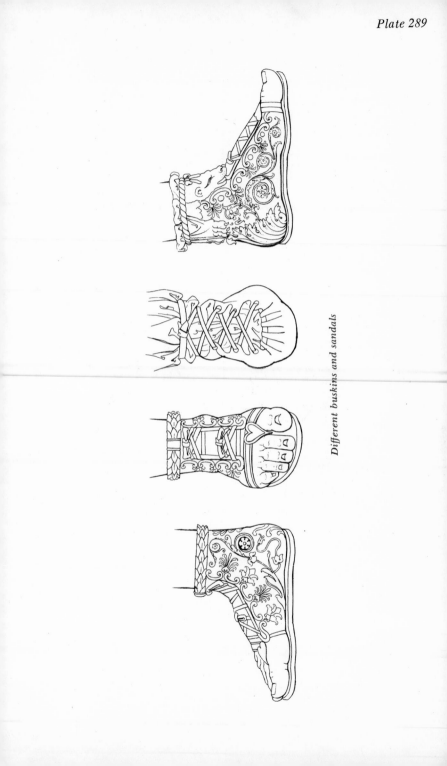

Different buskins and sandals

Plate 290

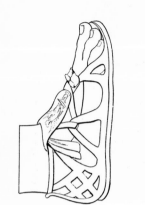

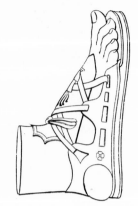

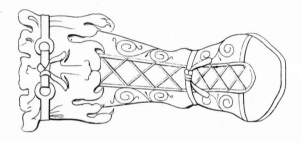

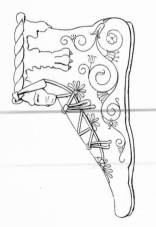

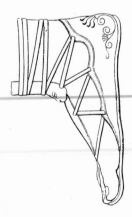

Roman buskins and sandals

Plate 291

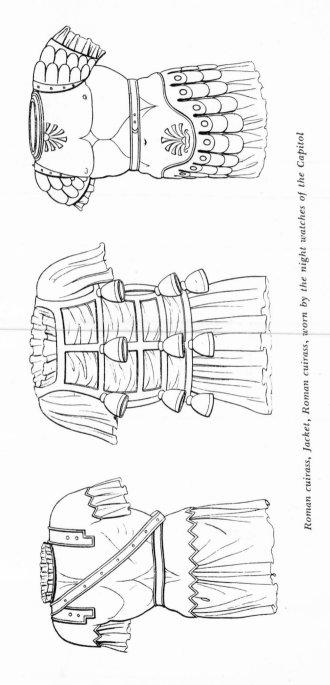

Roman cuirass, Jacket, Roman cuirass, worn by the night watches of the Capitol

Plate 292

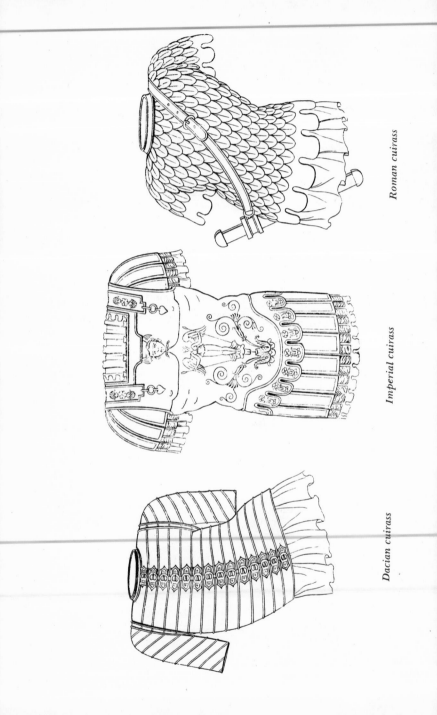

Roman cuirass

Imperial cuirass

Dacian cuirass

Plate 293

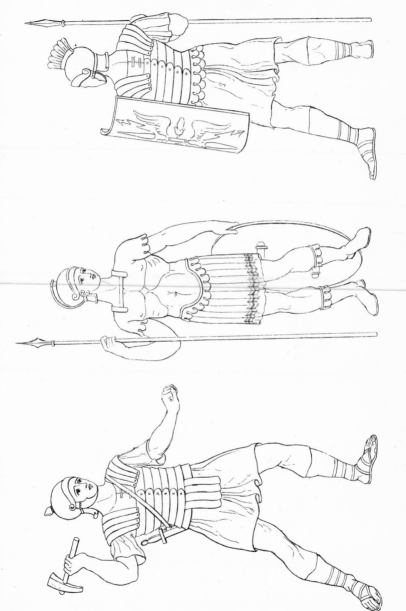

Roman soldiers

Plate 294

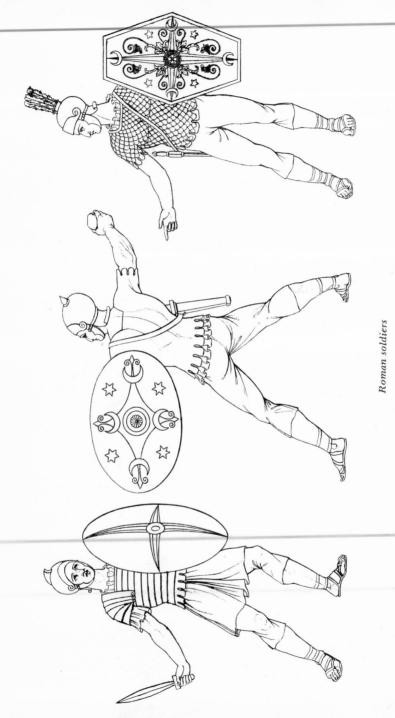

Roman soldiers

Plate 295

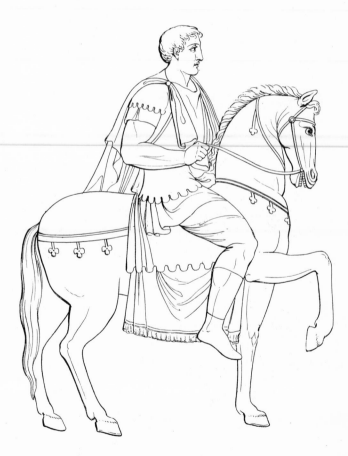

Roman officer from the Trajan Column

Plate 296

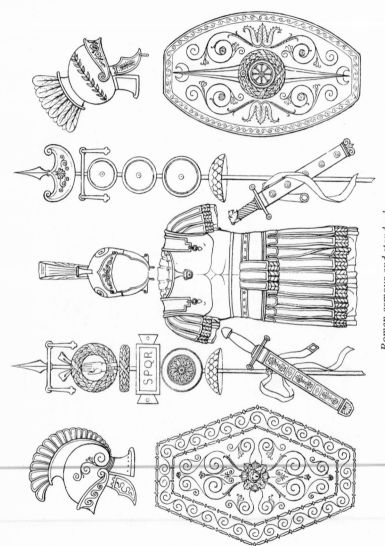

Roman armour and standards

Plate 297

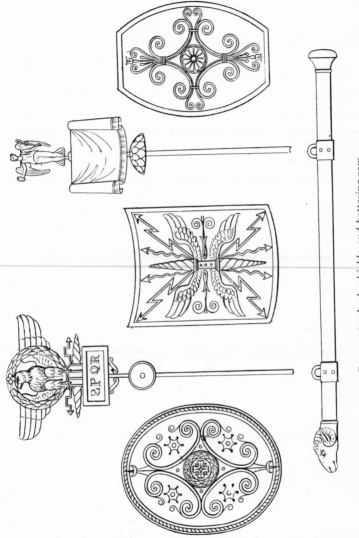

Roman standards, shields, and battering ram

Plate 298

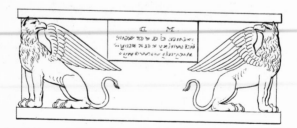

Sarcophagi

Plate 299

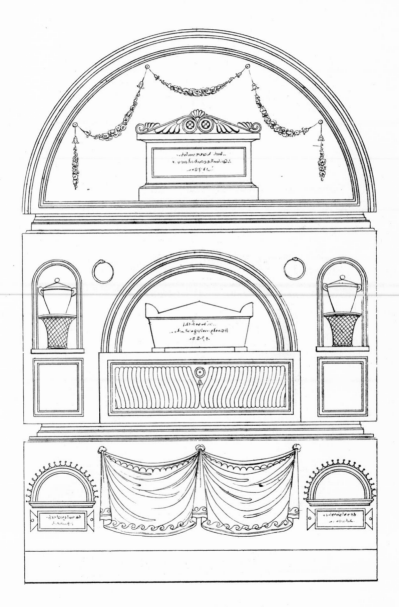

Roman columbaria for the reception of cinerary urns

Plate 300

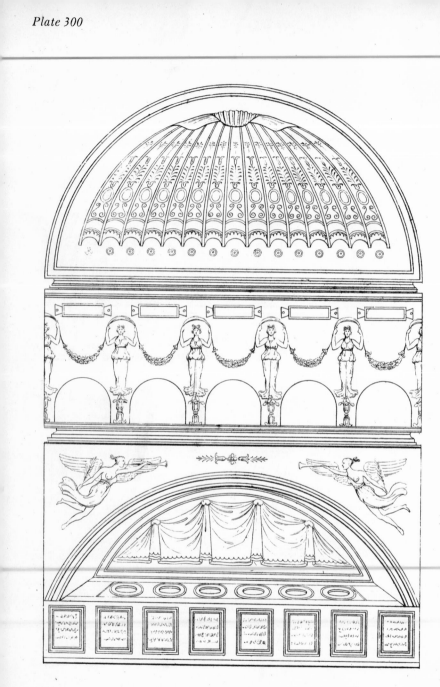

Roman columbaria